Museum Educator's Handbook

*This book is dedicated to the memory of Charles Edward (1922-1980)
and Doris Rose (1919-1999). The best of parents – together again.*

Museum Educator's Handbook

Second Edition

GRAEME K. TALBOYS

ASHGATE

Published by
Ashgate Publishing Limited
Gower House
Croft Road
Aldershot
Hants GU11 3HR
England

Ashgate Publishing Company
Suite 420
101 Cherry Street
Burlington, VT 05401-4405
USA

Ashgate website: http://www.ashgate.com

British Library Cataloguing in Publication Data
Talboys, Graeme K.
 Museum educator's handbook. – 2nd ed.
 1. Museums – Educational aspects 2. Museums and schools
 I. Title
 069'.07

Library of Congress Cataloging-in-Publication Data
Talboys, Graeme K.
 Museum educator's handbook / by Graeme K. Talboys.
 p. cm.
 Includes bibliographical references and index.
 ISBN 0-7546-4492-8
 1. Museums--Educational aspects--Handbooks, manuals, etc. I. Title.

AM7.T35 2005
069'.15--dc22

2005018438

ISBN 0 7546 4492 8

Typeset by Saxon Graphics Ltd, Derby
Printed and bound in Great Britain by MPG Books Ltd, Bodmin, Cornwall.

Contents

Acknowledgements

This book owes its existence to a number of people whose confidence in me and the support they gave during a difficult period is humbling in its magnitude. My thanks to them all, especially my brother, Alan, for doing all the work for us and making all the arrangements; my sister, Lorna, who helped with the research and flew round the world to dispense much-needed comfort; Joan and Kathryn for their boundless warmth and great spiritual strength; Sam Cocksedge and her team on D2, Brighton General Hospital; the team on VV1, Newhaven Downs House; and the staff at The Haven Nursing Home, Peacehaven. My thanks also go to Suzie Duke, who approached me with the initial idea for this book, Elizabeth Teague, who knocked it into shape, and everyone else at Gower, who saw the project through with great professionalism and forbearance; John Pickin and the other staff at Stranraer Museum for putting up with me long after my use-by date; all the individuals and organizations around the world who had the courtesy and took the time to answer my queries; my wife, Barbara, as ever supportive, resourceful and an inspiration to us lesser souls; and, not least, Catkin, Matilda and Toby Kitten (wherever he may now be), each for their own form of companionship. Although these good folk have contributed a great deal to this work, I lay sole claim to any errors that may follow.

<div align="right">January 1999</div>

The acknowledgements for the first edition tell their own tale. Much has happened in the intervening years, not least the success of this book. I would like to take this opportunity to thank everyone at Ashgate and Gower, especially Suzie Duke and Dymphna Evans, for helping to make my museum books prosper as well as for commissioning this new edition and seeing it through to press. I would also like to thank Thelma Lin, Aven Kuei of Five Sense Arts Management Inc., and the British Council Taipei for working together to produce the wonderful Chinese language edition; Sally Pointer, Glanely Discovery Gallery Manager, National Museum & Gallery of Wales, for so readily sharing her experiences of and insights into work with Home Educators; Janette Bell and Yvette Staelens, BA (Hons), AMA, FMA for their work on loan services; and, once again, John Pickin of Stranraer Museum for allowing me to litter up the place with my presence and keep up to date with journals and other material. My wife, Barbara, also deserves a completely new set of thanks for being such a tolerant and supportive companion. As before and always, all mistakes are mine alone.

<div align="right">Graeme K Talboys
Clas Myrddin</div>

Introduction

Two major reports on museum, gallery, and heritage site education – Anderson (1997) and Hein and Alexander (1998) – made comprehensively explicit two points that had been known implicitly for some time. The first is that museums are enormously important and wide-ranging, resource-rich centres for lifelong education. The second is that most museums have a long way to go before they fulfil their educational potential.

This is not a criticism of museums. Many are engaged in a constant struggle to provide the best educational service they can against enormous odds. Whereas they are being told all the time how wonderful they are as educational resources and how important they are to all forms of educational endeavour, they find it ever more difficult to secure the money and other resources necessary to provide what is increasingly expected of them.

One of the major obstacles to museums trying to develop their educational potential is the lack of specialist education staff. For many museums the employment and resourcing of another member of staff is a low priority – in some cases an impossibility. Others have recognized that if you make education a priority, then most other things follow, but they still find it difficult to commit the resources.

That is not all. No matter how willing museums may be to move education to the centre of their efforts, no matter how ingenious they are in finding the necessary funds, they still face the problem of convincing others that whoever is taking on the task of developing education will need a great deal of time and support. Even those who are convinced of the necessity of making education a priority are not always fully aware of just what such a task involves. There are many different levels and aspects to the structure of a museum education service, as well as a whole host of problems to be solved to ensure that education is an integral part of the museum rather than an add-on that can be cast off again at the first convenient moment.

By exploring the core aspects of museum education and being a museum educator, as well as some of the obstacles that will be met on the way, this book has two aims. The first is to help museums and museum staff set up a successful structure to meet the needs of educational users and enhance the prospects of the museum. The second is to explain in some detail what museum education entails so that its importance and complexity will be better appreciated within museums, by museum management and by those who fund museums.

If curators, conservators, designers, educators and all other staff understand each other and work together, their needs can be satisfied to their fullest extent and the museum is strengthened – and visitors get the best possible deal. Moreover, if those who make decisions about resourcing are made fully aware of the complexities involved, they may even give less grudgingly and more generously. An ethos in which the tensions between conservation and access are allowed to flourish is damaging to all concerned.

This book cannot cover every aspect of museum education. It is intended solely as a guide to creating the framework of and running a working education service. Much of the subsequent detail that you will need to provide will depend, of course, on individual

situations. What follows is largely confined to practical and logistical matters. You will not find herein any extensive discussions of philosophy and reviews of learning theory, for example, nor any of the other many theoretical subjects that are of relevance to the every-day work of the museum and gallery educator. These subjects are, without doubt, of great importance, but there is not room in a book of this nature to do them justice. They are left to those more competent in their exposition and you are urged to seek them out.

Although the chapters of this book deal with distinct aspects of the subject in a par-ticular order, it is important to remember that this was simply the best way to write them. Real life is, as always, much more complex. Everything mentioned herein is interconnected, and circumstances will often dictate that things be done differently. It is important, there-fore, to read each chapter, even if it does not seem immediately relevant. It may spark ideas and point out pathways and connections pertinent to your own context that could not pos-sibly have been imagined by anyone else.

Extensive use is made throughout of certain words and phrases and it seems prudent to outline the way in which they are used in this particular context, and why I have chosen them over others. They are: 'museum', 'museum educator', 'educational user group', 'school', 'student' and 'teacher'.

Precisely what a museum might be is contentious. Although the many definitions that exist agree on many points, there are enough areas of disagreement to ensure that the debate continues. Some discussion is offered in Chapter 1. One point, however, should be made very clear from the start. For the purposes of this book, the word 'museum' includes art galleries and any other establishment that collects and displays examples of material culture. Those who work in museums should have a good idea of what they consist of, and will need to apply what follows to their own particular circumstances.

A 'museum educator' is any member of the museum staff who has specific responsibil-ity for organizing and delivering educational services, as well as ensuring that education as a function of the museum is kept to the fore in discussion and planning. This person may not necessarily be an education specialist and may have other responsibilities within the museum as well.

An 'educational user group' is any group of any age or ability, be it formal, non-formal or informal, actively making use of a museum for educational purposes. It is not a phrase that trips lightly off the tongue, but it does have the virtue of being unencumbered by asso-ciations that more specific words such as 'school party' or 'college group' might have.

'School' is used throughout as a generic term to denote any institution where formal learning takes place – from kindergarten to university. Where specific types of school are under discussion, the appropriate term is used. Where no generally accepted generic term exists for a specific part of the school system, use is made of the terminology of the system in England and Wales. This can then be compared with systems in other English-speaking countries with which the reader is familiar by referring to Appendix 5.

In arguing (as this book does) that education is central to the existence and activity of all museums, it would seem redundant to differentiate between visitors on grounds of who is and who is not engaged in an educational activity. All visitors are. However, there are dif-ferent levels of engagement and different reasons for visiting. The casual visitor looking for something to do on a wet Saturday afternoon may undergo an educational experience when wandering around the museum, but it is of a different kind to that of someone who visits because they are following a specific educational agenda – no matter how informally. A 'student', therefore, is any person of whatever age, ability, and motivation who is actively

and consciously engaged in learning toward a specific and predetermined end. A 'teacher' (sometimes referred to as a 'lecturer' or 'tutor' where it is more appropriate) is any person who is consciously engaged in helping others to learn. It is important to remember that not only are the roles of student and teacher reversible in any given situation, but also that student and teacher can be one and the same person. All students and teachers are visitors, but not all visitors are students or teachers.

With those definitions in mind, it is time to consider what follows. The vision is of a perfect world – what you should do rather than what your circumstances will allow. However, adapting the ideal to the particular is part of the challenge. Working within the constrictions while maintaining a vision of what to work towards leads to development and progress.

If you are reading this because you have been given (voluntarily or otherwise) the onerous task of starting up or overhauling a museum education service, may I wish you good luck and remind you that no matter how difficult it may seem, the end results will more than compensate for any difficulty you will undoubtedly encounter on the way.

1 *The Educational Role of Museums*

To most people outwith the museum community, the prime function of museums is usually considered to be the preservation and display of artefacts of archaeological and historical interest. They are unlikely to have given a great deal of thought to the wider role of museums in society but would probably agree, if asked, that museums are worthwhile.

To those who are part of the museum community, museums are understood to be much more complex institutions that fulfil a great number of interdependent roles. The relative importance accorded these roles will depend upon whom you ask. A curator, for example, will give an answer with emphases and biases that differ from those of a conservator or a designer. In the end, however, they too are likely to agree that museums exist, in part, to preserve and display artefacts of historical and archaeological interest.

There is nothing particularly remarkable or contentious in this. However, as it stands, it does beg a very important question. Given that museums do exist for the reasons already stated, what is so important about these artefacts that we are prepared to finance special buildings to house them, procedures for their upkeep, as well as the training of people to care for them, and then spend more money going to see them? After all, in the UK more people visit museums each year than go to soccer matches and visit the theatre. Museums in the USA record more than 500 million visits a year.

The importance with which we imbue museums and the artefacts they contain demonstrates, even before an explanation for this is attempted, that there is a deeper, more fundamental reason for their presence – one which has existed since museums themselves came into being many centuries ago.

Against a background of the complex cyclical rhythms of nature, the world of humanity is constantly changing – more so now and at a greater pace than ever before. Communities and societies once remained largely unchanged from one generation to the next. The pace of change in all aspects of life was so slow that a deep-rooted sense of social continuity existed. Now we find that items that were familiar only ten or twenty years ago are already disappearing and, with them, the ephemeral ethos that brought them into being. Nor are these simply trivial objects. Many of those that had a profound effect on the lives and the thinking of whole generations of people have vanished from our lives. If these items are not preserved in some way, we feel that they will be lost to us for all time.

Yet even when the pace of change was much slower, there was a sense that objects from the past were worth preserving. During the sixth century BC, for example, there was a school attached to the temple precincts in the Sumerian city of Ur. Two rooms of the school housed objects that pre-dated the temple complex by as many as sixteen hundred years. We do not know for certain that this was a museum, but it seems unlikely to have been anything else.

However, the fact that our forebears considered ancient objects worthy of collection and preservation still does not tell us why they did so or why we continue to do so. We must look elsewhere for clues to that.

The choice of objects that tend to be selected for collection and display by museums gives us a hint. Most people think of museums as containing aesthetically pleasing objects. That is partly true, but it has never been the whole story. Moreover, during the last fifty years a much broader approach to what is worth preserving has developed.

As an example, some countries are moving into a post-industrial phase of their social development and some people have realized that if the industrial aspect of their past is not preserved in museums, it will largely disappear. There is very little that is aesthetically pleasing about industry and its processes, although, to state a truism, beauty does tend to be in the eye of the beholder. But no matter how ugly an industry, no matter how heavy its social and environmental costs, there will always be enough people who want to see it pre-served – in memory if not in actuality.

The same is true of armed conflict. The overwhelming majority of people will be only too glad if they are never involved in a war, but many men and women who have endured such experiences spend countless hours reading about them and visiting museums with relevant exhibitions. It is an attempt to make sense of something that radically altered their lives – something they could not understand and a process they could not see *in toto* at the time.

Indeed, social and historical phenomena in our rapidly changing world have now become so vast and complex that we need, more than ever, a system by which we can make sense of what has happened and, in some cases, continues. This role is fulfilled by museums. They can tell the whole story (in outline at least), be it of coal mining, ship-building, war, the town we live in or anything else, and tell it so that it is readily assimilated, safe, and can be returned to again and again. What is more, they can tell it in a unique way using the artefacts of our material culture.

Human beings, with their insatiable curiosity, have a collective desire to know, remember, muse upon, and make sense of their personal and cultural pasts. Nor is this a matter of idle curiosity, because self-knowledge in both an individual and a community sense is essential for other knowledge. However, there is a further reason for such self-knowledge that has less to do with a search for knowledge and more to do with wisdom and a concern for the future.

One feature that marks out human beings from other creatures is our sense of time. We can conceive of a past stretching back many thousands of years and of an equally distant future. We can also recognize the continuity of ideas, actions, and social influence that is woven through this flow of years, despite the evolutions they have undergone.

Our concept of what the past was like is based in part on an understanding of ideas and actions that we have inherited from our forebears. The world we inhabit today has been created from those ideas and actions. One of our concerns as humans is that we pass on this understanding of the world (past and present) to our children, so that they might have a better chance of personal and social survival. It is why we send them to school to equip them with the ideas and knowledge that previous generations have bequeathed to us. What was once a useful strategy that improved upon and replaced instinctive behaviour has developed into a potent aspect of what defines us as human beings.

There are many ways in which this knowledge can be passed on, some better than others. Practical skills are still best learnt by doing. The understanding and passing on of

ideas is best accomplished through communication between people, using the spoken and written word – as in schools. However, there is another aspect of human culture from which we derive a great deal of our knowledge of the past – material objects, the combined product of what we do and what we think.

It is a reflection of our society that much of what we are is defined by material objects of one form or another. We are therefore predisposed to understand a great deal about ourselves and others as well as the events through which they lived from the material objects associated with them. Of course, they do not tell the whole picture of what we were, are, and could be, but they do provide a unique focal point for contemplation and a uniquely multifarious starting-point for exploration.

This is not the only role of museums in society, any more than they are the only institutions within society that perform this role. They are, however, the most prominent of institutions involved in this exploration of material culture and they are specifically designed for this purpose.

What all this implies, in answer to the original question, is that museums act as one form of the collective social memory of a people. And just as a person has integrity through their store of memories of first-hand experience, a culture has integrity through what it stores of its first-hand experience of itself and of other cultures and the relationships between them.

However, there is more. The International Council of Museums (ICOM) defines a museum as a

non-profit-making, permanent institution in the service of society and its development, and open to the public, which acquires, conserves, researches, communicates and exhibits, for purposes of study, education and enjoyment, material evidence of people and their environment.

In *Using Museums as an Educational Resource* (Talboys, 1996) I defined a museum as

an organic institution or dedicated space open to all wherein a genuine artefact or a collection of genuine artefacts of aesthetic, archaeological, cultural, historical, social, or spiritual importance and interest from any place or time is preserved, conserved and displayed in a manner in keeping with its intrinsic and endued worth. As such, it is an informative means of storing national, cultural and collective memories, where people can explore, interact, contemplate, be inspired by, learn about and enjoy their own and others' cultural heritage.

However, both of these definitions, whilst touching on the major reasons for the existence of museums, fail to make explicit an extremely important aspect of that purpose. For although museums deal with material culture, non-material culture (that is, the shared values, ideologies, oral traditions, rituals, ethical standards and beliefs that give meaning and symbolic or spiritual significance to the social and natural world) is of equal importance. Material culture cannot be understood properly without an understanding of the non-material culture from which it arose. The museum is not and cannot be isolated from the rest of the social and natural world.

Through museums, we learn about the past of our own society and, because of their ability to present an overall or large-scale interpretation, come to an understanding of that

past. Through museums, we learn about material culture and the non-material culture that gave rise to it, as well as the context in which both cultures are embedded. Through museums, we tap into human experiences of the past. Education begins with experience. As such, museums are quintessentially educational.

It takes no great leap of the imagination to see that museums could and should be central to a good education, just as education could and should be central to all museums. If this is the case, then people must have access to museums, just as they must have access to their own memories. Without access, memory is worthless; it has no function. Without access, we are denied the experiences that are the foundation of education. Nor is it sufficient that memories be paraded without understanding and interpretation, for what we come to understand of the past (be that personal or social) shapes how we react to the present and shapes the future. That is why repressive political regimes suppress, control, or destroy access to museums and education.

Even in open societies, there are some people with collections, buildings, and sites in their guardianship who feel that the only way to care for them properly is to prevent all access to them. You can see their point to a degree – after all, schools would be wonderful places to work if it were not for the students disrupting everything. Hospitals would be wonderful institutions if only all those sick people would just stay away. However, that would defeat the object of such places. And the same is true of museums.

A museum cannot ever be just a collection of physical objects. Artefacts need care but they also need interpretation, for experts and the public alike. There can be no museums, therefore, without people – people with their ability to interact with aspects of their own and others' material culture, people with their ability to come to some sort of understanding of both their material culture and themselves. To achieve this, a museum should offer the opportunity to see, touch, hear, and have sensual, emotional, and intellectual interactions with and experiences of what it contains. A visit to a museum should be an experience similar to listening to music, visiting a library, reading a book, going to the theatre or cinema – a confrontation with the products of fellow human beings that can lead to revelation and deeper understanding.

No museum can claim, with any logical justification, to be uninterested in education. Education is intrinsic to museums. Unless they make purposeful provision for a broad range of education, they are not truly museums. Indeed, much worthy educational work is done within and beyond the bounds of museums. Many museums have actually led development in this field, dragging other areas of education along with them.

The activities, properties, and collections of museums represent an educational resource of enormous wealth, and not merely with respect to archaeology and history. Just as the resource is of enormous wealth, the range of subjects it covers is (and is so as a necessary consequence) extremely broad. The catch-all area of culture is perhaps the most obvious because it is itself such a vast area of study. However, there is much more that can be offered beyond (or perhaps, more accurately, within) these broad sweeps of interest. The resources of museums are of interest to teachers and students, of whatever level, who have an interest in virtually any subject or field of study that could be mentioned or imagined. In addition, the connections between the collections held by a museum and the subject of study do not have to be the obvious ones. The student of mathematics, physics, or design is as likely to be interested in steam engines, for example, as the student of transport systems.

What is more, museums are places in which material and non-material culture can be connected and where disparate notions can be juxtaposed and explored. Through this, they

can affect the values and attitudes of students by, for example, making them more comfortable with cultural differences or developing environmental ethics. They can promote exploration of and identity with culture, community, and family. They can provoke interest and curiosity, inspire self-confidence, and motivate students to pursue new avenues of learning. Above all, they can affect *how* students think and approach their world as well as *what* they think.

To be in possession of such vast, multiform, and powerful resources places a great responsibility upon museums and those who manage and fund them. They are quite at liberty to deny the existence of such a responsibility. They can allow the resources to lie unused, and thus, in essence, go to waste. The resources will not disappear or deteriorate if they are not used for educational purposes – museums need have no fears about that. However, they will be wasted in terms of the stimulation and enrichment they could have given to students. Moreover, if resources of this nature are not used, the rationale for their existence is very much open to question.

Denying a responsibility does not mean, however, that it does not exist. Nor, in this case, does it mean that the potential wealth of the resources is diminished. However, as John Ruskin observed in *Unto This Last* (1970), true wealth is not measured in how many ploughshares you possess. Rather, it is measured in the number of furrows you make with those ploughshares. Museums cannot deny the richness of their resources. Nor can they afford, in academic or in financial terms, to let them lie unused. The resources should be put to work; the ploughshares should be set to making furrows.

However, the on-site services offered by many museums are still of great passivity. The extent of the educational provision of many museums amounts to little more than allowing public access to their properties and collections. However, the days when museums could be considered the preserve of those who had the educational wherewithal to make their own interpretation of what they saw have long since passed.

Much more than a passive approach is necessary if museums are to fulfil their function as a collective social memory and enjoy the support of the public. After all, for every worthwhile display and exhibition that is mounted, selections have to be made. Selection of artefacts and materials is based on learning. Yet there can be little point to such selection, no matter how erudite the performance, if the significance of the material selected is not then conveyed to students and other visitors. Although interpretation will always be partial (in both senses), it is one of the main factors that provokes the dialogue fundamental to education. Without that, visitors may come once, but they are unlikely to return. Similarly, studies of the past based on these collections and on archaeological activity are of little worth if the fruits of those studies are not made available to as wide an audience as possible. Passive provision is no use. It does not provoke attraction, reaction, or curiosity, and instigates no two-way flow of information, all of which are essential to education and to the well-being of museums.

Nor is it enough for a museum to take one of Ruskin's ploughshares, make a few furrows, and see what seeds the wind blows in. That way lays chaos – an open house inundated by groups who do not know how to make proper use of the resource and who stifle the museum's chance to innovate because they make narrow demands.

To extend the metaphor, a museum must cultivate its educational users, choosing seeds that best suit its soil, nurturing them, and always looking for ways to improve yield and diversity. Educational users must be taught the skills needed for work in museums. They should be guided into the learning spaces that the museum has created. Once there, they

need to be given assistance to explore those spaces thoroughly, making the most of their experiences. The development of understanding must be nurtured while the museum also challenges; arouses; interests; makes anxious; gives confidence; provides support, information and advice; coordinates endeavour and achievement; and encourages reflection on the use of skills and on the content of the subject (or object) being studied.

If the resource of a museum is to be developed to accommodate such use, this must be done holistically, comprehensively, and in accordance with a basic structure. There are, after all, many specific groups with specific and disparate educational needs who would wish to make use of a museum education service. Moreover, the museum itself needs to retain its integrity. With the guidance of a basic structure, it is possible to do so while developing the flexibility required to cope with the many and varied demands that will be made on it.

None of this can be achieved properly without a great deal of thought, research, and hard work. Ideally, museums should employ full-time, permanent education staff on attractive professional salaries with sufficient budget and autonomy to do justice to their work. This is not always possible, especially where smaller museums are concerned. However, the person undertaking the work needs to have the expertise and the experience to take many factors into account.

To fulfil their role in society, museums must accept that they are quintessentially educational and that they must actively promote that aim. By recognizing education as their reason for being, museums not only return to the purpose for which they were first created, but also firmly establish themselves in a role that is essential to the future of society. It is understandable that there are worries that too much emphasis on the educational element will overshadow the other important work that museums do, but that work would not exist were it not for education. In addition, education, far from endangering that work, or being in conflict with its principles, can – if properly structured – do much to enhance it. It is not just the content of museums, but also the work of those employed within them that could and should be the subject of an education service, as well as museums *per se*. Brought to the attention of the public in a well-structured way, museums will benefit from their enthusiasm, their good wishes, and their financial support.

Museums must work, therefore, to become centres of education. Furthermore, they must activate the great store of memory that they are, and engage in becoming a voice that speaks to us on behalf of those long past. They have much to teach us!

2 *Why Provide Education Services?*

It is easy enough to expound on theory, but the arguments outlined in the previous chapter, though sound and necessary, are insufficient. In the first place, abstract ideas take on meaning only in their application. In addition, a museum and the person or persons responsible for running its education service will be involved in practical work and will need to base what they do on sound utilitarian as well as sound theoretical principles. This is especially so if the museum has a sceptical or impecunious managing body. Such a body will want to know what the practical advantages of an education service will be to their museum. It will also want to know that a museum educator is fully aware of the disadvantages of such a service.

Even if there is a well-established museum education service, it is a worthwhile exercise to review what theoretical and practical reasons were originally given for setting it up. They may no longer be relevant. The world of education changes rapidly. Increasing use of computers, greater use of personalized learning programmes, a growing belief (in these troubled and litigious times) that visits may be more trouble than they are worth, changes to the content of the curriculum – all these and more escalate the pressure on museum education services. If these services do not constantly evolve to suit current needs, their ability to cope with present and future demands would be undermined and any attempt to set the pace of future thinking on education would be severely restrained.

Whether you are reviewing an established set-up or preparing a new one, there are a number of distinct practical reasons why it would be of advantage to a museum to have an education service run by a specialist museum educator. Some of these reasons will vary, depending on location and type of museum, but the following will apply in most cases.

Professionalism

Museums are professional institutions. The work that is done in them, as well as their general ethos, is characterized by and conforms to technical and ethical standards. Likewise, education is a professional undertaking. Teachers should know what they are doing. Education is much too important to be left in the care of anyone who is less than competent in its exercise.

It is hardly fitting, therefore, for any museum to be less than professional when it comes to offering an education service. This does not mean it should immediately recruit a qualified teacher. Such a move may not necessarily be appropriate, let alone affordable. However, it does mean that at the very least a museum should take the challenge of education seriously, seek good advice, and offer what service they can in a professional manner.

Broadening perspective

Whilst there may be financial constraints, having a member of museum staff dedicated to education does provide a number of benefits. In the first instance, it allows curators to do their own jobs on a full-time basis. Being free to concentrate more fully on the collection means they are able to provide a better curatorial service and develop the exhibitions.

An important aspect of this development is that there is an education specialist to call on at the very earliest stages of planning and design. This does not mean that new exhibitions have to be created. It does mean being able to reassess existing exhibitions from an educationist's perspective and making adjustments that enhance them both as educational tools and as general visitor attractions.

This new perspective need not be limited to exhibitions and educational users. Education is, in large part, about clear communication. It is also about providing people with the tools to educate themselves. Such a perspective can work just as beneficially in-house, with staff training, improved routes of communication, and a wider vision of the role of the museum.

Meeting the demands of providers of formal education

A professionally established museum education service will properly satisfy the many demands made on a museum by a whole host of formal education providers. For example, with increased concerns about safety (along with an increase in litigation), risk assessments need to be made of a museum in respect of various educational user groups. Furthermore, educational establishments demand best value from visits. They will not use museums where they have to do all the work themselves, especially if they are also charged for the privilege. There are also many (and sometimes bewildering) developments in education which a museum must understand and to which it must respond.

If there is no education service, a museum will not attract anywhere near the number of educational users it would if there were. However, it will still attract some, and they will inevitably take up curatorial time that would be better spent on other things. And no matter how interested in education curatorial staff may be, very few of them will have the time, let alone sufficient educational training, expertise or experience to meet the demands made of them.

To avoid the ad hoc nature of such an arrangement it is far better to have staff within the museum whose specific remit is education. This means an overall education strategy, not just a sideline that deals with schools and keeps them out of everybody else's way. Education needs to be considered throughout the museum, and this is far better done by someone who has the time and expertise.

Meeting the demands of providers of non-formal education

A non-formal group is one that has educational aims, but which is not a school. Many of the demands made by providers of non-formal education are similar to (if not identical with) those made by providers of formal education. There are, however, differences. Approaches to teaching vary widely, as does subject matter. The students also vary, having a wider range of ages, interests, backgrounds, and experience.

Meeting the general needs of such groups, as well as devising specific programmes of work is exacting and time consuming. Much of what they require cannot be used on a regular basis. However, the rewards are enormous as there large numbers of such groups who could use the museum. Whilst curatorial staff may meet some of their needs through the giving of talks on their own specialist subjects, this would realize just a small proportion of the potential for coping with and attracting non-formal providers.

Coping with the unexpected

A properly structured museum service acts as a fail-safe mechanism by which to cope with the unexpected and the unplanned. No matter how well organized a museum may be and how well advertised its educational protocols; there will always be those who are not aware of them. At one extreme this might consist of an unannounced coachful of students arriving to do work or simply to make a visit that has not been arranged with the museum. This sort of occurrence is increasingly rare but is still far too frequent. Of course, a museum may be within its rights to turn a group away – especially if it is already full with pre-booked groups. However, it would be a shame to miss the opportunity of educating the teachers in proper protocol and opening their eyes to how much better the visit could have been if it had been prearranged.

At the other end of the scale are the many families that arrive, especially during the school vacations. These groups are not disruptive but they do present an enormous challenge. Parents usually have some vague notion that visits to museums are educational, but are not sure how to tap into the resource once they are there. As such family groups represent a very large majority of the visitors to most museums, it is worth investing time and effort in catering for them. Moreover, there are many situations in between, where unexpected and last minute demands are made.

This not only relates to having a well-organized stock of materials to be used and places for people to go. It also relates to the general ethos of the museum that makes a visit an educational experience through its general layout and approach to catering for visitors. If staff are accustomed to dealing with educational groups as well as casual visitors and the museum is generally structured toward education, those visitors who turn up unexpectedly or make unexpected demands can be dealt with confidently and professionally.

Standards of behaviour

Allied to the provision of a structure that can deal efficiently and professionally with the educational demands of visitors is the education of visitors in appropriate behaviour. 'Appropriate' is the key word here, as acceptable standards of behaviour will vary from museum to museum and even from gallery to gallery within a museum.

This is not an overt business that can be dealt with in a series of lectures or a ten-minute welcoming session – although it never does any harm to remind younger visitors of some of the basic courtesies expected of them. The teaching of appropriate behaviours is part of what an educationist might call the 'hidden curriculum'. There is nothing sinister in this; it simply means that such things as behaviour are learned from the example of others as a by-product of other activities. It is, therefore, essential that educational work is structured

so that ways of working are taken into consideration as much as the content of the work itself. Method is, in any case, just as important as content, as it provides the structure for successful and accurate work.

This is not just a strategy to be established for the good of a particular museum, as the skills that are learned are transferable. It is simply a matter of deciding upon and establishing an environment and a style of work that elicit behaviours conducive to the aims of the museum in general, the education service in particular, and the comfort of other visitors.

Kudos

Any museum must be aware of, and make continual efforts to present, its public image and foster public support and acclaim. Public acclaim is not easily quantified, but it can prove to be a powerful ally for any museum in a whole host of situations. As with appropriate behaviours, this is not something that can be done in isolation. It cannot be achieved by a museum continually telling the public that it is a good museum. The public will weary of it and demand proof. Image without substance is fragile and easily destroyed.

Promoting a positive image can only be done if there is something worth promoting. Then it does no harm at all to draw attention to what is going on. Strangely, one of the least-promoted aspects of any museum is the education work it does. Often this is because it is not particularly glamorous, but most work in museums is not glamorous – although much of it does have a mystique born of obscurity. Part of the general education process is to ensure that people realize that a great deal of hard work goes on within the museum and that the results are significant if not spectacular. And of all the things for which the general public will hold a museum in high esteem, education will probably come top of the list, particularly if they are directly involved through using it themselves or having children or other family members benefit from the education services on offer.

Commercial interest

Easier to quantify than public acclaim is the amount of cash that flows through an institute. Education, for all the other claims made for it, is of interest in economic terms as well. If museums are simply perceived as impenetrable repositories of dusty artefacts and even dustier academics (a perception that is partly encouraged by a passive approach to education), they will lose out in what is an increasingly competitive field. Museums must be concerned with their own future, financial as well as academic. Interest in the past continues to grow, and the number of potential visitors has also grown. The so-called leisure market is expanding, bringing many new people into contact with the museum environment. If they are to be kept coming back, they must feel they are gaining from their visits. Schools are increasingly in control of their own budgets. They will be looking for the best value in terms of the complementary education they can offer to students. A good and positive museum education service will guarantee their continued patronage.

In the short term, income from educational visits can boost the amount of money flowing through a museum (if not substantially increase its income). For smaller museums, this can make a considerable difference to their day-to-day running, helping to ease some of the pressures they face. This income is not just derived from payment for educational

services. Most students will have some extra money to spend in the museum shop or café, even if it is only a small amount.

In the medium term, educational use of museums generates a secondary area of income. Students who have come on organized group visits tend to return to the museum with their family or with friends. The numbers vary according to the particular user group involved and most follow-up visits are one-off affairs. However, surveys show that, on average, 25 per cent of children who visit a museum with their school will return within two weeks with their family. Those who do make such visits, however, usually have more to spend than on the initial visit. In most cases, this represents curious parents coming to see where their children have been taken by their school, but the potential for building longer-term relationships is enormous – hence the need for an overall education strategy rather than one that only deals with schools. There is certainly plenty of scope for picking up on this trend. As just one example, a museum could offer a discount to returnees – perhaps using a voucher distributed to students during their visit that can be redeemed on a return visit with their family.

There are also longer-term commercial interests generated by educational user groups. Educational visits have a lasting impact on students in terms of knowledge and of social skills acquired. There is little evidence to suggest that adult visitors use museums simply because they went as students. The picture is more complex. What the evidence does suggest is that regular good use of museums enhances the education of students and their enjoyment of education. Those who have enjoyed their education are more inclined to continue it, to make use of museums in that pursuit and to regard such places as legitimate centres for leisure and enjoyment.

Other educational users can also become involved in long-term relationships with a museum. This does not apply just to visits to view exhibitions. Many non-formal and informal groups meet on a regular basis. Where they are not attached to a specific institution, the museum may be able to play host. Such an enterprise is entirely dependent, of course, on the museum having the space and other facilities (chairs, tables, and staff, for example). Where they do, there is no reason why appropriate groups should not be using the museum as a meeting place and contributing to raising its profile in the community as well as the size of its bank balance.

Long-term benefits also accrue from a long-term strategy to increase the educational attractiveness of a museum and move education to the centre of its being. This opens museums to greater public scrutiny and increases the opportunity to explain the important roles they play. Presenting a professional face and exploiting the prestige that goes with education, along with educating the public in general about museums and how to get the best out of them, as well as spreading the visitor catchment within a given community, all help to ensure longer-term commercial strength.

Although money is important, museums and museum educators must firmly resist all attempts by management and funding bodies to make museum education services 'self-financing'. Funding is looked at in more detail in Chapters 5 and 15, but is worth keeping in mind here as arguments about the financial advantage of education services are often misconstrued.

Cultural interest and social benefits

As well as commercial reasons for encouraging the educational use of museums, there are other less tangible reasons for ensuring that museums put education at the core of what they do. Education is the key word here, in that the aim is to teach about more than just the content and more than just the skills required to understand that content. Non-material culture, as already stated, is just as important (if not more so to some people) as material culture and the exploration of both is a key to wider work.

Museums are often invisible within a community and much undervalued because few people think a great deal about their role in society. A broad educational remit will allow a museum to incorporate a much more overt message about its worth in the work it does, as well as opening up a wider exploration of ideas and issues that are relevant to the present day. This cannot stand alone, but needs to be part of the overall approach of the museum to its local community.

Educational programmes enable museums to engage with their local communities and participate (if not take a leading role) in the cultural development and the cultural and economic regeneration of their area. Museums cannot do everything. Museum education is no panacea. Nevertheless, a well-considered approach to a two-way community involvement can help museums become an essential part of community life.

A museum that works with its local community in order to involve it, and which does what it can to improve the lives of those around them, is far more likely to be appreciated and valued. Not only does this mean that long-term financial support is more likely to be secure, but it also means that local involvement places the museum to the fore as part of everyday life rather than as something a little out of the ordinary and a little out of reach.

Museums should emphasize the social benefits of their existence as much as (if not more than) the number of tourists they attract. Tourists are in no way to be despised, but tourism is fickle and prone to fads and fashions. Social development is non-stop, locally based, and likely to outlast any benefit from outside the area. This means that museums should not be seen as the preserve of an elite, but as places where everyone is welcome.

Meeting legal and other requirements

Museums, like all other organizations, are bound by laws and may have to meet many legal as well as non-statutory obligations. Among these may be requirements that a museum provides an education service. These requirements may be internal, in that they are part of the legal constitution of a museum. They may also be imposed on a museum by external bodies such as local or national government, funding bodies and the like. It may even be that a museum is gifted money in a will on condition that it is used for education (although some museums have been known to take legal action to try to have such conditions put aside).

Whatever the requirements may be, it is in a museum's best interest to embrace them rather than fight them or pretend they do not exist. Even without a 'separate' education programme, it is possible to produce temporary and permanent exhibitions with a more educational approach, as well as making it easier for students and educational institutions to gain access to material and documentation. Such work, of course, is far better coordinated by a specialist who can assess the needs and devise ways of meeting them that do not disrupt the other work of the museum.

Assessment

Instituting an education service that has a broad remit (rather than just being a buffer to deal with schools) can have wide-ranging implications for a museum and will, in the end, produce a much better place in which to work, as well as offer a superior experience for visitors.

Integrating an education service into the structure of a museum means rethinking everything that goes on. This does not imply that anything should be rejected or that there is anything wrong to begin with. This is, unfortunately, a common feeling among those being assessed. Moreover, the fault often lies with those who are doing the assessing. All too often, it is looked on as an exercise of judgement on what has been done. True assessment is participatory and should allow those involved not only the opportunity to consider what they have been doing in the past but also how they, with their knowledge of the system, can improve it and their own working conditions. This involvement in forward planning imbues participants with a sense of ownership and a willingness to make it work.

Education staff are in an excellent position to carry out such assessments, especially within larger museums, as it is part of their work to know what goes on within the system as a whole. It may be argued that management know this as well, but the unique aspect of education staff is that it is also their role to teach others about it. Whether those others are the public at large or the much smaller community of museum staff, they are well placed to increase understanding about problems and assist in finding solutions.

There is also a role for an education service to provide in-service education for museum staff. Whilst it is unlikely in most cases that this will be at a professional and specialist level (usually well catered for by national specialist bodies), there is ample scope for broadening the horizons of those who work in museums. For example, if front-of-house staff know something about the work that goes on behind the scenes, they are better able to explain to visitors why certain things are as they are (such as galleries closed or objects removed from display).

Similarly, if those who work behind the scenes understand more of the pressures that face front-of-house staff, they will understand why certain work becomes a priority or why they are being asked to do something that seems to them to be outside their normal field of expertise.

These examples are somewhat simplistic but clearly demonstrate the point. This process of education extends in many other directions as well. It should certainly include a programme of events to enlighten visitors about the work that goes into producing and maintaining a well-run museum. This sort of change will not happen overnight but it is certainly an excellent opportunity to bring a renewed sense of purpose to a museum and its staff.

Drawbacks

As with all human endeavours involving change, there are drawbacks to altering the culture of a museum so that education becomes integral with or even central to its purpose. Knowing what some of the drawbacks might be, however, will go a long way towards working out strategies that minimize their effect.

To begin with, having an education service produces a great deal of work. This is not just for the person or persons given the task of setting up and running the service. There

will also be increased workloads for other staff members, especially in the initial phases. This will tend to fade for non-education staff as both the idea and the practice of education become absorbed into their normal routines.

For the museum educator, however, the ongoing workload will be heavy, especially in terms of administration. However, that is only part of it, because the museum educator will also have to spend a great deal of time ensuring that they are up to date with the latest developments in museology as well as education. They will also have to meet statutory requirements. And on top of all that, they will have to produce educational materials, work with educational user groups and museum staff, liaise with other individuals and organizations, constantly assess their work, and cope with a whole host of other duties.

As an adjunct to this, museum staff may find themselves faced with the need to adopt new or altered working practices as well as opening themselves to the scrutiny of someone they may feel is unqualified to assess them. Even where the issue is handled sensitively and everyone in the museum has a positive attitude, it will still result in considerable upheaval that may (though will not necessarily) cause other projects to fall behind agreed deadlines. One of the first things that has to be done in setting up an education service, therefore, is to recognize that this initial period of establishment may cause delays.

Once an education service is established and it becomes known that the services of a museum educator may be called upon, a museum is likely to experience an influx of new visitors. Whilst this may be welcomed in theory (and financially), it will cause disruption to well-established routines, no matter how well planned and catered for. This disruption is likely to be felt most by other regular visitors. That is why it is essential for an education service to have a broad remit that allows it to plan in such a way that it can cater for and educate all visitors. With that sort of scope, it should be possible to launch (or relaunch) an education service so that it is eagerly anticipated by everyone it will affect.

Allowing such a broad remit, however, will mean that a great deal of the museum comes under scrutiny and a great many alterations may be needed in order to make it a better museum. This need not happen overnight (and is unlikely to do so, given the finances of most museums), but it should at least become part of general museum policy that, whenever an exhibition is replaced or renovated, the opportunity is taken to bring it in line with new educational developments as well as with museum policy.

This, of course, will cost money. Good education cannot be provided on the cheap. Even if the education service is phased in over a period, it will mean an added financial burden on a museum. Some of the implications of this will be looked at in the relevant parts of later chapters but, although it will undoubtedly be a major factor, it should not be seen as an insurmountable problem.

The aura produced by and associated with an active and professionally run education service, as well as a generally more central role for education (of whatever level and type) greatly enhances the worth of a museum, and gives it prestige in the eyes of others. There are doubtless many challenges to be met along the way and no one pretends that establishing or enhancing an education service is ever an easy task. If such challenges are not met, a museum must first face the question of what it is for and must then face the very real possibility that it will become extinct. However, there are many compelling reasons for meeting the challenges and making available the opportunities that will enhance the museum itself as well as provide a broader education for students.

3 The Museum Educator

The role of the museum educator is an unusual one within the museum community. It is often regarded by other members of that community as being not quite a true museum job. This is not a universal perception and it is by no means as widespread as it once was, but it is still common. There are a number of factors that have led to this situation. However, two are predominant and have been for a long time.

To begin with, there has long existed the notion that a museum presenting artefacts for display is sufficient in itself to constitute education. What need, therefore, of specialist education staff? Although it has been demonstrated that this reticence to engage with museum visitors leads to a failure in satisfying educational needs, such erroneous thinking has become paradigmatic in some quarters. It is so deeply seated that it can inform the structure of institutions and the attitudes of staff, and is invisible to those who perpetuate it even when they openly profess contrary views.

The other main factor is also historical. In the past, many (though by no means all) museum educators were teachers seconded to or permanently employed by museums, paid for out of local government education budgets. This, too, produced a feeling that the museum educator was an outsider.

In addition, museum educators usually spend most of their time working beyond the relatively narrow concerns of the rest of the museum community (even if they spend all their time in the museum itself). That is, they have dealings with individuals and organizations whose prime concern is something other than the collection, conservation, and display of artefacts. This is not unique amongst those who work in museums but, allied with the factors already mentioned, it does lead to a situation in which many museum educators are constitutionally and psychologically isolated from the mainstream of museum work.

Another important factor that continues to contribute to this feeling of division is the apparent dichotomy that exists between conservation and education. This can be expressed simply as the fear that you cannot possibly use artefacts for education *and* stick to the high standards of conservation demanded by curatorial staff. It is an understandable fear on the part of curatorial staff, whose central role in life is the care of the artefacts under their protection. However, the idea that education equates with hordes of marauding students fingering everything in sight and dropping rare and precious items is specious. This is a reflection of the specialist concern of curators, but it shows a lack of imagination and a lack of respect for the skills and sensibilities of museum educators. Not only are museum educators aware of the prime importance of conservation; they are skilled in finding ways of working with fragile material that do not compromise the curatorial concern. After all, it is not necessary to touch things to understand them – even if it is a good way of learning.

Of course, once it is understood by curators that one of the aims of museum education is to teach about the value and fragility of the resource, much of this conflict should be

resolved. However, there is no simple formula that can be applied to artefacts in respect of their use. The variables are so diverse that a constant balancing act must be undertaken to ensure maximum education and maximum conservation. After all, if the resource is damaged or destroyed, it can no longer be used for education. It is, therefore, in the interest of everyone to conserve the resource. At the same time, it must be remembered that the whole purpose of conserving the resource is to make it available for education.

Nevertheless, many a museum educator, even in the most enlightened of museums, will find themselves in a curious situation. They work for a museum but are not quite seen as museum professionals; they deal with the concerns of various educational user groups but are not quite seen as education professionals. A role that fulfils two functions and faces in two directions at once can be extremely difficult to cope with. A person who works at this full-time can, if not careful, fall between two stools and hit the floor with a hard smack. This has little to do with the competence of the museum educator and much to do with attitudes and perceptions of what the post entails.

A museum educator, despite their apparent halfway house position, should not be regarded as an add-on who is not truly part of the museum. What they do is integral to the good running of a museum and they should and must have input into a museum's structure and day-to-day running. Happily this now happens with increasing frequency as museum educators are recognized as true museum professionals who specialize in education rather than as teachers grafted on to a structure solely to cope with visiting schoolchildren.

More and more mainstream teachers are also recognizing that museum educators are highly professional persons with a great deal of specialist expertise in a specific form of complementary education. Museum educators *are* teachers, but they are also museologists, managers and administrators, experts in their field, curators who specialize in education. The integral nature of their role is now being further enhanced by a growing number of colleges and universities offering graduate and postgraduate courses in museum education. There is, perhaps, a danger that this will lead to the pendulum swinging the other way, with only graduates of such courses being acceptable to museums. This would be a shame as such a development would institutionalize museum education and remove some of its vigour.

There is still a long way to go to redress current perceptions, and the person best able to do this in specific cases is the museum educator. Indeed, this is one of the important parts of the job, bringing about a complete integration of education into the ethos of the museum. Of course, whoever is appointed to provide an education service must work within the set-up as it is. This will range from hostile to supportive, and beyond to the manager or curator who will allow nothing to be done unless it has passed their stringent and minute examination. It may also be that curators who are indifferent or opposed to museum education have museum education staff appointed for them by management boards. In addition, there are those who expect museum educators to work miracles on a shoestring budget, work only with children and keep those children out of everybody else's way. The variations are enormous.

However, the fact that a museum has a museum educator is a step in the right direction. No one will find themselves working in a perfect world – even the museum that positively relishes having educational visitors and ensures it does what it can to accommodate them will never be completely free of problems. The ideal is simply what the museum educator must work towards from the particular situations in which they find themselves.

Roles of the museum educator

What does the job of museum educator consist of? The specifics of the job will depend on a number of factors. Management attitudes to the idea of education and to dedicated education posts have already been considered. The resources made available are also a significant factor, as are the type of museum, its size, relationship with other museums and the community, and the nature of its collection. Finally, there are the demands that are made upon it by the various user groups within its catchment area, as well as the potential for development of these and groups not yet using the museum.

As we have seen, everyone who works in a museum is a museum educator. However, where there is a person (or persons) whose primary role is education, they must be sufficiently well versed in these and other areas to perform effectively. That is, they must be museologists and educators of sufficient expertise and experience to be accepted by specialists in both these fields.

In general terms, there are seven core areas of work. A number of others may apply in specific circumstances, for example with highly specialized collections. The proportion of each of these core areas in relation to the others depends on the extent to which education is seen as integral to the museum as a whole and the demands that are made upon the museum by specific user groups.

MUSEUM TEACHING

The highest profile activity, and the one most expected of museum educators, is museum teaching. That is, whoever is responsible for such work will be expected to teach students in the museum about whatever they have come to see. It is also worth remembering that museum teaching may include outreach work, teaching in schools, colleges and other places of education.

This can be a highly satisfying, hands-on, part of the job, not least because of the opportunity it presents for exercising a wide range of skills in a wide range of teaching situations. There are also opportunities for instant feedback and for learning more about the efficacy of the museum as a teaching environment. However, teaching is not the most efficient way for a museum educator to spend their time if they are the only member of staff and that is all they ever do. Not only does every hour spent teaching require at the very least an hour of preparation and another of administration, but also constant teaching allows no time for development.

EDUCATING TEACHERS AND STUDENT TEACHERS

To avoid spending all their time teaching, it is imperative that museum educators target both practising and student teachers in order to instruct them in the proper educational use of museums. An hour spent with 30 students reaches 30 students. An hour spent with 30 teachers is an hour spent with, at the very least, 900 students. An hour spent with 30 teachers of teachers is an hour spent with, at the very least, 27,000 students. In reality, the figures are much higher as the skills acquired by teachers are there for their entire teaching career, to be passed on and used with countless numbers of students. The museum educator's time is therefore much better spent in this way.

This works at two levels. First, there is the need to convince teachers of the worth of using museums in their teaching. Some have no problem with this and are eager to tap into any resource that enhances the work they do. However, there are still many teachers (especially in subject areas not traditionally associated with museum work) who do not understand the worth or importance of working with material culture.

Once teachers become convinced of the worth of museum work the second level comes into play. Museums are exceptional educational resources but they are not schools. The ways of working with the resource are different from those employed within a school context, even where material culture is introduced into the school. A detailed exposition of these skills and other factors involved in visiting museums is given in *Using Museums as an Educational Resource* (Talboys, 1996).

Any museum educator, if they are to be an effective advocate for museum education, must have at least a basic knowledge of educational theory. They must also have a set of quality arguments (which they understand in depth) that they can use to persuade others that museum education is worthwhile and that all teachers should learn how to use museums for themselves.

Where practising teachers are concerned, this can be achieved through training and familiarization sessions at the museum. It can also be accomplished in conjunction with specific schools by offering them in-service training (InSeT). The scope is enormous and the courses you offer could cover basic skills for using any museum or gallery as well as introductions to the artefacts, collections, and services that your own museum can offer.

Very similar courses can be offered to students undertaking initial teacher training (ITT). However, this is easier said than done. Surprisingly, given their importance as educational resources, the use of museums, galleries, and other forms of complementary education is not a compulsory of ITT courses. Introducing this to students is very much dependent on the enthusiasm of individual lecturers. You will need to seek out these enlightened individuals and persuade them to make use of your museum.

TRAINING MUSEUM STAFF

Another area of concern for the museum educator is to educate museum staff about education – in general and with specific reference to museums. This is difficult, not least because museum staff have full working lives of their own. However, it is extremely important they are given the opportunity to understand what the museum educator does. After all, their work will affect that of the other staff to a lesser or greater degree, and an understanding of issues makes them less likely to be points of conflict.

Many museum staff have fixed and sometimes outmoded ideas about education based on their own experience and do not recognize that, although a museum is a prime educational resource, it is not a school. Therefore, ways of working with the resource differ from ways of working in a school environment. Not only that; one of the main reasons for taking children on visits is to 'socialize' them, getting them used to appropriate behaviours in particular environments.

This concern to spread a general understanding of the principles of the museum educator's work can also be made more specific. It is not only a courtesy to keep other staff informed of specific projects that will be going on; it is also an ideal opportunity for consultation. Everyone who works in the museum can contribute to the museum educator's work and such input helps to increase awareness and tolerance of that work.

Those most likely to come into contact with educational users should also understand that they can participate in the work that is going on without it interfering with their primary function, be it guarding the treasures on display, working in the shop or serving refreshments. Museums in the USA have done a great deal of work in this area.

INVOLVEMENT WITH THE WIDER COMMUNITY

Beyond the confines of the museum and of what is normally considered the work of the museum educator, there is the wider remit of educating the public about the worth of a particular museum and of museums in general. In part, this comes about because of every-day educational work. If that is done well, then people begin to realize that museums are of value to society. However, a more specific programme of educating the public about the worth of museums should be undertaken, in concert with a programme of events designed to increase the involvement of the local community with the museum. This dual approach is more sensible as it rolls content and method into one package. Each on its own would lack the context of the other and be far less effective.

INVOLVEMENT IN PLANNING AND DESIGN

It is not just educational users who will have need of the experience and expertise that you bring to the museum. A great deal of work within the museum needs your input, particularly the mounting of new exhibitions and the production of written materials. As an educator, you have a perspective on these things that other museum staff do not.

In setting up a new exhibition, for example, there may be a wealth of curatorial expertise and knowledge about what is to be displayed. There may be professional designers who know how to set things up and make them look good at the same time as producing an overall layout that expedites visitor flow. As a museum educator, you will have another agenda, and your input into the displaying of artefacts, writing of text, labels, guidebooks and the like, along with ideas on how the display will work better as an educational resource, will be vital.

What is more, it is much easier to design educational programmes for an exhibition if you are involved from the very beginning in all aspects of the exhibition's creation. Indeed, you might even be able to suggest exhibitions that would attract large numbers of educational users and which would be most relevant to topics of study in schools and colleges.

Close collaboration with design and interpretation staff is essential. Moreover, regular meetings on more general areas of concern are just as important as those that concentrate on specific projects. Regular contact with other museum staff as well as input into planning is beneficial in a number of other ways as well, not least of which is the opportunity to raise your professional standing.

ASSESSMENT

Evaluation and assessment of all educational and related activity is an essential part of the museum educator's job. Formal systems of assessment need to be built into projects and programmes of work as part of the basic structure. Not only does this save a great deal of work later on; it also means that all aspects of educational work are monitored as they proceed – starting with basic educational and museological aims, administrative and

marketing efficiency, budgetary controls and more prosaic matters such as visitor numbers and shop spending.

Informal assessment is just as effective, if less easy to present to others. However, it is worth undertaking – asking teachers if a session went well, asking students if they have enjoyed themselves, chatting to museum staff after user groups have gone.

All this assessment allows the museum educator to do several things. To begin with, it provides a rich source of quantitative material so beloved of management – the statistics that show, in their eyes, the progress and effectiveness (or otherwise) of a given activity. That they measure in numbers only, means they do not give a well-balanced picture. Qualitative information is just as important, if not more so. After all, education is not about numbers but about enriching people's lives.

The aim of assessment is not to gather evidence that allows you to pat yourself on the back. Assessment involves the continuous gathering of information that allows you to make continuous improvements to all that you do. If it is not used in this way, it is a great deal of wasted effort. A further discussion of assessment and evaluation can be found in Chapter 14.

ADMINISTRATIVE WORK

If all the preceding activity is to run smoothly, it must be backed up with an efficient administrative system. Unless you work in a museum with a large enough museum education staff to warrant your own office personnel, you will have to do all your administration yourself.

Many of the details of this are discussed later, in Chapter 14, but it is worth considering at this point the importance of such a function. It should never be looked on as a necessary evil, something to be dealt with as quickly as possible and without too much attention to detail. This can happen, especially as administrative work is done behind closed doors, rushed through last thing on a Friday. Unfortunately this only leads to problems – work not done, letters not answered, bookings mixed up, paperwork lost.

If administration is seen as an integral part of the job and adequate systems and habits are set in place as the service is developed, it will be seen as part of the whole and be dealt with as and when necessary. For example, when a teacher books a visit, that should be seen not as an administrative chore but as an integral part of the visit. Indeed, a good administrative system is essential if you hope to develop an efficient and professional service. You will be dealing with a large number of outside agencies and your transactions need to be monitored closely and accurately.

In addition to the foregoing duties, you may find you have some or all of the following with which to contend.

MARKETING AND PUBLICITY

The work of the museum educator and the services they provide must be made known to as wide an audience as possible. In this age of highly sophisticated marketing, with so much competing for the attention of potential educational user groups, it is important to be able to catch the interest of those you wish to make use of your services. Larger museums may well have marketing specialists on the staff whose expertise and services can be used. Most museum educators have to do it for themselves. However, for all that you may tap into

accepted routes of advertising and promotion, every personal contact you make is also an act of marketing and no opportunity should be missed to make the most of it. Being confident, courteous, and helpful makes a great impression on people, more so than unsolicited leaflets full of information.

FUND-RAISING

Although attempts to make an education service self-financing should be rigorously rebuffed, there will be times when it is politic to look for sources of funding or other resources for specific projects. With larger museums, there may well be professional fund-raisers on the staff who can advise or deal with such matters. However, it is more likely that you will have to do this yourself. For many this is a daunting prospect, but only because they have never done it before. Much useful information exists in book form and a framework for such activity can be found in Chapter 15.

MISCELLANEOUS DUTIES

In some cases, a museum educator will be required to fulfil other roles within the museum, especially if it is a small institution. This may entail general management work, curatorial duties, as well as work in the shop or café, putting up exhibitions, even cleaning floors and windows. Such teamwork should always be regarded as an opportunity to get to know the museum and its staff, and virtually everything can be seen in an educational light and provide inspiration for educational work. In addition, the chance to participate in a museum in this way provides an excellent insight that is not always available in larger institutions where specialists can be somewhat isolated from one another, let alone from the day-to-day running of the place.

Just as the range of work expected of a museum educator is enormous, so too is the range of working environments. A museum educator may be one of a team in a large museum or working alone to provide a service for a handful of small museums scattered throughout a large area. They may even be doing education work part-time, along with other duties such as curatorial work or marketing. Whatever your situation, it will have a bearing on the sort of work you are able to do and the way that you have to organize your workload.

Knowledge and expertise

In order to accomplish the above effectively, museum educators should become conversant with a number of areas of knowledge.

EDUCATION

In the first instance, the museum educator needs to have a good background knowledge and understanding of educational psychology, philosophy and sociology, as well as educational theory and practice. This may seem a little over the top. It is not expected that museum educators will be the foremost experts in this very large field. However, a good grounding provides the basis for informed choices and decisions as well as for implementing projects that will better achieve the aims that have been set. It also means that a museum educator

can converse with teachers and other educators on a level playing field. This not only makes life a little less complicated for the museum educator; it also helps to make teachers and user groups confident that the person they are dealing with is a responsible professional.

Any museum educator who enters the museum world from teaching will have acquired this sort of background of knowledge and understanding from their own training. It is important, however, that the museum educator keeps abreast of developments and new research, and is given the chance to do so, especially as museum education has different priorities and emphases. Thus, a broad approach to theory and practice is required so that the different environments of museum work are exploited successfully and married to working styles with which students are familiar.

However, it is not just the professional aspects of education with which a museum educator must be conversant. Other areas of educational knowledge and understanding are equally important. For example, the law as it relates to the educational use of museums, especially where minors are concerned is of supreme concern to the museum educator, who must know it thoroughly.

The museum educator should also have a good grasp of subject matter – what is taught to students in their schools and how it relates to the museum. In addition, they need to know how the education system is structured, financed, and administered. Furthermore, they should be aware of the basic day-to-day running of education, including the dates of school vacations.

Finally, a museum educator needs to be conversant with the processes of planning and preparing a visit to a museum with a group of students. Knowing the logistics involved as well as the museum's place in the educational process is essential. Not only does this increase understanding of group dynamics (readily affected by travelling and working in a strange environment); it also makes it easier to tailor educational programmes to the needs of students and teachers.

EDUCATIONAL USE OF MUSEUMS

Having a working knowledge and understanding of what goes on in the educational world outside the museum is only half the educational story. Whereas museum educators require a working knowledge of that, there is one area in which they must be experts – the educational use of museums. Again, this covers both theory and practice.

Museums are unique educational establishments with unique sets of working environments, methods, skills, and priorities. It is not enough, for example, to know the major theories of education; the museum educator must understand how they apply to both a general and a specific museum situation. If those that are applied in schools are not relevant, then it is incumbent upon the museum educator to seek out those that are and that can be applied.

As with any profession or field of knowledge and practice, a great deal of research is done each year and the museum educator should keep up with this. Not all of it will be obviously or immediately relevant, but that does not mean it never will be. Keeping up, however, should never be allowed to take over. There are many fine organizations that help museum educators digest all this information.

The practice of working within the museum is also important. Much competence in this comes with personal experience, but there is a great deal that can be learnt about it from other practitioners. A growing number of professional and commercial organizations

now exist to facilitate museum practice. As a museum educator, you should take what opportunities you can to avail yourself of these services. All this knowledge and experience is vital in being able to present material culture to educational users in an authoritative way.

MUSEUM PRACTICE

It must be a main aim of a museum educator to be conversant with the principles of all the different forms of work that go on in the museum. They should get to know some of the detail as well, so that they can talk with a degree of authority about the various skills employed. Of course, it would be ideal to make use of the conservators and designers and other staff members to explain what they do. That, however, is a limited option. These people have work to do and they may not, in any case, be very good teachers.

All aspects of museum work should come under the museum educator's scrutiny, including collection, cataloguing, research, restoration and conservation, cleaning, display, design and administration. Having become familiar with this 'inner' world of the museum, the museum educator must then see how the detail and the broader sweep of museums relate to the world at large. Museums are extremely important aspects of any community or society, but they are not always very good at explaining this to the community or society that supports them. This important role can be fulfilled by the museum educator.

THE COLLECTIONS

The area of knowledge most expected of museum educators relates directly to the collections held by the museum in which they work. It would be impossible to expect a museum educator to know everything about every object; specialist areas are the province of their curators. However, the museum educator will need a working knowledge of the artefacts and collections, especially those that attract educational user groups.

This need is more acute if the museum educator spends a great deal of time teaching. It is one reason why museum teaching is so time-consuming. If research is to be done, it is far better for it to be used in producing information packs that teachers can then use.

For all that, the museum educator will be asked plenty of questions about artefacts and collections. Moreover, it is surprising what questions will be asked by educational users and what degree of background knowledge is needed to answer them. Whatever you, as museum educator, learn about an artefact, someone will have a question for which you have no answer. That is why it is important to cultivate a way of working that puts emphasis on exploration and the building and testing of hypotheses rather than straight question-and-answer sessions.

ARCHAEOLOGY AND ASSOCIATED SUBJECTS

One of the best ways of coming to know about individual artefacts and collections is to have a working knowledge of how they were originally produced as well as how and why they reached the museum. This means knowing a little about the principal crafts such as woodworking, pottery, metalworking, textile production, and so on. It also means knowing something of the principles of archaeology and the collection of both organic and inorganic specimens.

As well as all this, and no matter what your own beliefs and convictions may be, you, as museum educator, must appreciate that non-material culture has been important in shaping material culture. An understanding of non-material culture as it relates to artefacts in a museum is essential to an understanding of such collections. This should be considered an integral part of the understanding process. You need to know not just how a thing came into being, but also why.

This is particularly relevant where artefacts have spiritual significance or were originally collected in ways we would now consider unethical. It may be that this is covered by legislation. In the USA, for example, part of the Native American Grave Protection and Repatriation Act refers specifically to items held by museums. Often, however, these sensitive issues fall outside any legal framework. Informed debate and sympathetic handling are of far greater value to museums than the imperialistic attitude they sometimes adopt. As a museum educator, you may find yourself in the front line not only of general discussion of such issues but also of specific controversies. Acquaint yourself with museum policy on such matters.

All this may seem daunting, as does any body of knowledge before it is acquired, but it is surprising how quickly information is picked up through day-to-day working and small amounts of daily study.

Job requirements

There has been a great deal of discussion over the years about what sort of experience is desirable in someone coming to the job. This is a difficult area, not least because of the 'Catch 22' problem of only getting work if you have the experience and only getting experience if you are given the work. Of course, all people coming to work in museums for the first time clearly lack experience at that point. Moreover, for every aspect of experience thought necessary there are many examples of successful museum educators who entered the field without it. What follows, then, is a look at some of the core areas of experience that would prove very useful, even if it cannot be claimed that they are essential.

MUSEUM EXPERIENCE

Museum experience is a clear advantage. From this sort of first-hand awareness you can derive an understanding of the dynamics of a museum, the priorities of other staff and the museum in general, the timescales involved in the work done and so on. To have worked with artefacts is also very useful. Knowing how to handle, store, and analyse them will not only make your job easier; it will also help you to gain the respect and trust of colleagues.

TEACHING EXPERIENCE

Teaching experience in mainstream education is not a prerequisite of museum education work any more than it is a guarantee of success in the museum environment. Many good classroom teachers flounder and fail in the museum setting simply because they fail to appreciate that a museum is not a school and cannot be used as such. Indeed, many people in museum education were originally already in museums doing other work which led them increasingly into direct contact with educational user groups.

For all that, many museum educators have previously been teachers and their experience has proved invaluable. Most, though not all, have worked with six- to sixteen-year-olds. This limited experience of age range has often been cited as a problem. Whilst this may be true to a certain extent, it is not intractable. It is no greater a barrier to dealing with groups outside that age range than that of having no experience at all of teaching.

Those who have some difficulty in accepting that a museum educator can be a good educationist and know all about museums as well need only look at other specialist teachers. Good classroom teachers who specialize in a specific age group can still be leading experts on their subject and work well with groups of other ages. It is not unknown for classroom teachers to have PhDs. Conversely, there are specialists in many fields who also happen to have a gift for passing their knowledge and understanding on to others, despite the fact that they have never had any formal teacher training.

It can help potential museum educators to have worked with user groups in the environment they normally work in (for example, a school). This not only offers insight into what they are working on, but also how they are working and how best to use the museum to enhance that (rather than replicate it). It also means having experience of dealing with the dynamics of groups of students in different environments.

Experience of teaching does not just refer to contact time. It also includes the preparation of teaching sessions, the production of teaching materials, assessment, and all the other skills that a teacher must have to work successfully. Whatever the amount of previous experience, however, it can only be regarded as a foundation on which to build, a starting-point for gaining experience in the techniques of museum education.

COMMUNICATION SKILLS

Given that most of a museum educator's work involves communication with others in a wide variety of forms and contexts, the ability to communicate well must be considered a primary skill. Ideas as well as complex (and often incomplete) sets of information will have to be conveyed quickly and clearly. In addition, it will often be necessary to provide a context, as most students are more used to working with text than they are with objects.

Methods of delivery will vary. They will involve speaking, writing, and making multimedia presentations to individuals, small groups, large groups, young and old alike, formal and informal. You will also have to consider the production of leaflets, teaching materials, and marketing materials. In some cases, it may be expedient to obtain the services of others to produce printed material, but mostly you will have to do this for yourself.

COMPUTER LITERACY

A specific extension of communication skills is the need to be conversant with and experienced in the use of word processing, databases and spreadsheets, graphics software, the Internet, as well as producing digital images. This goes beyond the normal use that the majority of people make of the computers they have at home. There are many excellent courses available although the European/International Computer Driving Licence is fast becoming a recognized worldwide standard of computer competence.

Aspects of website design are also worth considering. It will not be necessary to become an expert, but given the prevalence of websites, it would make sense to be able to make a knowledgeable contribution to the content and design of any site the museum may have.

UNDERSTANDING OF THE PUBLISHING PROCESS

As the person most likely to oversee the production of educational materials (if not carry out the process in its entirety), it would be sensible to have a basic knowledge of the processes of publishing. This would need to include the preparation of text and images (including proofreading), layout, printer's jargon, the time each stage takes, and so on. It also means having some notion of the rate at which materials sell or are used in order to print the correct amounts. There are many books (written principally for authors) that explain the processes in detail.

Computers now make it possible for much of the work to be done in-house, producing material that is ready to go straight to a printer. There are obvious advantages to this. Retaining control of the process makes it easier to change items at short notice, and to print off short runs of material using a high quality printing machine. It would be worth taking a course in desktop publishing, as this would save the museum money in the end.

FLEXIBILITY OF APPROACH

The museum educator will need to take on many roles in their work, from the traditional form of teacher to a more relaxed and less pedagogical approach with older students and informal groups. There are times when the lead role needs to give way to a supporting role, guiding and providing back-up in learning situations. There are also times when you, as museum educator, need to give way altogether, perhaps taking on the role of pupil, learning from others who have expertise and understanding that you do not.

Beyond the direct teaching side of the work, you, as museum educator, will find yourself in many different situations working with different groups, organizations, and individuals. At all times you need to be able to adapt to your environment without ever becoming subservient to it.

EMPATHY

Empathy is very important. It is a dirty word in some circles, which believe that only objective and analytical systems work in respect of museums and their collections. If they were just objects that might be possible, but everything in a museum has a human connection, very often at the deepest level of human existence.

The ability to empathize with those who made and used the artefacts, as well as those who have collected and studied them is important if one is to educate others about them and their original importance. This does not mean a reckless and unfounded use of imagination. Empathy must be based on fact or it is worthless, but it is an application of understanding as well as knowledge, an acceptance of the irrational in human existence, an acceptance of aspects of life that cannot be quantified.

The museum educator also needs to be able to empathize with students, most of whom will be encountering specific artefacts and collections for the first time. Some may even be entering a museum for the first time. It is all too easy, when working in a particular environment, to lose the memory of how it feels to the casual and infrequent visitor. Indeed, even the frequent visitor will see it through different eyes, as it forms a different aspect of their experience of life from that of someone who works in the museum environment.

RESILIENCE

Museum educators also need resilience. Most will be working on their own. Despite the contact they may have with colleagues and with user groups, they often work alone at a job that is primarily about long-term aims and rewards. Often those rewards are experienced by others in a way that is invisible to the museum educator, as membership of user groups is ephemeral. The same school may visit on a regular basis but the museum educator rarely gets the chance to build up a long-term relationship with students. It can be lonely work at times.

DIPLOMACY

Diplomatic skills, too, are extremely useful. This relates not only to handling museum staff who may find the presence of user groups difficult to cope with; it also relates to other visitors to the museum who may find the presence of groups who appear to be enjoying themselves or getting privileged treatment too much to handle. There are even those who do not think that museums should function in this way at all. Of course, as is constantly stated, part of the long-term task of any museum educator is to educate the general public so they will accept not only that their visit may coincide with the visit of educational user groups, but also that such an event is part of museum life.

If all this seems daunting and makes the museum educator sound like some kind of wonder being, then you are right. The job involves a great deal of study and hard work. Educational users must have sufficient confidence in the museum educator's ability, experience, and training to want to use the museum. The museum must be sufficiently confident in the museum educator's understanding of museums, collections, artefacts, restoration, conservation, and so on in order to let them loose amongst all those precious objects.

Above all else, however, the museum educator must be that – an educator. Interpretation has its place, but it is one small aspect of education. An interpreter merely toes the party line and gives the official explanation of what is on display. A museum educator works to involve groups in an active way, providing them with the skills and the sensibilities to work with what the museum has to offer. A museum educator teaches people how to make their own valid interpretations and follow their own lines of enquiry. A museum educator teaches people how to question. The rewards of success in that venture are enormous for all involved.

4 Setting Up – Background Research

Before launching any sort of museum education service, ensure that it is properly tailored to meet the needs of those it purports to serve. To that end, you will need to undertake a considerable amount of background research in a number of different areas. This will guarantee that whatever you do later is both soundly based and a carefully measured response to the needs of various user groups and the capabilities of the museum.

Although this chapter relates specifically to setting up a new education service, it is an exercise well worth considering for anyone new to an existing post or even for those who have been in the post for some while. The greater your understanding of your catchment area and those who live and work in it, the better will be your response to educational users.

All research should be carefully planned. In the first instance, you should aim to provide yourself with a framework of information that will allow you to set priorities both for detailed research and for the design of programmes of work.

A considerable proportion of the information you require is probably available on the Internet. Get to know the relevant websites. These may well include the sites of local and national museums associations, local and national government (containing arts policies, advice, and law), academic institutions, local schools, and local museums. Keep a record of their addresses.

Websites are useful for gathering information, but use of the Internet should never be substituted for face-to-face contact. Getting out and meeting people is essential to building good relationships with different members of your local community, especially those who have no natural lines of communication with the museum. Furthermore, meeting people and visiting places in person gives you a far better idea of what you are dealing with and the dynamic qualities involved. This is particularly true of schools and colleges.

Educational user groups

To begin with, you should consider who might make use of an education service. Within easy travelling distance of most museums there can be found the whole range of formal and informal educational institutions and organizations in both the public and private sectors. There will be a range of schools within the compulsory sector, at least one university, colleges of further and higher education and teacher training facilities. Pre-school provision will also exist in a number of forms.

In addition to this, there are likely to be special schools, field-trip residential centres, adult education centres, open learning centres, and a host of extra-mural courses on offer.

There will also be many hundreds of local people registered on correspondence courses of varying levels and just as many following private courses of study.

Further afield there are usually many more establishments that are within day-trip range of museums. Although travelling longer distances may preclude visits from more generalist or younger students, older and specialist students are often very willing to travel much further – as are their teachers. Students from greater distances may also be using field study centres for longer stays in the area. These are groups that could well be persuaded to visit several museums with collections on a common theme of interest to them.

Between them, these students will be involved in studying a vast range of subjects, aiming for all levels of qualification or simply out of interest. These subjects are offered not only in traditional courses, but also as talks, lectures, workshops and so on. Furthermore, the population of educational establishments is constantly being renewed as students pass through the system. Such renewal creates a constant need for educational resources – a need that means that educational establishments are likely to become regular users if they receive a good service from you.

Next to be considered is the whole field of educational delivery as it pertains to schools within the catchment area of the museum. Is compulsory education provided to the dictates of a national curriculum? Are there certain subjects (such as sex education and religious education) that are subject to specific laws or taboos? How are lessons presented and how is work assessed? What assessments and examinations do students take? How does all this relate to the museum and its collections?

For each institution within the catchment area, record a basic set of information, including details such as address, type of institution, size of student population, courses and subjects being taught, and so on. In addition, establish the names of contacts within these establishments. As you gather information, remember this will be an ongoing task. Do not overload yourself with trivia, as you will have to keep everything up to date. You may find much of what you need in published directories and registers, which are updated annually. These can be expensive but should be considered.

You should also familiarize yourself with specific approaches to education within various user groups – is it learning by rote, whole-class, project-based, research-based, cross-curricular and so on? This is not so that you can replicate these with appropriate groups (an approach that would not work in the museum), but so that you can best tailor your own approach to match the educational experience and mood of the group.

You should also become familiar with the overall structure of the education system. Knowing how the individual parts relate to one another and how they are administered, along with the staff who administer and monitor the system, is just as important as knowing about the individual institutions from which user groups will be drawn. Indeed, getting to know who the members of staff are at this administrative level is vital to gaining access to other levels of the system. You do not need to know everything about a system as long as you know the people who do.

Having assessed the size of the potential educational audience, you should next consider the past educational use of the museum itself. Even if there has been no formal education service or specialist staff in the past, there must be some record of educational user groups who have used the museum. Find out who they are and what they came to the museum to see or do. If you are newly appointed, these groups provide the perfect opportunity for first contact and initial research into the use of the museum and the needs of its users.

Determining what groups already use the museum and why they have done so is only the first step. You then need to move on and find out what other user groups want from the museum and let them all know what you want from them. It is at this point that you must begin to create links with individual educational user groups and teachers.

More detailed ideas for contact with educational user groups can be found in Chapter 7, but it is important that you find out as much as possible about what exists within your catchment area. In the long term, it will be worth trying to visit as many of these as your time will allow, but in the short term, it is much more important to assess your priorities.

Finally, if your local and national education authorities distribute materials, whether curriculum materials or directives, updates on the law, administrative memoranda, and all the other paperwork that circulates, do whatever it takes to get yourself or your museum on their mailing lists. This can be an invaluable source of information that helps you to keep up to date with educational developments and administrative and legal changes. Most of it will not affect you directly, but you will soon learn to scan such material for relevant information. Even if this means registering the museum as a school or some such similar ploy, it is worth the effort, as you will then not have to go cap in hand to a number of different sources to get a glimpse of this material.

General population

As well as the core work with educational user groups, there is, as we have seen, a much broader remit for education. If this is to be effective, it must engage with all who visit the museum as well as encouraging new audiences.

Beyond the specific and easily defined educational clientele, there is an educational element involved in the visit of the humble tourist and of the local visitor, as well as long-term community involvement. Educational user groups may be easier to cater for as they have specific and well-defined goals, but there is no lack of motivation on the part of what one might term casual visitors. Many surveys have consistently revealed that more than 80 per cent of casual visitors to museums consider one of the main purposes of a museum to be educational. Parents (a sizeable sub-group of casual visitors) have a similar expectation and they will often bring their children to museums in the belief that it will enrich them. Other people take their holidays in areas that interest them and spend a great deal of their time visiting museums. Foreign tourists also visit museums with an educational intent – that of absorbing something of the cultural heritage of the country they are visiting.

In one sense or another, nearly every person who visits a museum does so with an educational intent. It would be sensible, therefore, to aim to maintain a high level of informed interest in all visitors. With this as a basic policy, it should be possible to establish specific educational packages and a general educational approach that is sufficiently flexible to appeal to various sectors of the casual educational market.

To do this sensibly and coherently means beginning with a high level of awareness of the composition of the local community. This should include such factors as social conditions, ethnic backgrounds, religious and spiritual beliefs, as well as age distribution, educational backgrounds, first languages, cultural backgrounds and so on. Information of this nature need not be over-precise; nor should it be used in itself for drawing any conclusions. However, an accurate grasp of such facts means that you are working from a well-informed base when considering ways in which the museum can cater for the local community. Of

course, not all museums have collections that relate naturally to some or all sections of the community in which they reside, but therein is the challenge.

It is far more difficult to gather this sort of information for tourists – although that is no reason for catering for them any less well. They may be transient, but they can spread the word about the museum far and wide. Any information you do require will have to come either from in-house visitor surveys or from local tourist organizations.

Such information is also relevant to the make-up of educational user groups – especially those originating from the compulsory sector, which are far more likely to reflect accurately the make-up of the community at large. As well as providing a base of information that will inform decision-making on a wider remit, it also acts to alert the museum educator to the areas that the museum may have neglected in the past. It is also useful in pointing out possible areas of controversy and problems that may be caused by exhibitions, as well as problems that may be faced by individuals in confronting artefacts and ideas that are taboo within their cultural or ideological background. This is not to say that anything that is possibly controversial should be abandoned or avoided, only that it needs to be planned and approached with sensitivity to the ideas of others and put forward for good reasons and with well-prepared arguments to counter any possible objections.

There is one other reason why it is useful to know about the composition of the community in which the museum exists. Most people living within reach of the museum are unlikely ever to have visited it. There are many reasons for this; and many, with a little effort on the part of the museum, can be overcome. In the end, the majority of those reasons come under the general heading of relevance. That is, most people who do not visit their local museums simply do not see them as relevant to their lives. It is up to the museum to provide temporary exhibitions and activities that will overcome that apathy and engage the interest of these people. It is not just a question of getting them to accept the museum as it is. Education pertains to the museum as well, for it must learn to evolve in order to involve local people, finding out what they would like, finding ways in which the genuine interest of these people can be matched to the vision the museum has of its own future.

Although it is sensible to look to professional research and professional knowledge when determining the shape of your education strategy, it is prudent to seek also the common sense, the ideas, and the needs of the general community. Use your professional understanding to deliver what is required by the community (and never forget that you and the museum are also part of the community and can have your say).

Museum characteristics

Having gathered information about those who are likely to want to make educational use of the museum, as well as those who may be persuaded to do so in the future, you should now turn your attention to the museum itself.

In researching your own base of work, you need to consider a wide range of factors that will affect any education work that you do. To begin with you should investigate the popularity or otherwise of permanent and temporary exhibitions for the general visitor as well as educational user groups. This will allow you to prioritize further investigations into why certain areas of the museum are more popular than others. It may be that educational groups only use certain areas because they have yet to see, work out, or be guided into realizing that other areas, collections, or artefacts can also be of use to them.

In addition, you will need to consider how use of the museum alters with time – what times of day, what days of the week, what weeks, months, and seasons of the year are more popular than others. This applies to the general visitor as well as educational user groups, not least because they are sometimes at variance in their needs. Looking at visitor numbers in this way is not a precise science. People are notoriously fickle when it comes to visiting museums, and factors such as the weather are not reliable indicators. However, general trends can be observed and work can then be done to ensure a flow of educational visitors that does not conflict too much with that of other visitors.

In concert with this, you need to explore the physical space of the museum, visitor flows, its capacity for absorbing large groups, possible bottlenecks, and possible problem areas such as the shop and the toilets. It would also be wise to see if there are places where groups can gather on arrival, leave their coats, work, eat lunch, and gather before leaving – all without unduly disrupting other visitors or breaking fire or health and safety regulations. Not every museum has such spare capacity but even the smallest museum, with a little careful planning, can make some provision to accommodate groups in this way. As well as the physical structure of the building, you will need to become familiar with staffing structures, policies, protocols, and lines of communication. And learn people's names; even if it means, to begin with, writing them all down.

The form of the museum displays – especially if they are strongly thematic or dogmatic – may dictate the nature of the programmes you devise as well as how you teach. Not all museum environments are conducive to learning, and work will need to be done to assess the present form and devise ways of improving the displays and the general atmosphere. If students feel comfortable, they learn better. Of course, although comfort is a necessary condition for learning, it is not, of itself, sufficient. Many other in-house factors come into play.

The geographical location of the museum is also important. This is not so much whether it is in a rural, suburban, or urban situation, but where it is in relation to other geographical factors. For example, is it isolated or close to other facilities? If it is isolated, you may have to provide a sufficiently interesting package to attract visitors away from the heady arena of the city centre. You will need to know how the museum relates to public transport routes and their pick-up and drop-off points. People approaching you to make a booking may well ask for this sort of information. Can coaches off-load and pick up with ease? If not, can arrangements be made with the appropriate traffic authority? What about parking for private vehicles (including bicycles)? Do these services operate on a 24-hour basis or are evening, weekend, and holiday services limited or different?

You need to be aware of how groups are going to reach the museum. A group that comes by coach will want to fill that coach, which may mean a group of 50 or more. Minibus-size groups of around fifteen also exist. Other arrangements often apply. Imagine 60 children being ferried to the museum in private cars, three or four to a car. Is there parking space or dropping-off space? How do you cope with a group of that size arriving in small clusters? If you are some distance from a public transport drop-off point, what state will a group be in by the time they have walked to the museum in the baking sun or freezing cold or pouring rain?

Your museum research should extend to other museums in your area and what they provide for their educational users, both generally and specifically. You are not going into competition with them and should resist any such suggestion. Competition is destructive, wasteful of resources, becomes the overriding motivation for what you do, and reduces edu-

cational users to prizes in a game. It is far better to work in concert with others, even if only informally. Pooling ideas and offering a 'joint' service is of benefit to everyone. To do that you need to know what sort of museums they are, who uses them, what sort of education services they offer, and who runs their educational programmes.

It goes without saying that you must become familiar with the content of the collections held by your museum. Even if you are a specialist in one particular area, you should gain a working knowledge of what constitutes your resource and of the authorities who can tell you more. Ultimately, this may entail long trawls through reserve collections. To begin with, it is a matter of gaining an overall picture. Make sure you know how to handle artefacts properly and are aware of the principles of conservation and safe storage. You should also become conversant with the way in which artefacts are catalogued as well as the systems for retrieving that information. Take every opportunity provided to go on courses that deal with these and other aspects of museum work. Cultivate other members of staff. This is far easier if you work in a small museum where, as a matter of course, you may have to undertake curatorial and other duties.

This last is not just a matter of knowing the content of your resource. It is also a matter of showing an informed interest in the work of the museum and, if this is done with proper respect for the resource, it helps you to gain the trust and respect of conservation and curatorial staff. If they trust and respect your knowledge of and commitment to the work they are doing, they are more likely to include you at the decision-making level where it is important that the voice of an education specialist is heard and noted.

The law

The law is a complex issue and may affect the work you do as a museum educator in many ways. The museum itself should comply with all fire, health, and safety laws and regulations that apply, but it is worth checking that these cover the special situations where large parties are involved, especially if there are differences in the law in respect of groups of legal minors.

Compliance is not just to do with adequate toilet and washing facilities, clearly marked exit routes in case of fire or other emergencies, adequate ventilation and so on. It also applies to the relationship between adults and minors. Many countries now require any adult who works with children to be positively vetted in relation to past criminal activity. Even if this is not required by statute, it may well be worth attempting to make this museum policy in order to ensure the safety of children in your care. There may also be localized legal requirements or prohibitions in respect of what is actually taught. This usually applies only to the compulsory sector.

The complexity surrounding the subject should not be an excuse for sweeping it under the carpet. If you are in doubt, seek advice, usually from the body held responsible for administering and enforcing the law concerned. Other agencies may also be able to offer advice, including your local and national museums associations, professional organizations, and trade unions.

Research library

The gathering of all the above-mentioned information is a practical exercise that is intended to provide a sound base from which to work. Most of the information will be remembered in general terms, but details are not always easy to recall and may sometimes only be needed on rare occasions. It is important, therefore, that any information that is gathered is collated and comprehensively indexed as it is collected. Trying to index in retrospect can be horribly time-consuming – one of those tasks you never seem able to complete.

This applies to all information you gather. Do not just file it. Learn from it and then store it. Know where it is kept and devise systems for accessing it that are easy for all to understand. Anyone taking over from you, for whatever reason, must be able to find what information you have without any problem.

If finances allow, begin to build a library. Simple general works of reference such as a dictionary and thesaurus, along with an encyclopaedia and copies of relevant material produced by the museum itself would make a good starting-point. You might also want to include specialist reference material as it relates to the work you do (for example, a Latin dictionary if Latin crops up a great deal). If a museum is large enough, it may have its own central reference library, as well as specialist departmental libraries. If it does, locate them and find out what they contain. You will also need to start gathering specialist material that relates to education, museum education and so on – especially recent research material.

Persuade the museum to subscribe to journals and join museum education organizations, both local and national. Consider joining book clubs that offer remaindered texts. They often have academic and other titles at reduced prices, some of which may be of relevance to your work. If you bring in personal items (books and other relevant material), make sure they are clearly identifiable as your personal property so that you can claim them without any argument if you move to another post.

Read as widely as you can on all aspects of your work. Make use of whatever sources of material you can, especially the library of your nearest teacher training college – using this also as a means of making first contact with lecturers. Also, read as many relevant journals as you can and try to keep up with all major developments in the fields of education and museology. Keep a comprehensive index of what you read – this is especially important if finances are limited and you cannot afford to build up your own library. If an article, chapter, or book is of interest, make a note of the main points, the author, the title (and volume if it is a journal), as well as precisely where the book or journal can be found.

Ancillary services

Finally, you should find out about the ancillary services that you will need to call on. These are many and varied but certain basic ones can be determined straight away.

Of primary concern is the need to ascertain how the printed material you will undoubtedly wish to produce (posters, workbooks, information packs and the like) is to be handled. Unless printed materials are produced in-house or specific contractors are used, you will need to find out about printers. Printed materials must be of a high standard. Most museums now have sufficiently powerful desktop computers on which to produce text and graphics that are ready to be reproduced by a printer. You will need to become familiar with the software packages in use within the museum.

Suppliers of other materials such as paint, paper, glue and all the other consumables of education work need to be found. You should also be conversant with the museum's procedure for ordering and paying for such material. These materials must be budgeted for and you should find a reliable supplier at a reasonable price.

Specialist suppliers must also be found for the more unusual items you may wish to use, for example quills, beeswax and parchment. In addition, you may need to find a producer and supplier of replicas. If the museum has a shop, these items may already be on display. If not, there is scope to work together on such purchases.

As well as materials, it will be worth seeking out people with specialist knowledge and expertise relevant to your needs. These will be people who have a working knowledge of historical craft techniques, clothing, husbandry, militaria, and so on. They will be helpful for your demonstrations, working sessions, and for providing knowledge. They may also be able to advise the museum in more general terms when exhibitions are being mounted. There are also others who have unusual or specialized roles in society or who have adopted some way of living that may prove a useful resource to you or to educational user groups. Not only do such people provide a wealth of information about specific ways of life; they also offer an insight into the non-material culture of those who created the artefacts on display in your museum. Such people (monks of whatever religion, tribal medicine men, authors, explorers, farmers, artists, actors and the like) are well worth approaching.

This may seem a great deal to assimilate before you embark on your job – but it is extremely important. You should be allowed some time to settle in and become familiar with your surroundings. Time, therefore, must be allotted to this initial research if you are to develop as an effective professional and provide a good service. In some ways, this is more important where you are inheriting an established service, as educational users will have certain expectations that you will have to meet from the very start, even if you intend changing things. Whatever the case, time spent laying careful foundations is essential to creating sound and productive education programmes later on.

5 *Producing an Education Policy and Other Constitutional Documents*

Given that a museum has or wishes to offer an education service via the offices of a museum educator, it is best if this is set out in an official, written education policy supported by a job description and an action plan. Within the museum, these documents fulfil a number of important roles. They:

- set out the aims and objectives of an education service;
- provide a context in which that service can operate and develop;
- provide a framework within which it is possible to identify specific tasks and programmes of work;
- allow an overview from which it is possible to assess the relative importance of projects and set priorities;
- set guidelines that assist in decision making; and
- codify expectations, available resources and user groups, enabling accurate evaluation to take place.

Quite aside from the perfectly valid in-house reasons for producing an education policy, there are also compelling outward reasons. It may be the case, for example, that producing and implementing an education policy is required by bodies that fund the museum. Increasing demands for public accountability mean that the way money (especially tax revenue) is allocated and spent is closely monitored. Other funding, especially grants and sponsorship, is more likely to be allocated to a museum that can demonstrate it has administrative structures such as policies in place.

Policies, statements, and assessments also have an important role to play in demonstrating to others (both within and without the museum) that you are a professional, that what you do is based on sound and formally agreed principles. Educational user groups in particular are looking for such evidence when deciding whether to make use of the museum.

Much of the research suggested in the previous chapter will form the basis of what is required and can be encapsulated in a policy and its appended statements. The jargon used in such documents changes frequently, usually in accord with the latest trend. Avoid it where possible (and always explain specialized terms in an appendix). Use plain language. It makes the documents more accessible and cuts out ambiguity.

Primary policy

Although a policy is extremely important for overall planning and guidance, it must be endorsed by the managing body if it is to be truly effective. Once such documents are accepted by the managing body of the museum, this sets an official seal of approval on the idea of an education service. It also means that it is much more difficult for the service to be interfered with or later disestablished.

The first step in any move to provide a policy for education is to ensure that education is mentioned specifically in the general policy of the museum. If there is no mention, or the mention is vague, then it is well worth lobbying to have a mention made or made more specific. What is more, any statement on education should be so worded that education is recognized as an essential and integral part of the museum.

The notion of integration is extremely important. Education policy should augment the aims and objectives of the museum's research programmes, collection management, staff training, exhibition and conservation policies, design and fund-raising, as well as working in its own right. Museum education must, therefore, be planned, developed, and implemented in conjunction with the clearly defined aims and objectives contained in the general policy of the museum. If it is not, then there is the danger that education programmes will conflict with other notions of what the museum is as well as the image it presents to the world.

As we have noted, creating an education policy, by dint of the fact that it must augment other areas of museum work, may force a review of the museum's general policy – something that may not have been done for decades. This is not necessarily a bad thing. However, it means that drawing up an education policy must be a cooperative venture, no matter how strongly led by the museum educator. You must consult others and take heed of what they say. The more they are involved in the creation of a policy document, the greater their sense of ownership and willingness to be involved in its application.

Be prepared for a lengthy process, as some managements move exceedingly slowly. They must be involved, although it is to be hoped that when it comes to largely or wholly educational matters sufficient trust exists to allow you to hold sway. It is probably better to canvas ideas, prepare a draft, work on it with senior museum staff, and then present it to management for discussion and ratification.

Work on producing a policy may offer the ideal opportunity to cement the relation between education and curatorial staff as well as everyone else in the museum. Discussion at an early stage – so that everyone is clear about expectations – will help to obviate problems at a future stage. This is especially so if the policy sets up or recognizes a mechanism through which disputes can be settled and problems resolved.

The constitutional power of a policy statement is substantial. Although it is vital to have one in order to protect the position of education, it should never be looked upon or devised as a weapon with which to hold management to ransom. Devised or used in that way it will be turned against you. It should be carefully thought out and worded so that it is well integrated into the general ethos of the museum, provides practical guidance, and remains neutral in respect of individuals.

When the statement is being drawn up there should be a clear differentiation between primary policy (an overall statement of principles – which should fit comfortably on a single sheet of paper), secondary policy (an explication of these principles), and the action plan (an outline of programmes that derive from policy).

In essence these differences represent the distinction between aims (the general principles by which the education service is to be run, as well as the overall desired ends), objectives (the more specific ways by which the aims are to be achieved) and priorities (the best order in which to devise, research and put into action the programmes that will fulfil the aims and objectives). The policy documents will need to be backed up by statements about available resources, user groups, evaluation, liaison, and so on, as well as a job description for each member of the education staff. These not only provide the basis for the final policy, but also are the means by which the work of the education staff will be assessed.

DRAFTING PRIMARY POLICY – BACKGROUND

Whilst it is essential that the finished document is clear in its meaning, it is meant to be no more than a set of guidelines. Make sure there is nothing that need not be there. For the same reason, do not include anything too specific. Policy documents are not the place for that.

Everything that goes into a policy document has long-term implications for the work of the museum educator and the service they will be able to offer. It is important to be aware of what those implications might be and how they will affect the work of the museum educator in years to come.

One of the more specific things that should be considered is finance. It is no good having worthy aims if the money is not there to put them into practice. Education is a long-term venture and cannot be planned without some notion of finance from year to year. This needs to be settled at the outset. It is impossible for anyone to predict actual figures, but it would be wise to negotiate a guaranteed percentage of the overall museum budget to be allocated to education. That way, at least, the annual fight for money can be avoided.

Other financial matters will also need to be settled and set out in policy. Strenuous efforts should be made to combat any notion by management that education departments and staff should be self-financing. Not only does this display a complete lack of understanding of the place of education in museums; it is also ethically dubious (education is a right, not a privilege) and would set a dangerous precedent in which quantity becomes more important than quality.

If this argument is raised, find out why and what other departments within the museum have been asked to become self-financing. If it is replied that they are integral to the museum, ask if that means that education is not. You must be very firm about this. This is not to advocate conflict or hostility between yourself and management, but it does point to a lack of understanding on their part that needs to be corrected.

It may be that in certain circumstances the work of museum education staff generates an income that exceeds overall education costs. This is all well and good, but linking performance and income generation is a dangerous move. If necessary do a cost analysis explaining precisely what you would have to charge each student and teacher currently making use of educational facilities if self-financing is to work. In most museums, it will be a very high figure per person. Of course, you could point out that everyone who comes through the door is making use of the educational aspect of the museum and you should therefore get a proportion of any receipts from them, as well as those of a dedicated nature (for example, from schools).

This does not preclude charging for your services unless to do so goes against the general policy or charter of the museum. Many state-funded institutions are meant to provide serv-

ices free of charge. It should be noted, however, that a free service could be taken for granted and treated with less respect than it should, simply because it is free. Even a nominal charge can make a difference. It may deter some (although it is always possible to come to special arrangements with those who are financially disadvantaged), but most people respect the notion that if a service is good it should be supported – especially if money gained through charges is put directly back into that service.

Precisely what line you take on this depends on your particular circumstances, but it is widely accepted that if charges are made they should be set at a level to cover no more than material costs. If this is to be the case, then charges are dependent on budgetary concerns and educational user group numbers, and a formula can be worked out for charging that can then be included in the policy document.

One of the other main determinants of the work that can be done is the physical space available. Firm commitments need to be obtained that certain areas will be set aside for educational work. Make it clear that the ability to maintain certain programmes of work is entirely dependent on the space available.

As space is important, so too is access to teaching material. In some cases, it will be necessary to make do with artefacts on display in exhibitions. However, much more than that will be needed for successful work. Guidelines and procedures will need to be negotiated so that time is not taken up with discussion each time an artefact is needed for teaching work. This may involve setting up a teaching collection (to which additions are made on a regular basis) or it may involve other means by which items are coded as acceptable for use. Access to teaching material should also include other museum staff who have experience and expertise in specific areas that can be tapped as an educational resource. Guidelines are also needed here to ensure that everyone is aware of the situation and that requests for their help may be made.

As it is important, for reasons already mentioned, to ensure constant monitoring of the effectiveness of museum education work, realistic procedures for ongoing assessment and evaluation need to be identified that will allow for future changes based on hard evidence rather than whim.

One of the difficulties that will have to be faced in drawing up an education policy and integrating it into the overall policy of the museum is the matter of definitions. What are the meanings of 'education', 'museum education', 'museum educator' and so on? This is extremely important, not just as an exercise in ensuring that these terms are well-defined, but also in ensuring that the definitions are understood and agreed by the museum management. It is no good, after all, writing an education policy if those who ratify it have a completely different idea of what is meant by education to the person who actually puts the policy into practice.

DRAFTING PRIMARY POLICY – DETAIL

To begin with, there should be a general statement that the museum recognizes it is an educational resource of enormous wealth and that it will do all within its power to promote its educational role.

It should be explicitly stated that both education policy and practice relate specifically to and are in accord with the policy and practice of the museum as a whole. Furthermore, it needs to be stated that the work of a museum educator or a museum education team is done in association with other staff in the museum.

There should be reference to the fact that, to work effectively, museum education staff need to keep themselves as well informed as possible about subjects that relate to the collections and core work of the museum. This will vary enormously from museum to museum depending on the nature of the collections held, although the basic tenets of collection care are transferable.

In addition to this, staff need to keep themselves as well informed as possible about the facts, theories, debates and developments in education and related subjects (both locally and nationally) and make necessary adjustments to the education service offered in accordance with them where that remains compatible with the policy and practice of the museum education service.

Although day-to-day priorities change, it should be firmly established that sufficient time is given over to research and preparation, liaison with other museum staff (especially in the preparation of exhibitions) as well as liaison with other relevant individuals, groups and organizations.

Then there is the core of museum education work. Staff must devise, research, and produce educational materials. They must also put into practice educational programmes that highlight and explore the collections and core work of the museum as well as suggesting ways in which to complement work undertaken by students elsewhere. Although discussion of the different forms that educational provision can take follows in later chapters, the detail of this depends very much on specific circumstances, the needs of user groups, and the ingenuity of museum education staff.

Allied to this is the need to teach and otherwise work with students and teachers in ways that make best use of museum education staff time, provide the most direct and appropriate forms of educational experience of the available resource, and which do not duplicate (as far as is possible) work that can be done elsewhere. It needs to be made clear that not all services and programmes should slavishly meet the needs of user groups. Museum education should be innovative, taking the initiative as well as reacting to demand.

As well as direct teaching and other forms of education work, there are associated tasks that fall in the area between education and marketing but which are none the less essential. Museum education staff need to explain, disseminate information, actively promote their work, and encourage use of the museum (formally and informally) to as wide an audience as possible.

Involvement with the museum as a whole is essential. Such involvement should also be enshrined in policy so that it is recognized that museum education staff, in close association with curatorial and other senior staff, are involved with all stages of the evolution of any developments within or of the museum.

All this activity needs to be monitored and kept under review. Methods of record keeping and assessment need to be devised, targets set, and work closely monitored to ensure that it evolves in a positive way. This should include a full review of education policy and practice on a regular cycle that is long enough to allow sensible levels of development to occur and short enough to prevent any major problems developing. Three years is generally considered a good length, although constant review should alert museum education staff to problems long before that.

Museums will usually have a general staffing policy that sets out terms of service, job descriptions, the qualifications and experience required for the post, as well as training opportunities and routes for advancement. This should include a statement to the effect that any staff who will be working with children should undergo checks to ensure they are safe to do so. In some countries this is a statutory requirement but, whether it is or not, it

should be part of museum policy. If it is not, then the writing of an education policy for the museum provides an excellent opportunity for its inclusion. This is a delicate subject and may require legal advice where it is not already law. However, it is essential that such action is taken. This is for the protection of children and displays a responsible attitude on the part of the museum.

A sample primary education policy can be found in Appendix 1.

Job description

From a primary policy statement, it should then be possible to draw up a job description (if one does not already exist). This is not an exercise in pedantry. It is important that the role of the museum educator is clearly defined within the museum, although in smaller museums all staff must contribute to keep the place running. Contractual obligations are well worth defining, to avoid the possibility of conflict at some future date. Most museums will already have a description of the job they wish to fill. This does not mean that it cannot be renegotiated if a sensible case for change can be made.

The purpose of a well-defined job description is twofold. Not only does it provide a set of guidelines that delineate day-to-day duties and responsibilities; it also provides a clear statement of the overall scope of the post. It should be made clear that a museum educator is not the same as a museum teacher. As a museum educator, you are not there just to teach. You must be allowed to develop a much wider role within the whole museum. This is not to say that face-to-face teaching should be abandoned; it is after all the main reason why many go into museum education. However, there is, as has already been stated, a much wider role to be exercised.

It can be argued that there is no need for a written job description if a written policy exists, as the job of a museum educator is to implement that policy. However, such an approach is too vague and open to many problems. Besides, there may be duties required of a museum educator that are not covered by an education policy – especially one who works in a smaller museum. There may also be specific administrative duties that are not apparent within the broad definition to be found in the policy. As an example of this, it may be necessary for the museum educator to make a regular report on their activities to the museum management. It is this finer detail that is to be found in the job description, a sample of which is offered in Appendix 2.

Secondary policy

As well as a job description, the primary statement will require a more comprehensive outline of the objectives derived from the policy, a list of the resources available to carry out those objectives and a survey of the catchment area and educational user groups. This is the secondary policy statement.

Drafting this statement is a useful exercise as it provides the opportunity to collate your setting-up research in a form that will prove useful in several respects (not least in the area of fund-raising). It also provides an essential tool in monitoring the progress of the education service as it lists not only your objectives, but also the means at your disposal to bring them about and the constituency with which you have to work. Such a document can

afford to be more specific than the primary policy statement, but must remain sufficiently flexible to cope with the exigencies of real life.

In drawing up such a document make sure it contains:

- a list of major objectives;
- details of staff available and possible future staffing needs;
- equipment available for education work;
- an outline of the forms of educational provision already available and those that might be developed;
- details of actual and potential educational user groups;
- details of teaching resources that can be made available from the museum's collection;
- current and proposed marketing strategies;
- proposed means of evaluation and what is to be evaluated;
- current sources of funding and possible future sources;
- an assessment of training needs and how they might be fulfilled;
- areas of liaison.

The main objectives you wish to achieve need not be too specific, and can be used in some cases to qualify the main aims set out in the policy statement. They also rely to a great degree on the status of the education service. If it is a new service, then you will be setting out to achieve these objectives, rather than assessing what is already done and setting out what you want to improve, add and see fade away.

This should be followed by a statement of staffing available for educational activities (including volunteers and those available from other areas of the museum who could be tapped for their expertise for lectures and demonstrations), as well as a copy of any relevant job descriptions. Mention whether or not and at what stage it would become necessary to consider taking on extra paid education staff.

When it comes to recording what space is available, this is not simply to do with floor space. Everything that is available should be included, as well as information about to what extent it is shared space (and with whom it is shared). Time restrictions placed on a given space should also be noted. An assessment of future possible needs and identification of areas that might meet those needs should be included where appropriate.

When listing what equipment is available for use, group this into capital equipment and day-to-day consumables. If any of the equipment available is in a common stock and thus to be shared, this should be made clear, along with an assessment of how much opportunity actually exists for access. For example, the museum may have a camera but it is no use for education if it is in use all the time for cataloguing. It is also worth assessing how old equipment is, how reliable it is, and how compatible it is with other equipment of a similar nature.

Educational provision should be grouped to differentiate between programmes and services currently in use, those that could be instituted in the near future, longer-term prospects, and priorities for future developments. As well as simply listing forms of provision, make it clear what specific forms these take and by whom they are currently used. Future markets should also be indicated.

Details of educational user groups should list the different categories already using the museum (if any) along the lines to be discussed in Chapter 6. It would also be helpful if numbers are supplied, with an indication of how these are spread out over a year, how each group relates to the others as a proportion of the whole, and how much museum staff time

is required for each group. In addition, areas for future development and their relative priority should be included.

Teaching resources are all those parts of the museum's collection of artefacts and documentation, research material, books, videos, slides, computer hardware and software and the like that can be used by the museum educator for teaching work of one form or another. These resources can be grouped together in a number of different ways. Details of each group should be given, along with an assessment of those groups that need to be strengthened.

Effective marketing is a highly refined art. Current strategies should be outlined, along with an assessment (if possible) of their effectiveness. Other avenues to be tried should also be mentioned. An outline of approaches can be found in Chapter 7.

The forms of evaluation (both informal and formal) that are currently in use should also be included, together with details of what is being evaluated and why. This should indicate precisely for whom the evaluation is being done (and in what forms) as well as what steps are in place to ensure that information derived is put to good use.

Statements on the source of funding help to clarify what is dedicated to education and what may have to be negotiated for on a regular basis. This should include:

- the source of museum education staff salaries, to what degree they are secure and who has ultimate control over continuity;
- the source of day-to-day running costs (whether these come from a general fund for which constant permission has to be sought or whether there is a specific education budget managed by the museum educator);
- whether grants and sponsorship form part of the normal running costs and who is responsible for raising this money;
- whether charges can or should be made for any of the educational services.

Training falls into two categories. The first is that provided by the museum educator for other people. This includes museum staff and may range from basic introductions to the education work offered by the museum and updates to keep staff fully informed, to training sessions run in association with the managing body and outside professional organizations to improve the qualifications and professional standards of the museum as a whole. This, if expertise is available, can extend to other museums. Training may also be provided for teachers in the use of museums, school students on general work experience placements, older students undertaking museum studies, and so on. The second category is training that museum educators should be able to undergo on their own account. An indication of how much time and funding is available should be given, along with changes to salary scale if recognized professional qualifications are achieved.

Finally, there should be an outline of the different networks (informal and formal) available to the museum educator in order to liaise with other professionals. This should include those that exist internally (staff structures, lines of formal communication and complaints and disciplinary procedures), as well as those that exist outwith the museum to enable the free gathering of relevant information and ideas. A sample secondary education policy document can be found in Appendix 3.

It is probably apparent by this stage that in producing a policy it is far easier to compile the secondary policy statement first (as it is, in essence, a summary of the preliminary research suggested in Chapter 4) and, from that, derive the primary policy statement.

Action plan

Having established primary and secondary policy documents, along with a job description, you should draw up an action plan that prioritizes what actions you will take to implement your policy. The content will depend entirely on a combination of what services you can offer your target user groups and the resources that are available to you. These things take time and you must be able to work from the security of an open framework grounded in accepted policy. Get your list properly ordered, but do not tie yourself to anything more than a general timetable. Priorities are more important than deadlines. Quality is more important than quantity.

Be prepared to rewrite as you go along, constantly assessing what you are doing and why. An action plan is intended as a working guideline only and should not be regarded as ineluctable. Although the first year of development is mostly fixed by the specific need to establish the scope and nature of the museum resource, basic working and administrative practices, and a formal education policy along with some basic levels of educational provision, the order and nature of the suggested developments in the years ahead can be fixed less easily. This may seem far in the future, but you will be working to timescales set by others whilst you also have to deal with day-to-day demands.

Where a given project is mentioned, its development should be seen as long-term. Each project has to go through several stages, including research, development and consultation before it can be put into effective practice. Once launched, it should be reviewed and updated at regular intervals, as well as being further developed to greater levels of sophistication. It is also important that all relevant members of staff are consulted about and kept informed of developments as they take place.

Proposed developments will have to run concurrently with the normal day-to-day educational use of a museum and the concomitant day-to-day administration. In addition, of course, you cannot rule out any developments that arise in fulfilment of needs identified by user groups of the resource.

The education service (whatever its form) must be allowed to develop in such a way as to concentrate primarily on providing a quality service, even if that means relatively low user numbers in the first few years. A quality service (which, among other things, means value for money), when well established, will attract an increasing number of users. If you aim for quantity first, you will be unable to provide the quality that will ensure that educational users will wish to make continued use of the service in the future.

Important as it is to produce a policy and other constitutional documents, this aspect should not become dominant; otherwise, it becomes an exercise in bureaucracy. Nor should it be restrictive. What you want is a solid foundation on which to base your efforts, but one that allows for change in circumstances so that you can alter the emphasis of your work, expand into new areas, and wind down other activities as necessary. As with any good foundation, care in its production is vital, and once you have built upon it, you do not want to be altering it all the time.

Producing a formal education policy does not guarantee that it will be translated into practical action, although that is the intention. However, it does yield a tangible plan of action that will give a better chance for education to be provided on more than an ad hoc basis. Moreover, once it has been accepted by the management body of the museum, it is incumbent upon them to make sure the resources are available for you to put it into practice. Having fought for it, you must use it.

6 *User Groups*

Most people assume that a museum education service exists for the single purpose of dealing with children. It is a perception that every museum educator will encounter and which they will have to work hard to dispel. Whilst it is true that the bulk of the work of an education service will be with children of school age, museums contribute to every stage of educational development and support lifelong learning. There are, therefore, a large number of other educational groups that can and do make use of museum education services.

These groups come in all sizes, ages, and abilities. Each has their own dynamic and their own agenda. Some groups are from the formal education sector, others will be non-formal groupings, and still more will be informal. Each will be used to working in a particular way and will adapt to the museum environment with varying degrees of success and enthusiasm.

The way in which students learn varies according to age and previous experience. Children, in particular, have apparently random ways of approaching museums, which are, in fact, full of purpose. Adults want to learn, and enjoy doing so, but prefer to have a greater degree of control over their learning experience than would be afforded younger students. You, as museum educator, must consider all this, even if user group teachers do not.

The chances of coping with these different groupings using a single approach are zero. The differences between them are too extreme – differences of kind rather than differences of degree. That is why it is far more productive to encourage the teachers to teach them, once you have equipped them with the necessary skills.

Whoever they are and whatever reason they might have for visiting, it is important to remember that any form of categorization of educational user groups is for convenience only. Each group will be different, even the same group visiting on different occasions will be possessed of a different dynamic. In whatever way you categorize a group, it should only be in order to provide yourself with a basic set of facts from which to work. Information about specific groups comes from talking with their teachers and from your own experience. Indeed, one of the great skills to be learned by any museum educator is how to 'read' a group and, within a few minutes of first encountering them, have a good general idea of their temperament.

Children up to five years old

Children up to the age of five will enter the museum for a variety of reasons, but they will not visit as often as one would like. In general, however, they come with organized play or nursery groups or they come with their parents. Neither group will normally appreciate the full value of visits for such young children, and that is because museums are not geared, on the whole, for such young minds. There are, however, good reasons for encouraging young-

sters into the museum environment, where they have the opportunity to become familiar with museums as part of their everyday life and encounter interesting objects, respond to such objects and generally enjoy themselves. It is also worth remembering that most leaders of organized pre-school groups would not normally consider museums as places worth visiting.

Children of this age are full of wonder, and for them all things are possible. The environment of the museum may be somewhat awe-inspiring, but that is no bad thing as long as they feel welcome and secure at all stages. Never assume that they can get nothing from a visit to a museum or that they are not to be taken seriously. Observers of children at this age will know just how insatiably inquisitive they can be. Nor should it be assumed that childish inquisitiveness is easily dealt with. Young children ponder on the deepest of philosophical questions, ones that have outwitted the profoundest of thinkers. They also notice a great deal that we miss. Moreover, they have an almost frightening ability to ask questions about the world around them that we have learned to accept as 'just one of those things'.

Family groups can be offered playtime sessions in which the children (accompanied at all times and not just dumped while parents go shopping) are given the chance to explore objects and ideas at their level. Story sessions using artefacts also work well. There is an opportunity here to work in conjunction with other agencies that offer support and training to parents. This should be kept separate from organized events for playgroups and the like, but arranged in conjunction with providers of playgroups. They will know what sort of activities are suitable for children of this age and you can then offer what you have that fits their requirements.

This is one of the few times when it is better to try to keep the environment of the museum as similar as possible to the home environment of the playgroup. Activities, too, should be of the sort with which the children are familiar. It is far better to keep to a pattern with which the children are acquainted. Be guided in this by their teaching staff. Working with young children can also be messy, so you need special areas where they can get sticky to their hearts' content.

It is not possible with children of such a young age to introduce the more rarefied aspects of artefacts or concepts such as continuity, progress and the like (although you have to start somewhere and handling old things can help), but it does give them a chance to handle objects. When they first begin, it might be useful to choose themes that relate to their everyday experience and work with artefacts that are familiar to them in form if not in detail. If your museum only has a specialist collection that has little to commend itself to the very young it may still be possible to arrange sessions for groups even if it is only to get the children used to the idea of going into museums.

Do not short-change the children just because they are young. We learn more in our first five years than during the rest of our lives. All the basic patterns of behaviour and all the really difficult stuff (learning language, for example) happens in that time; hence the need to get young children into museums and introduce them to material culture. Find their level and expand it. You will be surprised at how long they can work at a particular task, even if their patterns of concentration are not constant. They can return to ideas and discussion a number of times over a lengthy period.

Never try to teach facts beyond the basic. Children of this age have plenty of time to do that later on. Although the world is largely concrete to them, their emotional development goes on apace and they are more likely to respond to things on an emotional level. Nor is

the aim of their visit just to handle objects and see the working of a museum. There are a number of other objectives to which you can aspire, including helping the children to:

- mix with others in unusual surroundings and circumstances;
- learn appropriate behaviours for museums;
- develop listening and cognitive skills;
- expand their vocabulary; and
- develop their ability to discriminate between objects that occur naturally and those that are made by people.

Make sure they have some art- or craftwork to take away with them, as this will help to keep the visit alive in their minds and give them something to use as follow-up in the playgroup or nursery or when talking with their parents.

Five- to sixteen-year-olds in state-funded education

In educational terms, this is a vast age range. It is considered a single grouping by virtue of the fact that students in schools provided by the state will be following a reasonably well defined curriculum that is delivered in ways that are well known and which vary little from school to school. This background, coupled with the organizational set-up, makes this a coherent group.

It is relatively easy to make contact and develop working relationships with teachers. It is also relatively easy for the museum educator to develop programmes of work and make artefacts and collections available in such a way that many schools can use them on a regular basis. This means that courses can be run for teachers in the use of museums, maximizing the use of the museum educator's time. This is particularly useful because this group is normally the largest.

At the younger end of this age range students will be starting their formal education and learning the basic skills they require for later work. This usually includes familiarization visits to various parts of their local communities. As they go through their first years of education they are invariably introduced to libraries – their personnel, how they work, and how to find and borrow books. Most libraries cater well for this. Many commercial enterprises such as supermarkets and department stores also provide familiarization and behind-the-scenes visits. Museums should offer the same service with short sessions in which students progress from the play sessions of pre-school activities to learning more about museums – what they are, how they work, who works in them and the jobs they do, and how and when they can visit. Such programmes are essential for the success of a long-term approach to encouraging wider educational and social use of museums.

Once students have progressed through this stage, they are ready to tackle in-depth work with material culture, augmenting text-based classroom study. It is now possible to begin introducing the skills that enable objects to be read as fluently as text. Students can then begin to study for themselves (rather than absorb a received wisdom) and devise means of investigating and constructing their own programmes of study.

By the time students are between nine and thirteen, they are in the group that is brought most frequently to museums. If they are used to it, and have acquired the basic skills of working with material culture, they will be able to make in-depth studies based on

a series of visits. Even if they lack the basic skills, it is reasonably easy to devise programmes of work that introduce such skills at the same time as they are working toward fulfilling the specific objectives of a visit.

Although it depends on the structure of the education system, nine-, ten- and eleven-year-old students are likely to be involved in cross-curricular project-based studies. Older students will have begun to specialize and museum visits generally (though not exclusively) become the preserve of history classes.

This is one of the challenges that you will have to face. Artefacts are inherently cross-curricular in their nature and can be studied from a number of different viewpoints. The tendency to do cross-curricular work with younger children stems from a project-based approach that goes in and out of favour depending on prevailing political and educational ideologies. However, it will always be a feature of work with younger children and allows plenty of scope within museum-based work, not only for different forms of investigation but also for the directions that can be taken from the starting-point of a single object or collection.

As specialism takes over, this type of work becomes more difficult, and artefacts and collections have to be used in a different way that is subordinate to the subject under study. That is, they move from being a focus and stimulus to being illustrative. There is nothing wrong with either approach; nor is one better than the other. What is important is that students have many opportunities to experience both ways of working, regardless of their age.

Another challenge is to ensure that as students get older and begin to concentrate on gaining qualifications, they continue to use the museum as frequently as they did at an earlier age. Forms of use may differ yet again, as students grow older. When they are first introduced to the museum environment, everything will be very much teacher-led. As they become more experienced at working with material culture, they become able to instigate their own programmes of work as well as use the museum as a form of reference, much as they would books in a library. Confidence building, familiarity, and the provision of working skills will all help to ensure that, as students progress through the system, using the museum is a natural option.

Finally, and most difficult of all, is engaging the interest of specialist teachers who would not normally consider visiting a museum with students as a natural part of their work. There is, for example, a great deal of opportunity here for encouraging the study of mathematics and science as well as design and technology, language and literature, quite aside from the normal applications of history, social studies, and the arts. Chapter 13 explores this in detail.

The ideal that you should work towards is that students become as familiar and comfortable with museums as they are with text-based learning in the school environment and the library. In reality, to begin with at least, most students will not have the necessary background to carry out independent study based on material culture, so that the museum educator will be more involved with direct teaching. As time goes by, however, this should ease.

Five- to sixteen-year-olds in privately funded education

Although much of the above applies to this group as well, there are certain additional considerations that need to be taken into account. To begin with, students within this group

will not necessarily be following the same curriculum as equivalent students in the state-funded sector. Nor will privately funded schools have the same degree of administrative back-up and support that you can tap into to get an understanding of what might be required of the museum. Most, however, do belong to organizations that offer equivalent services.

This situation is further complicated by the fact that some privately run schools follow specific educational philosophies that lie outside the mainstream. Some of these are secular and some are religious. All have specific ways of working and specific approaches to certain subjects. These include Steiner and Montessori schools, Christian schools of various denominations, Muslim schools, Jewish schools, Free schools, Small schools, and so on. You must be sensitive to the ideologies that are being put into educational practice. And to do that you must know something about those ideologies and respond appropriately. This is not the same as acquiescence.

Five- to sixteen-year-olds formally educated at home

A growing number of people are choosing to educate their children at home. There are many reasons for this. For some it is a commitment to a particular lifestyle, believing they can best educate their children in a way in keeping with their own general metaphysical stance. Others believe they can simply do it better than the state system. There may also be specific reasons of an ideological nature – be they political, philosophical, or religious. For others, there is little choice involved. People who move about a great deal (for whatever reason) may educate their own children, as it is the only practical way to ensure a decent and continuous education. Other children have tried the state system and been withdrawn because they cannot cope. Bullying, health problems, learning problems, behavioural problems... all these and more have prompted parents to become home educators.

Methods of working are equally varied. Whilst some home educators organize their children's education along similar lines to a school (with a timetable, pre-set curriculum, and so on), many do not. Children are more often than not encouraged to pursue fully areas of study that are of current interest to them. Moreover, the student-teacher relationship and thus the whole educational dynamic is markedly different from that found in schools, even small private schools that offer unconventional modes of education.

It is clear, then, that working with children being educated at home throws up a number of interesting challenges not found with other groups and individuals of a comparable age. To begin with, such students do not normally arrive in class-sized groups. Where groups are organized by local associations of home educators, the students are unlikely to be following the same topics of study or even to be following similar curricula (unless studying for external examinations). The age range within a group will also vary enormously. There may be babies and toddlers in attendance, not to mention the larger number of adults than is usual.

The different reasons for home education taking place coupled with the variety of approaches and the different educational dynamic mean that you cannot make a general assessment of academic ability based on a student's age. This is compounded by the fact that some students may now be educated at home after having worked in a school environment. Children educated at home are also likely to be less formal and regimented and more inclined to pursue their own lines of enquiry rather than those demanded by a curriculum or a museum educator.

All this has to be kept in mind if you wish to attract this important group of students to the museum. However, you cannot hope to cater for them properly without a great deal of liaison and adaptation. To begin with, though, you must start with what you have. Make it clear through whatever means is available to you, as well as by contacting home educator associations, that you are happy to offer sessions for students in this user group. Start with introductory sessions so that you can get to know the various members of this group and the different approaches that will be required. These sessions also give them the chance to get to know you and what you can offer. Once this initial ground is broken, you can start to develop programmes and services that will best suit the particular needs of this user group.

One of the keys to success, as elsewhere, is to teach the teachers how to make full use of the museum and its services. This will not be as easy as these teachers are parents and cannot easily release themselves from their responsibilities for training sessions. Working with and through home educator associations is vital. They may be able to make the necessary arrangements that release parents for training and familiarization.

Although the process will take time, you will eventually be able to add sessions to your repertoire that suit home educators' direct needs (those students who are studying) along with their indirect needs (babies, toddlers, other family members, differing pressures of time, and so on). What is more, it will provide you with the opportunity to innovate, dealing with subjects and using approaches that would not otherwise normally occur in the work you do. Not only does this prevent you from becoming stale, but it also allows you to assess your more conventional endeavours from a new perspective and enhance what you do in all your fields of work.

Five- to sixteen-year-olds in non-formal groups

A non-formal group can be defined as an organized group that has educational aims, but which is not a school. This includes groups such as Scouts, Guides, Woodcraft Folk, Sunday School groups, holiday clubs, museum clubs, Young Archaeologists and so on.

Catering for non-formal groups presents a completely new set of challenges for the museum educator. To begin with, it is possible that the individuals within the groups will have visited the museum with the formal institute of education that they attend. It is, therefore, not good enough simply to use work that would be used with formal groups. In the second instance, as a non-formal grouping, they will not be following a normal curriculum. They may be following an educational programme but it will be related to an end specific to the group and it will not be compulsory in the sense that ordinary schooling is. What is more, the dynamic of the group, in most cases, will be far more relaxed.

Groups of this nature, though requiring input from the museum educator, need to be treated differently from formal groupings. Materials should be provided and work should be done, but overall the students in this situation should be treated much more as an adult group. Part of the joy of going into a museum with such a group is the feeling of entering an adult world and being allowed to do so on equal terms. This is especially so with groups that have strong natural links with the museum, such as archaeological groups, natural history clubs, museum clubs and the like.

Five- to sixteen-year-olds in informal family groups

Family groups usually follow agendas in which social interaction is a key element. There is rarely any specific purpose to these visits. They certainly are not intended to follow a pro-gramme of learning. They are also rarely planned more than a few days in advance, reflect-ing nothing more than an impulse to visit the museum. What is more, such groups will most probably wish to have a largely unstructured experience. That does not mean, however, that they would not appreciate the chance to participate in activities that can be done on a family basis. Sadly, however, this tends to be the group most neglected when it comes to catering for visitors to museums. It is a surprising and lamentable oversight, as many surveys over the years have shown that family groups comprise the largest single element of visitors to museums, consistently around two-thirds of all visitors.

The emphasis here is on the idea of family. This does not mean catering for the children while the adults do something else, or simply providing things for the children to do and for the parents to help. What is important is to provide an environment as well as events and packages in which family units can participate as such. This approach caters not only for present-day needs, but also for the future. Surveys show that nearly two-thirds of adults who visit museums do so because they visited as children with their families. Less than 5 per cent claim that school visits led them directly to continue the habit.

Museums that simply display objects are going to be a turn-off. Museums that offer effective communication of ideas, even if they are based on objects, are more likely to attract. If that communication is especially designed with families in mind, then all the better. As they are the mainstay of visitor numbers, it would seem sensible for the whole museum to be designed to cater for the family. This is especially important as family involve-ment is voluntary and any learning involved is informal. They do not have to come and they are not looking to have a structured learning experience when they do. At the same time they come because the visit is seen as educational and a place where the family can be together and learn together.

Of course, it is all too easy to fall into the stereotypical view of the family. Before trying to provide for them, you must look very carefully at present-day trends, especially as they relate to your local community. What is more, it is not just family composition that has changed. The roles of family members have also undergone a change, as have their expecta-tions of what a day out together should be like.

Sixteen- to nineteen-year-olds in Further Education

A large number of students need to extend their formal education in order to reach certain basic levels of understanding or qualification. There are three main groups here, each of which needs to be catered for in different ways.

To begin with, there is the group containing students of average intelligence who are, for whatever reason, intent on broadening the attainments they made at school. This may well reflect a change of heart about their career and the need to gain the required qualifica-tions. It may be that examination results were poorer than expected and subjects have to be taken again. On the other hand, perhaps someone is undecided about what they want to do but acknowledges the need for a wider base from which to launch themselves.

This first group will be covering much the same sort of ground as the top-end students in the formal education grouping already discussed. However, they are older, generally more mature, and they are now in a situation that has a slightly more relaxed dynamic. All these things have to be considered when working with such a group.

The second group consists of what one might call late developers – students for whom education only begins to make sense once they are a bit older. The challenge here is to provide a content that is suitable for the older student but which is presented in a way that acknowledges their particular educational level. This is not just a matter of taking material normally used with adults and presenting it with methods used for children. That would be laziness on your part and an insult to the students. Consult closely with their teachers to find the correct levels.

The third group consists of those students who have special educational needs. These may derive from a number of physical, social, or mental causes. With this group of students, it is usually social skills that will be the main part of their education. Often it has been the lack of developed social skills that has prevented their education from advancing at the rate of other students. Indeed, the content of the museum, in some cases, may be incidental to the aims of any visit made by such a group (although never irrelevant, as social skills cannot be learned without a social context). Visiting a museum is a social skill – a museum that is aware of this and that can offer differing opportunities and environments for such visitors, as well as something of relevance to interest and educate them while they are there, will be attractive to their teachers.

Sixteen- to nineteen-year-olds in Higher Education

This group comprises those who have successfully completed their education to age sixteen and are now studying for advanced and slightly more specialized qualifications. These may be as a prelude for entry into college or university, or may simply be required for the sort of work students are seeking. There may also be students on day release from work, studying specific work-related subjects.

It is rare that the teacher of such students, visiting as a group, will ask for the assistance of a museum educator. In many cases, this is quite reasonable. They will be coming to look at specific things (often a temporary exhibition will attract the attention of a teacher) for very specific reasons and the teacher may feel there is no need for further input. However, there is plenty of scope to elaborate on such work and to involve teachers much more actively in using museums to assist with their programmes of study.

Most of the contact with students in this category is likely to be orientation within the museum and assisting individuals with project work. Whilst this has traditionally been confined to the occasional archaeology student, there is plenty of scope for students of technology and design, tourism, history, art and so on.

Such students will have no problems with or qualms about using a library and are, in the main, very sensible and trustworthy. There is no reason why they should not also be making use of the research resources in a museum, once they have been inducted in their use and a means is established to keep a record of these students.

College and university students

Undergraduate and postgraduate students as well as those studying for various certificates and diplomas are likely to be attracted to museums as groups and as individuals. This will depend largely on the subjects they are studying and the interest of their lecturers, but enormous scope exists. However, at this level of education you may encounter the problem of academic acceptance. That is, some lecturers believe, quite unjustifiably, that a museum educator does not have sufficient academic qualifications to work with undergraduates, let alone postgraduates.

Do not be intimidated by this. Perhaps there are staff in the museum who know more about a given subject than you do, and it will be your task to persuade them to spend time with the students. However, you will invariably come to know more about the educational use and the content of your museum than anyone else.

As well as straightforward fields of study that may bring students into the museum, there are a number of other areas that may be worth investigating and instigating. Students working at an advanced level may well have skills and ideas to contribute that would improve the museum and its resource at the same time as benefiting their education. It may be part of their coursework to do practical projects. For example, students who are working on computer-generated graphics might be encouraged to produce animated images of artefacts or of the processes used to produce those artefacts. Students studying design might use the museum itself as a design problem and be asked to consider ways in which the internal design of the building or of individual collections might be altered and improved. Students studying jewellery or pottery or some other craft-based subject might be persuaded to study ancient methods of their craft and produce replicas that the museum can then use for teaching. Students doing media studies may be able to produce a promotional video. Language students could undertake the translation of museum leaflets into other languages. The opportunities are enormous.

Students taking Initial Teacher Training

This is a key target group. Not every museum will have a teacher training facility within working proximity, but those that do must begin to create links with it as a matter of urgency. One of the main reasons why many teachers do not use museums in their teaching is that they lack the skills and confidence to do so. The best time to teach them these skills is while they are doing their initial training. The best person to teach them these skills is a museum educator.

It is extremely important that teachers are trained in the use of museums. Not only does it mean that museums are then used more productively; it also means they are used more frequently. In addition, it broadens the scope of a teacher's work, as they have an extra (and extremely rich) resource they can exploit.

Practising teachers can be taught these skills (see the next section), but it is much easier to do this when they are students, and immersed in the whole culture of learning about their profession. In that situation, they can more easily assimilate what they learn and integrate it with other aspects of their work. They also come to regard museum work as a natural part of teaching.

Important as this approach is, it will take time to get teacher training institutes to accept it as a permanent part of their curriculum. You will inevitably start work with those lecturers who are sympathetic to your cause. They can then help to lobby for a more comprehensive approach. Indeed, pilot schemes with smaller groups of students may well provide sufficient evidence of success to persuade the relevant authorities of a more wide-scale approach. It is also easier from your point of view, as there is time to explore the possibilities, evaluate what has been done, and develop packages of work that best suit the needs of students and the demands of their lecturers.

Practising teachers taking in-service training

This is also a key target group. Many teachers seek to improve their skills throughout their careers. Not only is time usually allocated by their employing authorities, but also many teachers are willing to give up their own time to follow courses of work that will enhance their teaching abilities and their understanding of education.

Whatever the case, time is of the essence. Any courses you offer must be concentrated and worth the time given up by the teachers. Arrangements can be made with individual schools so that any training days they have are based in the museum. Twilight sessions and weekend sessions can also be used. Moreover, there are the long vacations to consider.

The range of courses can vary enormously. Many different one-off sessions can be devised that will allow teachers to become familiar with the museum, its collections, and the services it offers. Specific items and ideas can be explored in connection with the curriculum.

Longer-term programmes of work may be more attractive if they lead to specific goals. Even if these are simple certificates issued by the museum and endorsed by curatorial staff, they are of value to teachers. These programmes might offer the opportunity to learn more about the workings of the museum and the special skills required to use museums in teaching. They can include sessions on using research resources, how to handle artefacts and so on. All this not only enhances the ability of teachers to use the museum as an effective resource, but it also reduces the chances of mishaps and mishandling destroying the resource.

Indeed, if a museum is particularly popular, it may be necessary to ration time and access. This is best done by running programmes that lead to certificates of competence, priority for educational use then being given to teachers who have successfully completed a training course. You will eventually reach saturation point again, but it will be at a higher level, as the need for concentrated input from the museum educator is lessened.

Adult education

Adult education can be considered in three distinct ways. The first way is tapping into established adult education programmes and working in concert with those groups and their tutors. This can mean a great deal of work in establishing contacts but it is generally fruitful once set up. One of the drawbacks is that many adult education classes take place in the evening and it may be necessary to consider ways of allowing access to the museum at times when it is normally closed to the public.

The second way is establishing adult education in your own right, offering lectures and courses. This can be a simple, museum-led lecture programme given by staff members on their work, on the collections, and on other areas of expertise. Guest speakers can be brought in. However, it can go further than that, with seminars and workshops based around the collections. There is as much scope here as there is for younger students – adults enjoy the sort of activities on offer to schoolchildren and there is no reason why similar things should not be mounted for them, giving those who run the workshops the bonus of working with adults as well as children. This is in addition to the family sessions that may also be run.

The third way is to cater for individuals who are seriously interested (for whatever reason and of whatever age or ability) in your collections. They may be researching family history, local history, or have an interest in specific items within the collections held by the museum. There are as many interests as people, and some of the people can be quite young (and therefore not strictly adults). Catering for individuals must be done on an ad hoc basis, but an administrative framework for you and sets of ground rules for students (perhaps even a signed contract) can be put in place to avoid the situation becoming anarchic.

It may be possible to set aside a room for students to work in. It is, however, a sad fact that there are unscrupulous persons who think nothing of stealing or damaging material to which they are given privileged access. Supervision is one answer but is expensive unless there are staff members permanently researching projects who can be on hand to keep an eye on things. Otherwise, it may be necessary to ask for references and keep records of who uses your facilities.

Remote researchers

A relatively new, but fast-growing group of users is comprised of those who utilize the Internet to conduct their researches. This group has an extremely wide age and ability range with an equally broad spread of interests and commitment. Its members may live next door to the museum or on the other side of the world. Those that live within the catchment area of the museum are likely to be members of other user groups as well. The only thing they really have in common is access to a computer and a desire to make use of any resource the museum has made available via the Internet.

Even the specific demands made on the museum will vary. Many people simply want to know basic details of what is on display, opening times, admission charges, other facilities, and so on. Likewise, teachers will be interested in finding out about educational services. In that respect, such users will be looking for the electronic equivalent of an information leaflet. Other remote researchers will be looking for access to documentary and graphic material held in the museum's archive.

This has presented museums with an enormous challenge in recent years, especially smaller and poorly funded institutions. Setting up a website containing basic information about the museum is one thing. Making material from the collection available in quality digital form is time-consuming and expensive. Digitizing fragile and light-sensitive material, as well as objects of unusual size and shape, requires care and professional expertise. The same is also true of presenting this material in a way that is clear and easy to access.

Any educational input into serving remote researchers will need to address two distinct needs. The first is for information about educational services. This can be kept up to date on a regular basis and, if properly managed, will help to relieve some of the pressures of the

museum educator's work. If, for example, you have a loan service, it is possible to set up a system whereby the catalogue is available in a downloadable form and in which it is possible to see whether items are available or currently on loan.

The second need that can be met is for material pertinent to students' needs. This can include information packs for students and teachers as well as direct access to digitized versions of source material. Students can be guided to specific material or areas with the use of introductory pages that relate to specific topics or projects that you have discussed with teachers. This has the added bonus of making such material widely and constantly available without ever putting the originals at risk.

The important thing, however, with both aspects mentioned above is to avoid making online access a substitute for direct contact – with students and teachers. You should be available to discuss bookings, as there will always be issues arising that are not covered by any information you have published. Students may also have enquiries that are best dealt with directly. Nor should online access be allowed to become a replacement for visits to the museum by those who live within the catchment area. Looking at a computer screen and pressing keys cannot provide any of the important lessons that can be learned and experiences that can be gained by exploring the museum and by being in the presence of physical objects and other source material.

Miscellaneous groupings

There are many other educational groupings and self-help networks at work within the catchment area of a museum that may ask, at some time or other, to visit or make use of the museum's resources. Many of these groupings, although not educational providers themselves, offer the opportunity, via networks, to reach providers not covered by the categories already mentioned. These include one-parent family groups, carer groups, cooperative education networks, exchange students (looking to improve their foreign language skills) and many more.

It may also be possible, if the facilities exist, to play host to reputable groups whose interests coincide (if only loosely) with those of the museum and whose expertise can be drawn upon. Calligraphy groups, re-enactment societies, historical societies, art groups, literary societies, music groups, and the like could be encouraged where their presence is likely to enhance the museum's reputation as well as provide more friends for the museum and increase its revenue, from the hire of rooms to extra spending in the shop.

Finally, and depending on whether the museum has the facilities, there are other educational groupings which may not have any particular connection with the museum but which would be grateful for space for their meetings. Where the museum has a shop and café, this is a particularly good way of guaranteeing their use throughout the year. These may include university extra-mural groups, adult education groups, Open University groups, locally run evening classes, and so on. Such a use has a low priority compared with accommodating other educational users who have direct need of the museum resource, but if the museum wishes to build a reputation as an educational centre of excellence, such uses should be considered.

Casual visitors

Finally, there is the broader remit of ensuring that casual visitors are catered for educationally – especially the transient tourist audience who have a limited amount of time but are still open to education rather than mere spectacle. Individuals who come in because they have nothing else to do are also a challenge because if they can be interested from the moment they enter, they may well return. This is especially so for the first-time visitor. It may even be their first museum ever! Do not let them get away without wanting to come back and see more. Included in this group are the ever elusive 16- to 19-year-olds who are not in the education system. When was the last time you saw someone in this age group in your museum?

Do not assume that such visitors are self-motivated and have some conscious idea of why they are there. They might just be in need of an afternoon out of the cold or the rain, but that is no reason to neglect them. The ideal is to make the museum so stimulating that they just have to come back. This may work with the literate person who is used to museums, but it will probably fail with many other such visitors who may, for example, have problems with reading, let alone 'reading' a museum. Even if they do have some motive for entering the museum that is more positive than keeping warm and dry, it is their agenda that is important and not the one set by the museum.

One important strand of work that can be done with any exhibition is that, in addition to information about what is displayed, there should be information about different ways of 'reading' it. That is, the museum should be intent on teaching all visitors how to use museums. After all, if you cannot read, you do not go to the library. If you cannot 'read' objects, you do not go to museums. This analogy can be explored a little further because in libraries, even if you cannot read, it is accepted practice that you can ask staff for information. They are a living reference section. Museum educators would do well to consider how this could be made possible in museums. In many cases of this nature, personal contact is the key. In a library, it is natural to make contact with a librarian, even if it is only to hand in a book or get it issued. Museums lack such a tradition. Some are working to change this, but many still come across as temples dedicated to objects in which people must keep their distance and act reverentially.

The disabled

Within all of the groups mentioned above will be those who have disabilities. Never fall into the trap of thinking of 'the disabled' as if they were a single, cohesive group. They are not. Not only is there a vast range of disabilities, but also the identity of disabled people has been transformed significantly in recent decades. It is now recognized that one of the greatest disabilities faced by any person is the thoughtlessness and negative attitude of those who consider themselves 'abled'.

Disabled people are valuable citizens with equal rights. They are part of society and contribute to it at all levels. At one time, the disabled were identified as having an illness or condition that affected the individual. This outmoded 'medical model' of disability isolated the person, considered them to be the problem, and placed the onus of coping with the problem on them. These days, a 'social model' identifies the barriers in society that create disability for individuals. The responsibility for removing those barriers, be they physical, cultural, organizational, or attitudinal, is shared by all involved in a situation.

Along with this change in perception of disability, it is important that we do not make assumptions about specific disabilities. For example, the majority of blind people do not read Braille. There is more than one sign language. Not all deaf people are profoundly deaf any more than all blind people are totally blind. Only five per cent of disabled people make use of a wheelchair. Not all disabilities are permanent.

Specific physical disabilities need to be catered for by the museum as a whole in a physical sense, making access easier and exhibitions clearer. Learning disabilities need special consideration by the education service, and this is best done in concert with specialist teachers. However, there are also those who lack social skills, for whom a visit to a museum may be an adventure in itself, let alone trying to make sense of what the museum contains. What is more, there are those for whom visual and tactile stimulation may be extremely beneficial.

What all museums should be working towards, however, is a total environment that is available to all people. Important though it is to provide special sessions, most disabled people would much rather be integrated into society and have museums as accessible for them as for others.

The whole museum should work towards becoming as open, accessible, and inclusive as possible. In the meantime, the education service can make a start. First, talk to people who find the museum disabling, as well as support groups and charities. Speak also with the teachers of disabled students. Explain the museum's position and what you want to do as a start. In most cases, you will find that quite simple, inexpensive, and common-sense changes to design and to working practices will make a world of difference. Carers, too, need consideration. You can talk to carers' groups and offer an opportunity for carers to visit on the rare occasions that they get time away from those they care for. They may not want specific educational input, but they will appreciate being remembered and catered for.

Common approach

There are many other ways of making distinctions between educational user groups, and you will need to identify those groups and divisions that are unique to your situation or locale. Yet, no matter how much you come to know about the background of any of the groups and the group dynamics that exist when they are on their home ground, such dynamics change when they visit a different environment. Changes in social context and structure, the disciplinary set-up, routine, physical set-up and the hierarchy of the group all contribute to changes in the way a group behaves and the individuals learn. These changes are quite subtle in most cases and are as likely to be positive as negative. It is worth bearing in mind that this is so, especially if you have had the opportunity to work with the group in their own environment. If nothing else, the diversity mentioned above shows that a museum educator must be infinitely flexible.

In addition, there are problems associated with working in public. As a museum educator, you will find yourself working with groups in public galleries, sometimes with an audience. It can be uncomfortable at first, but you soon get used to it. It is less easy for students and their teachers to cope with, as they are used to the security and privacy of their normal place of study.

Although you must work in different ways with different groups in order to accommodate their particular academic and social needs, a common approach to them all is essen-

tial. Basic courtesies such as politeness and promptness should go without saying but need emphasizing. There should also be a wider common approach based on policy about access, time, costs, quality of service, and so on. That is why it is so important to have constitutional frameworks – not to hide behind and say you cannot do something because the rules will not allow it – but to remind people that you and they are subject to certain constraints and that you will do your best to accommodate them within those constraints.

In all this, liaison with the teacher is the key to successful work and the creation of long-term working relationships. Teachers know precisely what they want of a visit. They know their students. Despite all the changes that may result from working in a different environment with different personnel, teachers know these things best. And the best teachers know that the best person to conduct work in the museum is the museum educator.

7 Marketing, Networks and the User Relationship

Marketing

Marketing, by very use of the word, can cause a great deal of anxiety and even hostility. There is certainly a feeling among some that marketing is part of a commercial world that has little or nothing to do with museum education and museum educators. Yet all museum educators market themselves and their services every time they talk to someone in a professional capacity, every time they produce educational material, every time they teach. They all do it. They all need it. It is best, therefore, if it is approached systematically and with some understanding of how it works – even if your museum has its own marketing section.

Three major misconceptions about marketing lead to unease. The first is that it is all about commercial activity, the second that it is selling, and the third that it involves competition. It can be these things to the exclusion of all others but, if it is, it is neither good marketing nor particularly relevant to museums and education.

There is a commercial element in any form of undertaking, for, at the very least, it must be able to pay for itself – otherwise it is a wasted venture. And not just in financial terms. It takes time to sort out a marketing strategy and keep it under review, let alone put the strategy into operation. The time spent must also be worth it.

Beyond that, there is a world of difference between marketing a manufactured product and marketing a service, just as there is a world of difference between marketing a commercial service and an educational one. Most of the basics are the same but application and approach can and do vary.

Remember that marketing is not synonymous with selling. Opportunities to sell your service (whether this is a financial transaction or not) should be the outcome of your marketing. Your service should be such (unique and of high quality) that it sells itself once your market has been made aware of it.

Marketing in the museum context is that process which identifies educational users and analyses what they need of what your resource can supply. It lets teachers know that you have a service to offer. It explains what that service consists of and provides opportunities to find out how good it is. It also allows you to consider ways in which to maximize your income (if you charge) without putting off users.

Is all the effort involved worth it? In the end, only you can answer that – and it is one of the questions you will have to answer, as it is fundamental to any marketing process. Remember, marketing must pay for itself. However, given that you will have to raise awareness of your existence and of the specific services you offer, some degree of marketing will be necessary. If you do not market, you will have no takers. Moreover, it will not be long

before museum management begins to question whether you are worth the space and resources you take up.

Not all marketing is or need be costly or time-consuming. Indeed, a great deal of it lies in the quality and relevance of the service you offer as well as in the way you present both it and yourself. Nevertheless, you still have to make that initial contact with potential users, which should not be seen as a chore but as a marvellous opportunity to exercise control over the development of the services you offer and of the educational groups that use them.

Before attempting any marketing, you must do the necessary preparatory work. The accepted practice is to undertake a SWOT analysis. That is, you need to identify your Strengths (what you are good at and can do for yourself), your Weaknesses (the things you are not good at or in which you have no experience or expertise), your Opportunities (an assessment of the gaps in the market that you can realistically fill), and Threats (anything that could put your services at risk). If you have done the research suggested in Chapter 4, then much of your basic market research will already be complete and you can use the information gathered to assess and understand your market.

Understanding yourself and your market, and then tailoring what you can offer to meet its needs is essential. Without doing this you can advertise your services all you want but you will get no takers. It is a financially prudent market, and teachers will not undertake any extra-mural activity unless it suits their needs exactly. Even if your service is free, teachers still have to find money for transport costs and do a great deal of work to ensure that taking students out of school does not unduly disrupt other elements of their education.

Of course, you should not compromise your integrity as an educator. You can provide for the market and take a lead at the same time. A great deal of innovative education work has been done by museum educators and they are in an excellent position to continue broadening the horizons of students and their teachers alike.

However, that still leaves you with the task of deciding what approaches to take. There are some basic precepts worth bearing in mind. Good marketing means making sure you approach the right person with the right message at the right time. This works on two levels. The first is raising a general awareness of your existence that is intended to whet the appetite and prompt more in-depth enquiries. The second is ensuring that specific information about particular services reaches those who require it. This means that information goes where it is wanted with minimum cost and fuss to you.

You should also stress, in all marketing material, what benefits the teachers and their students will gain by using your services. By all means tell them about what you do and the services you offer, but always give priority to the benefit to student and teacher. Interested as they may be in what you do, what will persuade them is whether what you offer is of use to them.

To achieve this, advertising is a necessity. It is a rare institution that has more educational users than it can cope with simply through word of mouth. It is feasible, given the nature of your customer base, that you could direct mail at all those teachers most likely to use the museum, but unless you have free access to internal mail systems (be they electronic or traditional) and can also produce an advertising shot that will stand out from all the rest, you may be wasting time and money.

All advertising needs to be carefully targeted at those who can influence others and at those who make the decisions. Do not target history teachers; target the heads of history departments and the secretaries of history teachers' organizations. Let them do some of

your work for you – though to do that, they have to be convinced. Once convinced, they can influence many others. Even a mention from such people can elicit enquiries that lead to regular use of your services.

It is good to have a raised awareness of education in museums, but that will not, of itself, sell your specific services. Quite often, it is better to raise general awareness on the back of the success of specific services. If you run a successful schools programme, for example, word of this will spread by a number of avenues. This in turn can lead to further bookings. Unfortunately, it has all the makings of a 'Catch 22' situation. Awareness raised on the back of success can only be achieved if awareness is first raised sufficiently to have allowed you to achieve that success.

This is one reason why marketing a service can be more difficult than marketing a product. The simple fact is that your customer is not sure what they are getting until they have bought it. All promotional material must be sufficiently revealing, perhaps even containing endorsements from teachers, to make it clear what sort of service a teacher can expect. Close and particular attention must be paid to creating and maintaining a strong image of your service.

There are two approaches to image. The first is a form of wish-fulfilment, spinning it out of thin air into a glossy and attractive façade. This is a waste of time and is dishonest. It simply will not stand up to scrutiny, and using this approach will do you great damage. The second is to allow the image to grow out of the work you do and the way you do it. If you are courteous and professional, if you fulfil needs and expectations, always follow up, and always do what you promise, you will soon gain a reputation that does much to sell you.

Even if you allow your image to evolve naturally, you must still nurture it. You must create an environment that will allow the evolution that gives the best rewards without having to compromise your own ideals. This is not an easy balance to strike, but experience will make it easier.

As a service, you work primarily and directly with people. Their impression of you is crucial, especially during your first contact. Trite as it may sound, it is none the less true that you never get a second chance to make a first impression. If teachers come to meet you, the way they are dealt with will sway their judgement. For example, if you have an office and invite teachers in, at least make sure there is a comfortable place for them to sit. If you cannot help but reduce your working space to absolute chaos, meet teachers elsewhere. Make sure your meeting-place is calm. You may be much in demand but while you are with someone, you must give them your undivided attention. Someone else can take urgent messages for you, to be dealt with later. Check that everything you need is easily to hand – diary, booking forms, leaflets, information. Moreover, if you tell someone you will do something, do it! There is nothing worse than promising what you cannot fulfil. If you are uncertain, ask for time to investigate possibilities and get into detailed talks with the teacher concerned. Together you should be able to come up with adjusted and workable ideas.

There are many other such aspects that need to be considered. They all help to create an overall impression – and if that impression is of competence and willingness to engage in solving educational problems to provide useful teaching solutions, then you are marketing yourself and winning custom. None of this costs anything more than a little time, but it is worth a small fortune.

Timing is important in marketing. Speculative material sent to teachers must catch them at the right time of the week, the right time of the term, and the right time of the financial year. It is no use mailing teachers during vacations, as your material accumulates

with other stuff and tends to end up in the bin. If you are offering a regular, year-round service, you still need to make maximum impact when teachers are planning the work that best ties in with what you offer. Nor is it just for the sake of the teacher that you need to consider timing. Popular services may be booked well in advance, filling your own diary. If a service is fully booked for one, two, or even three years in advance, and that is not unknown, it might be time to withdraw any advertising.

Special events (tied, for example, to temporary exhibitions) need to be advertised well enough in advance to fit in with teachers' planning. You must get access to the general museum diary for such events far enough in advance to plan and produce educational material, as well as promote it. It would be wise to negotiate a period of notice within which you will not undertake work. It is not fair of museum management to expect you to produce educational material and promote it at very short notice. It is disruptive of your other work (as you will probably have to put that to one side to complete such material in time and to a proper standard), and there is little guarantee that teachers will be able to fit it into their schedules at short notice.

General awareness of the fact that you are offering educational services can be raised through the media. If you have not already done so, make contact with local newspapers, radio, and television. Get the name of someone who will be your contact and invite them to the museum so that you can explain what you do and show them where you do it. This is very useful if you are new to the post as it makes a good story for local interest. Find out about and always observe your museum's protocols for media coverage and clearing press releases.

Advertising is best done in more specific media such as professional journals, newsletters, and the like. Adverts should be catchy, and contain clear, basic information and a contact address or number for those who want detailed information. It is worth taking professional advice on this.

If the museum has a website, make sure that information about education services is there as well. Keep it regularly updated. Spend some time setting up links with other relevant sites so that traffic is directed to you. Try to avoid using your website (or section thereof) for anything but the provision of basic information and contact details. Your aim is to meet people face to face.

Any item that you loan or sell, as well as all letters, pamphlets and publications, should be branded. An easily identifiable and relevant logo is invaluable, even if you have to pay an expert to design it. The museum may already have a logo that can be used in conjunction with the word 'education'. It is a simple way of asserting your identity while remaining part of the overall picture.

Any mailings, leaflets, or brochures you produce should be concise, informative, and relevant. If you have special requirements of teachers (for example, you will only take bookings from those who have attended your training courses), you must make this clear. You must also make it clear how they go about meeting this or any other requirements you have.

Remember that each leaflet and brochure costs money. Save your follow-up material for people who are genuinely interested. Make sure this sort of material contains details of how to book your services. And no matter how complicated it may be for you, make the process of booking as straightforward as possible for teachers.

No doubt, the museum will have general leaflets, guidebooks and other publications, as well as entries in guides and directories. Make sure that all of them mention that there is a

museum educator on the staff who can provide a variety of educational services. If the museum has had large print runs made without mention of education, produce high-quality flyers that can be inserted.

Get into the habit of writing short pieces and articles detailing your ideas, experiences, calamities, and triumphs. These can be homely in style or they can be academic. Try to get them published. Not all of them will be suitable or acceptable, but it is still worth the effort and provides material for talks and lectures. Your own professional organization will probably have local and national newsletters and journals that will at least want to see material like this. If these journals do not exist, get together with like-minded professionals and start them. They are an excellent source of information, a useful place to exchange ideas and another means of marketing your services.

Word of mouth, already mentioned briefly, should not be denigrated, although it is largely out of your control. If you offer a good service, word will begin to spread that this is so. Equally, your failures will be broadcast in the same manner. It would be a good idea to impress on educational users that if they are satisfied with your service, they should tell others, and that if they are not satisfied they should tell you. However, there is only value in this if you act on what you are told. In some cases, the dissatisfaction will not be any fault of yours. However, there is always room for improvement and you should be willing to listen and then do something about making an improvement. Then let the person whose comment led to it know what you have done.

Aside from word of mouth and providing teachers with the opportunity to observe your education services at work, one of the best methods of marketing is the way you present your services to teachers. That is, make use of *yourself* as your best and most flexible marketing resource. Lectures, presentations, seminars, and training courses to appropriate audiences make a big impact. Not only can you get detailed information across and impress everyone with how accomplished you are; your audience also has the opportunity (and must always be given this) to ask questions of you to clarify anything they do not quite understand or which you may have missed. This face-to-face approach (considered in more detail below) is extremely important.

If the museum has space, offer it to teachers as a venue for meetings (other than those meetings you would already have in the course of your work with them). Not only can you surround them with information about education services and be nearby to answer queries; it also gets them used to thinking of the museum as a place to go.

Small exhibitions in staff rooms with personal appearances at times when teaching staff are present can also work well. This should be extended with a positive campaign of visiting schools, teachers' centres, head teachers' meetings and so on with a portfolio consisting of a static display, a promotional video or multimedia display (if you have the facilities to produce and present one), information packages, and a prepared talk to help explain exactly what the museum education service can offer.

This approach is infinitely more flexible than simply relying on written material. To begin with, you can take things with you. If you have loan materials, workbooks, or other kinds of educational material, you can show them to the staff. You can tell them what your job involves, how the museum can help them, how you cope with visits, the sort of things they can do, and you can answer specific questions on topics and points that simply may not have occurred to you. Most importantly, by visiting the school, you have established a link. The staff of that school now know you; they know with whom they are talking on the telephone. Once you have made this sort of contact you can leave as many bits of paper as

you are asked for, containing basic information about yourself, because you know it is in the hands of those who want it and who are likely to use it for future reference.

If you cannot get out to schools, you can invite teachers to come to you by holding special open days, twilight sessions, or open evenings for teachers. These are best linked to special events such as the opening of a new exhibition or the launch of a new educational service. Provide refreshments and pamper your guests. This is an effective ploy as it means that teachers not only have the advantage of face-to-face contact, but they can also look at the resource you are offering. In addition, they can experience the environment in which they would be working with their students.

Teachers can also be reached through other people. This can be done by talking with head teachers or heads of department, but by far the best way is by getting to know advisory and support teachers and so on. It is their job to be aware of all that is available for teachers to use in the education of students. Moreover, one of the great advantages of this group is that you can concentrate on specialist areas.

In the first instance, you need advisory staff to be aware of what your museum consists in and the sort of educational programmes you can offer. They are on the lookout for this information. But the contact can go further than that because as advisers – forgive such an obvious statement – it is their job to advise. Suitably convinced of your worth, they can advise teachers to use your museum. In addition, they can advise you of a particular need felt by schools that you have the potential to fulfil.

These are just some of the many ploys that are open to you. There is one, however, that you should avoid – competition. Not only are you unlikely ever to be given a marketing budget sufficient to mount that sort of campaign, but also competition is highly destructive. If there are other museums offering education services within your catchment area, it is far better to liaise with them to avoid conflict and use that as a common marketing ploy. Your pooled resources and cooperative approach are likely to strengthen your work.

With all this marketing going on, you should keep two final points in mind. Never advertise a service without having it in place and without the ability to respond to any interest your adverts may provoke. This amounts to keeping any promises you make. Failure to do so is highly damaging to your reputation. And never rest on your laurels. Not only must you constantly upgrade your successes; you should always be looking to develop new services to broaden your appeal. There is no need to be frenetic about this but it is inevitable that the needs of educational user groups will change as time goes by. Look at these needs and make them the centre of your work.

Marketing is a complex business. Once you are well-established and have built up a good reputation, a great deal of your marketing is done for you. However, you have to start somewhere. There are many books available that explore the intricacies of marketing. There are even some that are specifically aimed at museums. The purpose of this part of the chapter has been to show its importance through looking at some of the basics. Marketing, however, is only a part of the story; its aim is to get the ball rolling. Once you have made initial contact with teachers, there is a great deal more to be done.

Liaison and networks

No educational service provided by a museum will survive for very long if there is no dialogue between the provider and the user. There are a number of ways in which museum

educators can forge links with schools and other educational user groups, keep those links going, and develop them for the benefit of all involved. The emphasis in all of them is on forging personal links and bringing together several people in order to spread workloads and increase the level of information flow.

To begin with, it is important to realize that there is a difference between persuading educational user groups to make use of the educational resource that is your museum and creating links with them. The difference between the two in terms of the effort involved is not so very great. The difference in the results, however, can be enormous. Indeed, this difference is likely to determine the failure or success of educational work in a museum. Moreover, the degree of success itself depends on how you maintain those links once they are established. This sounds alarming. But it really is a matter of success or failure. However, the ways of obviating failure and making the success superlative are reasonably straightforward.

Some strategies for attracting the attention of teachers have already been discussed. Try these and others in all their combinations to see which are the most effective, and adjust your overall approach accordingly. Once you have established links with schools and they are making use of you, it might be worth trying to find one teacher in an educational establishment who is willing to act as a liaison with the museum. Then, if you do send out mailings or have information to pass on, it goes to a named individual who you know will make what effort they can to pass that information on to other staff.

Once you have started to make links with educational user groups, you must maintain them. In essence, that means having some form of dialogue with the teachers who use your services. Again, a whole range of strategies can be brought to bear. The most obvious is providing teachers with such a good day out that they will want to come back. Precisely how you do that depends on what sort of resource you are working with.

When a teacher is considering bringing a group, it pays to ask them to be very specific about what they want. Narrowing a teacher's needs down to specifics will ensure that the day goes smoothly, but it is also an excellent way of forging and maintaining links. The flow of information is useful to both sides; it also lets the teacher know that you are interested and care about what they are doing.

The follow-up work an educational user group does should also be of interest to you. If you have time, visit a group after they have visited your museum. If you do not have time, encourage them to write to you or send artwork or a report that you can display. Perhaps if their school has an open evening in the near future you might suggest being there. Personal appearances are good for the educational user group because they can say to their visitors (parents, students, teachers and education managers) that they have a good relationship with the museum. It is good for you because those visitors might decide that your museum is worth a visit.

Even so, a good day out is not enough. To keep those links between educational user groups you must resort to other strategies as well. While the educational user group is with you, spend a few minutes chatting informally with the teachers and other helpers. It might have nothing to do with the visit but it does help to create an atmosphere that is welcoming and establishes the fact that you are approachable. After all, that teacher may have an idea to use your resource in some other way. If they know that you will at least listen, then they will approach you – possibly opening up a completely new area of work.

Another aspect of maintaining links is that you must be organized. Your booking procedure must be foolproof. Times and durations must be kept to, especially if you are juggling

several groups at once. Once an educational user group is booked, make a point of confirming the booking and the details of their visit by letter. Include a leaflet or booklet in which there are maps of how to get to the museum, where to park or where there are drop-off points, where the toilets are, general rules of conduct and so on. Appendix 4 contains a sample booking form, confirmation, conditions, and a sample booking chart.

This attention to detail establishes your competence and your professionalism, as well as showing that you care about those who are visiting you. Within this sort of structure, you must also make the most of opportunities for feedback from teachers. A simple questionnaire, sent with the confirmation and filled in at the end of the visit and left with you, will give you a great deal of basic information. Not everyone will complete a questionnaire, but you will have enough replies to give a good outline picture. Detailed information can be gathered with surveys that are more comprehensive. All of which helps to maintain the links you have established.

Once you have expressed interest in hearing what teachers want, you must be prepared to act on it. This is where the developing of links comes in. At a local level you should consider, through whatever agency is best suited (advisory teachers, professional organizations and the like), setting up working parties of interested teachers who have subject and student age group in common. With you as a facilitator, they can work out how they would like to use your museum and what sort of follow-up material they would need. Having established that, each individual within the party can be given a small task to complete. When the parts are brought together and compiled, you and the teachers have a significant package of material that can be used in conjunction with a visit to the museum without individuals having had to do all the work themselves. By using working parties in this way, you can get much more work done, safe in the knowledge that you are providing a service that is wanted by educational user groups.

The real challenge, however, is to involve teachers whose subjects do not normally lead them to consider a visit to a museum as a viable option. Why not, for example, try to involve mathematics teachers? They may not seem to be obvious candidates for museum work (along with a number of other subject specialists), but most museums have something of mathematical (and other) interest.

As well as producing educational materials relevant to specific sections of the education system, working groups can be a mine of information on other educational topics as well as becoming the hub of an extensive network of contacts. And through them you have further strengthened links between yourself and user groups.

Do not confine these initiatives to teachers. There are other specialists working in the field of complementary education as well as in areas associated with the museum's collections whose skills and expertise could be drawn on to produce and provide materials and programmes for the museum. The trick is to persuade such people (teachers and others alike) that the work they put in will be of benefit to them as well as to you.

From such working parties, it should be possible to build up a database of personnel and groups who would be willing to work with the museum. This could contain craftspeople, re-enactment societies, theatre-in-education groups, puppet theatres and so on. This is an especially useful approach if you are working within a tight budget, have little or no staff and little or no resources. Many people will be willing to help as long as they are approached in the right way and as long as they benefit from the activity.

Your links with groups can also be maintained and developed by making the logistics of their visit simpler. Legislation and policy can vary from place to place. Moreover, teachers

are sometimes so inundated with various rules that they find it difficult to be certain that they are allowed to do certain things. It is up to you to become an expert in this so that you can advise teachers and assure them that their visit and your museum comply with all relevant legislation.

Visiting could also be made smoother if teachers could buy into a package rather than making individual arrangements each time they want to visit. This could mean setting up a club with an annual subscription, to be paid for out of the educational user group's budget at the beginning of the financial year. Joining would give members certain entitlements and make visiting easier. For example, details of each member would be to hand so that the process of booking would be easier. Pre-payment would allow them to bring a certain number of students each year free of charge (perhaps with a reduction for numbers over that limit). This would mean that the process of paying and collecting money was also made less complex. Precisely what entitlements membership brings would be up to you and the circumstances in which you work. If you have a large number of regular visitors, it is certainly worth considering, but will need very careful thought.

There are, however, a number of pitfalls. The whole business of creating and developing links can be time-consuming. It is important, but it is just as important to keep a sense of proportion – otherwise you will end up spending more time on the exercise than it warrants. Differing geographical locations, content and style of museums, and the availability of staff and resources will make some of the above options more or less viable. There are many other options you could also explore. For all that, such approaches are worth repeated consideration because the whole question of your relationship with user groups can sometimes disappear under the sheer pressure of all the other work you have to cope with.

The foregoing concentrates on teachers and presupposes a certain level of resourcing. One of the great problems faced by many museums trying to run an education service is the lack of staff with a specialist education background. Most small museums simply cannot afford that luxury. How, then, can a museum in that position hope to keep abreast of the many and varied developments (legal and otherwise) that continually take place in the world of education, let alone set up a series of relevant programmes? Even specialist staff sometimes have problems keeping up with it all.

As usual, the best thing to do is go to those who do have specialist knowledge. They are likely to be busy people, but in every sector that you need to contact, there will usually be someone whose job it is to act as liaison with other interested groups, or simply to disseminate information. The crucial thing is to tap into these sources of information in the most effective way and ensure that while you are getting information from them, you pass information back about *your* work and concerns, so that your museum begins to figure in other people's thinking.

There are a number of ways in which these contacts can be made, but all of them involve spending a little time meeting and talking and exchanging information. A degree of formality is required, with an agenda (even if this is fairly loose) so that people can come to meetings prepared for discussion about specific issues.

To begin with, make contact with other museums and the members of staff responsible for education. It is highly likely that such networks have already been set up by professional organizations in one form or another. This contact need not be limited to occasional meetings, but can be arranged as a regular round in order to exchange ideas and advice, hold in-service training sessions, coordinate programmes of work and provide a united front on relevant issues. In particular, you should be attempting to identify new developments in

education, considering how these will affect the delivery of education, and working out ways in which museums can best respond.

You should also examine ways of making regular contact with the authorities responsible for providing education. You will need to find an appropriate level for this. Contact with national bodies is useful to gain information, but local bodies are better suited for dialogue. If you can persuade such authorities that museums offering education should be classed as schools, for example, you may be able to get hold of all sorts of material. This is more likely in the case of museums funded by local or national government than it is for private institutions, but even a group of those may be able to exert some pressure in this direction. The importance of this sort of contact is to ensure that you keep abreast of all developments, whether in education or administration.

If there are teacher training institutions in your locale, you will probably already have made contact with lecturers in order to invite students to attend courses of work at the museum. It is worth trying to go beyond an ad hoc system whereby only interested lecturers make use of you and work to persuade the authorities that using museums should become a compulsory element of student teacher education. Not only does this provide you with a steady flow of students; it will also equip whole generations of teachers with the skills needed to make proper use of museums. This is a long-term project and you will have to work very hard to convince the appropriate authorities of the standards of work involved.

Many groups outside of mainstream formal education will make use of the museum and may have organizations and groupings of their own with which it is worth developing links. These include local community groups, professional associations, social institutions, charities, and the like. You may not wish to involve yourself with them full-time but the opportunity to appear occasionally and explain what you can offer, as well as take on board their needs and concerns, is of vital importance if you are to create a role of educator rather than teacher.

You should also look closer to home and make provision for strengthening what links you might have with the museum's management body. They may well take a keen interest in all that goes on, but you should give them the opportunity to learn more from direct experience. An open invitation for them to observe you at work, as well as special sessions in which they can participate in events, could be a revelation – for you and for them. Do not use this to try to lobby for extra money, but simply as an opportunity to explain the work you do and the plans you have for the future.

If you do not already belong to any professional organizations, then you should find out which of these will best suit your needs. Join as many as you can afford, including a professional organization for teachers (if you qualify). These generally have national and local levels of organization and provide a great deal of useful information, as well as arranging networks that offer training, workshops, conferences, legal representation and an effective and united voice to argue in your favour and to lobby relevant groups for better standards and recognition.

As forums for the exchange of information and ideas, all the above have tremendous potential because there is usually a specific person to whom you can go to talk about a specific subject, someone who has their own contacts. This is a matter of plugging yourself into a set of networks and staying plugged in. This does not produce anything spectacular, but the more lines of communication you have and keep open, the better will be your chances of reaching the people you want to reach and getting the information you need.

What is more, these contacts are the means by which information about you and your services reaches those who need and want to know about them. For these reasons, they are

well worth the time required to maintain them. However, they also serve another impor-
tant function. It has already been mentioned that working as a museum educator can be
lonely. Developing these links gives you contact with people on more than just a superficial
level. You have time to build up professional relationships that add a great deal of depth to
your working life, helping to make it a little less daunting.

8 *Educational Provision – The Basics*

There are, as we shall see in the next few chapters, many different forms of educational provision that can be offered by a museum. Because of that, it is of the greatest importance that development of services and programmes of work should be in accordance with a single, sensible, holistic, and comprehensive structure. This is to ensure not only that developments occur in a logical sequence, but also that everything adheres to a set of principles designed to protect the resource while maximizing its educational use.

If you are starting from scratch, you will need to consider very carefully the best ways to proceed – ways that will leave you sufficient time to devote to the heavy developmental work you will need to do over the first few years. Even if you inherit a long-running service, it is by no means certain that it will be perfect. There is always room for improvement and you will be bringing new skills and new perspectives that will inevitably lead to change.

However, if you intend to develop a comprehensive set of services you need to be aware of certain prerequisites – have a good idea of the range of services you might be able to offer and the physical areas in which you wish to offer them; and have some general idea of how the main subject areas of most curricula can be served by the use of museums.

Assessing the resource

Before deciding on what specific forms of provision you wish to make, assess the museum. That will be your starting-point, and whatever you do thereafter must relate to it. You should already have an idea of the museum's collections, what it keeps in store, and the resources available to you both in terms of artefacts and the expertise of other staff members. However, you will need to assess what sort of museum you are working with in both physical terms and in terms of its ethos.

There are many physical forms of museum. You may be working in a well-established and traditional building – a large, stately looking edifice with separate galleries filled with large glass-fronted cases and polished floors. On the other hand it may be an open-air museum whose exhibits are mainly large-scale and with no barrier between them and the visitor. There are many other forms as well – large and small, high-tech and low-tech, formal and informal.

In terms of ethos, there is a large range of attitudes with which to contend. It may be that the museum wishes to present a serious and studious air, which would be at odds with large parties of students wandering around making a great deal of noise. Although you may be aiming to relax such an atmosphere (if that is what you have inherited), you will have to start with that situation. On the other hand, you may have an extremely relaxed museum

and have to contend with user groups that feel uncomfortable with such informality. Whatever the case, remember that a museum is a place of the muses, and learning to work quietly at appropriate times is no bad thing.

Visitors and students learn as much, if not more, from how they are treated and how the museum presents itself than from the content of any programme of work. After all, programmes of work, exhibitions, and the like change from day to day and year to year. The constant is to be found in the way you approach things. Method, therefore, is extremely important.

The way you work in a traditional glass-case museum is likely to be different from the way you work in an open-air environment or any other type of museum. This is not just a matter of personal style and ethos, but also of the constraints (or otherwise) of the environment. Not only is the physical aspect important here, so too are visitor expectations. User groups and other visitors will have preconceived ideas of what behaviours match given environments.

The way in which individual artefacts are displayed also dictates the form and extent of educational work. Displays sealed in cases with little or no context will have little or no relation to other displays or, for that matter, the average visitor. These will require an approach that, in the first instance, concentrates on the artefact alone in order to gather sufficient information to begin building a context for it.

It is becoming increasingly unusual to find this form of display. Things have moved towards the other extreme and in some cases, artefacts have become so over-contextualized that it is difficult to distinguish them from their background. Such displays may be socio-ecologically sound, but they require students to work from a very different perspective to make sense of what they see, beginning with a context and then working toward the ways in which single items might relate to it.

Either way of presenting artefacts can be as baffling to the student (and teacher) as the other. Very often, however, it is the non-contextualized items that are ignored by teachers – they are perceived as hard work and perhaps a little politically incorrect. The very fact that they are isolated gives the impression that some statement about their worth is being made. Whether that is so or not, it is one of the many factors to consider when drawing up educational materials and programmes of work.

You will also need to bear in mind very basic factors of display that are often forgotten about. That is, can students see the artefacts? Most displays are designed by able-bodied adults for able-bodied adults. This is changing, and new displays are usually much better designed, but the majority of museum displays are not new or even recent. When looking at a display, go down on your knees and look at it from a child's height. See how much that changes the perspective, blocks items from view, and alters the lighting.

Another factor you will have to take into account is the fact that objects are often presented with accompanying text. You will have to work with this, rather than against it. Artefacts are often presented with text that offers closed statements rather than more open, questioning statements. This can stifle curiosity and focuses attention on the text rather than the artefact. If the text is particularly bad, you should perhaps try to persuade curatorial staff to make changes. The question of appropriate language is discussed in Chapter 9, but no matter how good your own use of the written and spoken word, you must remain conscious of its use elsewhere in the museum.

Museums are places for non-rational and intuitive as well as logical and analytical approaches. Each informs the other. Museums have a responsibility to help people acquire

the skills to read such distinctive sites as museums, as well as the artefacts they contain. Perception, feeling, and imagination should be fostered just as much as analysis, critical evaluation, and communication. Thinking historically and aesthetically should be encouraged just as much as thinking scientifically. Museums should work to develop these complementary skills in their visitors; in addition, the development of skills should be given precedence over the acquisition of facts. We all know too much. We feel too little. We understand even less.

One of the great lessons to be learned from artefacts is that we can appreciate them without the need to verbalize. It is possible to interact with them on a personal and emotional level. We can understand them by meditating on them and being content with that experience. The experience must be verbalized if it is to be shaped for sharing, but that need not be a prime target of any work, any more than it needs to be the product. After all, one of the journeys we make in a museum is from material culture to non-material culture and a deeper understanding of ourselves, others, and the world in which we live.

Working space

In order to put educational programmes into practise, you will need space. This does not mean a dank room no one else wants where children can hang their coats and eat their lunch. It means a properly devised strategy that makes best educational use of all available space within the museum. This is especially important in small museums where there is no spare capacity to set aside a room or section of a gallery specifically for educational use.

Many museums have either no dedicated education space or areas that are wholly inadequate. They are often too small, ill-equipped, and poorly located – all of which reflect the importance accorded education by management. In older buildings the problem is historical, resulting from the fact that education was not originally designed into the system. In new or recently refurbished buildings, there is no excuse.

Whatever the case may be, you have to assess all available space. Your first task then is to make the best use of what you have, even if this means using tactics such as timing visits to start before the doors open to the rest of the public. Your second task is to draw up an ideal scenario so that if the situation ever arises, your case is ready made and incorporated into your secondary policy document. This should include a brief statement about the material and non-material value of an education space to museum users and the museum.

In making your case, either for present or future development, you will need to make a careful assessment and consider a number of aspects. To begin with, an education space must be presented as the focus of education work that must take place throughout the museum. It cannot be used as an excuse for keeping education groups out of the way. The space must be flexible. It will be used by all ages for a wide variety of activities and has to be able to accommodate six-year-olds doing artwork as readily and as comfortably as it does senior citizens listening to a talk.

Access is also important. Ideally, large groups should be able to reach an education space without having to traipse through the whole of the museum first. At the same time, it should have direct access to the exhibition space, toilets, shops, and other facilities. Access should not be disabling. Avoid stairs, narrow corridors and doors, and complicated routes to and from other parts of the museum. Issues of access also need to consider security (belongings must be protected) and safety, especially where children are concerned. Adults not

associated with school groups may need to be segregated – and would probably feel happier that this is so, especially if they are undertaking research.

Fittings and fixtures are equally important. It is no use having an ideal space if it is badly equipped. Visit other museum education spaces as well as schools, and similar venues. Talk with the people who use them and find out what does and does not work. Aim to get the basics right, even if it means spending more and waiting a bit longer for the extras. Quality flooring, easily maintained sinks, robust storage, plenty of hanging space for coats and bags, and comfortable chairs are essential.

Of course, all this pre-supposes that you have a choice and some spending power. If you do not, there are still many things that you can do to improve the situation through tidying, re-arranging furniture, and buying some tins of emulsion paint. Sometimes, though, you will find yourself confronted with a golden opportunity when the museum decides it is time for (and can afford) a major refurbishment.

If this happens it is vital that you are part of the decision-making process. This cannot be emphasized enough. You are the expert in this field and may well be responsible for a sizeable proportion of visitor numbers. You cannot be expected to accept major changes to the physical structure of the museum without having input into the design and allocation of space. Having ensured you have an input, you must live up to it. The brief you present to the architects and developers must be comprehensive, but you must be prepared to compromise as there will be many other demands to be met. Make sure you have a set of minimum requirements over which you will not give way. If you show commitment to the process and are willing to listen to the designers, they will be willing to listen to you.

After all that, be it two coats of paint on the store cupboard wall or a brand new museum with a state-of-the-art education centre, you need strategies for its management and integration with the rest of the museum. Simple things such as user group flow, along with strategies for keeping the area tidy (and thus easier to clean) are as important as the initial planning.

Why groups visit

As well as assessing the working environment of the museum, you will need to consider why it is visited by educational user groups. The primary answer (which is all too often overlooked or denigrated) is that they do so because specific demands of the curriculum or course they are following are best fulfilled by working in the museum. However, there is a great deal more to museum work than the acquisition of knowledge (which is a tertiary function of education), as we have already discussed. There is the acquisition of educational skills – learning how to learn (a secondary function of education). There is the primary function, which is to equip students with the basic skills such as literacy and numeracy needed to achieve the other functions. And there is the opportunity to introduce and explore wider social skills and issues.

In addition, there are a number of other reasons, perhaps subordinate to these, but perfectly valid in their own right. Amongst these are that museums allow students to break away from working with text-based information and to see that there is a wealth of material culture for study from many different temporal and geographical locations. Museums also present the opportunity to get away from the standard curriculum and explore the vast world beyond, enriching the understanding of what must be studied as well as showing that there is a great deal more.

Students come to museums to be shown the real thing. The psychological impact of proximity to or contact with genuine artefacts reaches deep and cannot be reproduced using text or pictures. This impact is achieved through a better appreciation of an artefact's scale, shape, texture, colour, even odour. There is also a less tangible quality to such items that is extremely potent, especially if they can be handled. This is their human connection – the fact that a student can handle and examine an artefact that was made and used by a real person hundreds, thousands, or even hundreds of thousands of years ago. It is a connection that can be made intellectually without too much difficulty or too much impact. However, once it is made emotionally, work with artefacts and collections takes on a completely new dimension.

Students can use museums to test hypotheses that they are studying or have formulated themselves. Despite the abundance of physical material to work with, many academic studies (be they made by young children or by university professors) rarely bother to check whether what they speculate upon is supported by the physical evidence. Quite often erroneous assumptions are promulgated and perpetuated when a little practical exercise would show them to be false. Controversial and disregarded statements might be given the irrefutable support they need by the same method.

As well as testing hypotheses, students will want to study artefacts in order to come to some sort of understanding about certain processes. The most common are those of manufacture, changes in style due to social pressures, wear and tear from use, what happens to things once they are lost or discarded and, of course, the processes involved in finding, conserving, storing, and displaying artefacts in a museum. Work with material culture also aids in the development of concepts such as chronology, change, continuity, progress and value as well as the whole idea of non-material culture.

In addition to these more pragmatic reasons, there are others that are sometimes given lip-service, but which deserve genuine commitment. They are of great importance in an increasingly material world – aesthetic appreciation, philosophical practice, the chance to muse, meditate, and speculate on the non-material imperatives that give rise to various forms of material culture. Students rarely have time for this sort of activity in overcrowded curricula, yet it is extremely important to personal and social development. Museums can create a space for this, alongside other demands.

There are other reasons why students come to museums, but most of them will fall into these broad categories. These, therefore, play an important part in the process of producing materials and programmes for students to work with.

Basic approaches

With such considerations in mind, it then becomes important to decide how the materials and programmes of work are to be delivered. Presentation and style is a very personal matter and we are not concerned with that here. The concern is much more basic. When you produce, for example, an information pack on a particular collection, you have to know at the outset who its audience will be – the student or the teacher. In either case, it must contain material relevant to the students being taught. An information pack for undergraduates is of no use to six-year-olds. An information pack for the teacher of undergraduates might be usable by the teacher of six-year-olds but would be unlikely to contain enough of the sort of material they would want to use.

Therefore, to begin with, you must decide whether materials and programmes are to be directed at the teacher or the student. You need to consider whether they are to be designed to be transmitted to students by you (through direct teaching in the museum); by their teachers (by providing them with training and resource materials to construct their own programmes and so on); or whether you wish to provide materials that students can use largely unsupported (workbooks and the like).

In reality, what you will opt for is likely to be a mix of these things, but it should not be a muddle. Decide very clearly for each project you undertake precisely who it is aimed at and who is to lead it. It is all right if it contains various elements, as long as each element is clearly defined in its approach, its audience, and its method.

You then need to recognize that within each of these forms of provision, there are different levels of complexity and approach depending on the user groups aimed at and any specific courses or curricula they may be following. For each of these variations there are many services and types of material that can be offered. These, as we have noted, depend on a number of variants, including the size of the museum, the nature of its collections, resources available for the education service, and so on. The number of permutations is enormous and might leave you wondering where to begin and how you will find the time to do it all.

The best way forward when faced with such an apparently overwhelming mass of work is, of course, to set priorities. In this case, it is best to consider generally the forms of provision and the individual programmes you wish to make available in terms of the amount of time they are likely to require from you once they are up and running. It is then a matter of beginning with those that will, when running, involve you least. This means that while you have services to offer, you still have plenty of time to develop more.

This management of time works on three levels of involvement. The first level relates to visits to museums by educational user groups that have minimal input from the museum educator. This does not mean that such groups are completely on their own. You can provide them with a whole range of information from very basic details such as opening times, layout of the museum and so on to very sophisticated packages of resource material. The important thing is that once the resource material has been produced, you are free to continue developing more.

Once you have built up a good selection of resource materials, it will be possible to consider moving to the second level. This involves some direct contact with visiting educational user groups, but which is restricted to orientation, giving introductory talks, or leading introductory sessions on given topics and then leaving the groups to their own devices for the rest of their time on site. Teachers, therefore, will have to provide much of the input for the visit. This may require a back-up programme of preliminary visits and will doubtless require a great deal of resource material. Whilst this still leaves you free to pursue the many other duties you have, it gives you the opportunity to work directly with students and thus directly assess the worth of the material you are providing.

The third level involves a great deal of direct teaching work with students. This can only be achieved where there is a sufficient quantity of resource material already in place or sufficient education staff to implement this level of involvement. In many ways, it is extremely satisfying for museum educators to be directly involved with all the education work that goes on in the museum. It is, however, extremely time-consuming and it can give the impression that museum teaching is the be-all and end-all of museum education work.

It may be best to confine this level of involvement to groups from which there will be a good return – with courses for student and practising teachers a priority.

In any event, the first level needs to be established first, and working successfully, before the second and then the third levels can be introduced. All of this requires tight administrative control, a foolproof booking system, and a great deal of cooperation from teachers, especially if some user groups are working at the first level and others at the third on the same day. It would certainly be necessary to provide a great deal of comprehensive resource material to support this system so that it works properly.

This depends on your situation. If you are working in a small museum with other calls on your time, educational activity may have to remain at the first level. Always make sure you do not involve yourself so much in one project that you have no time to develop others. Finally, try to avoid programmes of work that will leave you open to constant repetition (no matter how many subtle variations are introduced by different groups). It is extremely easy to become fatigued, lose interest, and convey your boredom to those you work with.

Some basic rules

It is worth adopting some basic principles by which to work. You can use those suggested below or adapt them to suit your specific needs. They may well be worth incorporating into a policy document under the heading 'Principles of development' so that they are recognized as fundamental to your work.

1 No educational development of a resource should threaten its integrity or existence. There is little point in degrading, damaging, or destroying that which represents your capital. Once the capital is gone, you have nothing to develop, nothing with which to teach. This is as true of museums as it is, for example, of forests. The prime concern, therefore, must be with the protection of that resource.

2 No educational development of a resource should be made for the sake of mere development. There already exists a strong and genuine need for development of and access to the educational potential of museums. It is this genuine need that should be sought out and used to guide development.

3 All educational development should act to instil in teachers and students an appropriate reverence for the resource, the requisite skills for using the resource to its fullest extent, and the confidence to do so. It is no use offering access to the resource unless teachers, students and other visitors are first taught how to use it correctly. This is the museum's safeguard that their resource will not be damaged, while ensuring that all visitors gain maximum benefit from its use.

4 Education is a condition of human existence. It does not take place only in formal, guided sessions. Therefore, every aspect of a visit to a museum has educational potential – from finding the building to the visit to the souvenir shop before leaving. In that case, every aspect of a visit should be given careful scrutiny to ensure that where educational potential exists, it is fully realized in accordance with genuine need.

5 The educational development of the resource should not be done in an aggressive or competitive manner. At all times there should be maintained an environment of highly informed dedication with an atmosphere of openness. Learned reserve and the maintenance of a mystique is what keeps people away from museums. The intention must be to

draw visitors and students in, make them feel comfortable, and send them away feeling enhanced by their visit. This will enable interest to bud or, where interest already exists, to bloom. A visitor or student should always leave a museum with the feeling that they want to return and, just as important, that they will be welcome to do so.

6 Whatever form of provision you decide to develop, it must have relevance to visitors, teachers and students, and it must avoid replicating anything they can do in their normal environment. That is, use what is unique about your resource and present it in a unique way. If the work can be done in school, then that is where teachers will opt to do it. Museums are not three-dimensional textbooks. What you offer must complement what is done in schools. One of the most important things you can teach is how to look at objects in a sustained and useful way, 'reading' what you can from them, rather than just glancing at them and then getting all the answers from a piece of text (be it museum label or school textbook).

7 Make all programmes of work enjoyable. This works at two levels. On the surface, all work should be interactive and engaging – challenging both physical and mental attributes. However, this must be combined with activities that aim to ensure that those who engage in them learn or acquire something new. A new fact. A new skill. A new understanding. It does not matter how small these might be, as long as they have meaning and relevance to the individual. If a visitor or student has such an experience, they leave the museum with a sense of achievement and that, for some, can have a profound affect on their lives.

9 *Information and Indirect Services*

From basic principles, we now move on to look at the major forms of service that a museum educator can provide. These fall into three main categories: information, indirect services, and direct services. Although these are categorized and discussed as distinct forms, in reality they often combine and are certainly interdependent. Information and indirect services will be dealt with below. Direct services are discussed in Chapter 10.

Information

In many cases, the giving of information will be the first moment of contact between yourself and any potential educational user. It is essential, therefore, that this is well organized, clear, and with any follow-up taking place as quickly as possible.

In the first instance, information required of you will usually relate to the logistics of educational visits. Teachers and other group leaders will want to know what services and facilities are available, costs, booking procedures, and the like. All this information can be included on the education section of the museum's website (if it has one) along with your contact details. Do not assume that having this information on a website is enough. Not everybody has access to the Internet or the desire to use it.

Compile all this logistical information into a booklet or loose-leaf folder that can be used in-house. Keep the master file for your own reference and give copies to anyone likely to deal with enquiries when you are not available. Whoever gives out information should take the name and contact details of the enquirer so that you can follow up, either with printed material or with a return call.

It is imperative that all information is readily to hand and that it is kept up to date (which goes for your website as well). Where printed matter is concerned, it will be cheaper if you provide a general leaflet outlining all your services and separate, more detailed leaflets with information about each of the services you have on offer.

You will also be kept busy providing information on artefacts, collections, archives and other aspects of the museum to students and teachers. Many of these will be one-off requests for snippets of information to resolve specific problems. However, there will be other questions that become frequent, prompted by the needs of a particular course or curriculum. With these you will need to research the scope of information required and compile an appropriate resource pack (if it is for teachers) or project pack (if it is for students). See pages 93 and 94 below for details of these. Copies of this material can then be kept to hand for use in-house or for distribution to those who require them.

You will probably be consulted on various matters by other groups and individuals as well, especially if you establish a successful education service. Teachers may well require information that will allow them to integrate any visits they make with the work they are doing with students. Other museums may wish to work in concert with you over a number of matters and may even want your advice on how to set up and run education programmes of their own. These will have to be dealt with on an ad hoc basis, as it is impossible to anticipate what the queries might be. However, patterns will emerge (just as they will with enquiries from students and teachers), and it should be possible to prepare material for the most frequently asked questions and rewrite existing leaflets and information booklets to take account of them.

You may also be called upon to provide information about museum education in general, as well as the educational role of museums and the place of museums in society. This sort of information will be less frequently called for. However, when it is, it will need to be of a high level of sophistication and convincingly argued as it will sometimes be required by those who (a) hold the purse strings, (b) make policy and (c) are influential in society.

Finally, you will be providing information for the media. Primarily this will be information about the educational activities that go on at the museum as well as all the outreach services that you provide. However, you may also have a broader remit to publicize the museum in general terms. Here, rather than reacting to requests and making sure you keep the information to hand, you are acting to promote the museum and its activities. Talk to journalists to find out what sort of information they prefer and how best they like it presented.

Indirect services

Indirect services are best defined as those in which you use some intermediary to provide them. In reality, this usually means printed material although there are a number of other ways of presenting services indirectly. Several of these come under the general term of 'outreach' and will be dealt with in detail in Chapters 11 and 12. Those that are used in-house fall within three areas.

OVERALL EDUCATIONAL INPUT

First, there is the general input you make as an education specialist to the design and construction of displays and exhibitions. In this, you also act as liaison between the museum and its educational users who may have a number of ideas of their own about what they would like to see done. Exhibitions and displays do not change very often. It is an expensive business. It is vital, therefore, that when such a change is planned, you have as much say in the process as possible.

If you work within an enlightened regime, you will be included automatically in decision-making. If not, you may have to argue the case. Do not wait until you hear of impending changes. Ascertain the position when you first arrive and make your case for inclusion as soon as possible.

If your input is included from the earliest stages, education becomes part of any design brief. The impact you make in terms of cost will be minimal. The impact you make in edu-

cational terms could be immense. However, this is not a one-way street. You are not there to dictate, but to cooperate. Careful study and understanding of design techniques, along with all the other disciplines that are brought to bear, will assist you in the production of better programmes of educational work.

The general layout of an exhibition, if correctly planned, should make it easier to follow certain themes and concepts. It should also make it easier to do gallery work with groups without impeding the general flow of other visitors. Colour coding and a number of other devices can be employed, with individual artefacts made visually accessible to children as well as adults and to disabled people as well as the able-bodied.

High levels of interactivity are also desirable. This does not imply expensive, computerized machinery. Whilst there is no doubt that the judicious use of technology can enhance the museum experience for visitors, there are drawbacks that have to be taken into account. Computers and associated hardware, along with the software required to run them, are expensive to buy. Such systems will come in for heavy use and will require frequent maintenance and replacement. The software may have to be specially written and will require debugging and upgrading. This method of providing information is inflexible and delimiting – set answers to questions set by the museum. The computer technology often becomes the focus of attention, rather than the museum and its artefacts. Finally, if the technology is a key component in the distribution of information and then breaks down, you are in serious trouble.

Expensive high-tech solutions are not necessary. Much can be done through design to involve the visitor more with the artefact or the collection. Much, too, can be done with text. All the text used – be it information panels, labels, leaflets, guidebooks and so on – needs to be considered carefully (see the general notes on language in the section on written material, page 90). Finally, any events that are to take place in concert with exhibitions (whether new or existing ones) should also come under the scrutiny of the education specialist to maximize their educational appeal and their use to educational user groups both at the time of display and later as possible travelling mini-exhibitions for outreach work.

Your input does not guarantee success. Some designers (even in-house museum specialists) are notorious for ignoring the specific needs of clients in favour of their grand concepts. However, the opportunity to influence decisions must not be missed. When things are done correctly it does much to enhance the museum as a place of education.

Not all museums will present the opportunity to influence design. This is especially so where there is no money to upgrade or create exhibitions. Yet there is still a great deal that can be done with simple and inexpensive changes. Colour coding, for example, can allow a number of themed trails to be created through the museum that cut across the pre-set displays. In a museum that has galleries devoted to specific periods, it would be possible to pick out domestic implements, tools, materials or any other such category and colour-code the labels so that students can work through the entire museum following a chosen theme. Used carefully, this device makes it possible to present a number of concepts without the need to mount new or special displays.

AUDIO-VISUAL DISPLAYS

Audio-visual displays and audio-visual material also come under the heading of indirect educational services. As with exhibitions and displays, audio-visual presentations are not the sole preserve of the museum educator, but the opportunity should be taken to influence

any new ventures. For some, mention of an audio-visual display conjures up images (if not memories) of clanking projectors, dirty slides, breaking sound tapes, and constant problems with synchronization. Thankfully, technology in this area has moved forward rapidly. These days, every home computer can produce an audio-visual display of some sophistication with a great deal of ease. Specialist editing software coupled with digital photography (still and video) and audio allow for the relatively rapid production or alteration of audio-visual displays.

Two forms of audio-visual display are found in museums. First are those that are integrated with exhibitions and which are usually specific to certain items or concepts. The second form is the showing of material, usually in a room or space of its own, to provide background and contextual information about whole collections. Always seek to have input into the design and content of new displays. If you have the time and aptitude, try to familiarize yourself with the technology and software used to produce them.

WRITTEN MATERIAL

By far the most abundant form of indirect educational service is the production of written material and associated media. Now that desktop publishing is commonplace, publications are far easier to produce. You have control over most of the process and with simpler products you can probably do it all yourself. However, you will still need to work to an extremely high standard and be aware of what happens during any process, like printing, that is done by others. The other advantage of using desktop publishing is that it gives you a great deal of flexibility. If print runs of material are relatively small, it is possible to keep material up to date.

The big advantage of written material is that once it has been produced it can meet a large and constant demand for information without any further call on your time. It is therefore a prudent move to concentrate, for a while, on producing a good selection of materials to which you can refer when you feel ready to develop other forms of service.

The most important aspect of any material you produce, no matter at whom it is aimed, is the use of language. This applies not only to any written material produced for teachers and students, but should also include a review of all information panels and text associated with displays as well as guidebooks and other general publications. If museum text and other visitor information could be improved upon, discuss this with curatorial staff. If the museum fails at this level, it will be losing a large number of repeat visitors.

Museum text is not an add-on, but an integral part of an exhibition and should be worded and presented accordingly. Most museums are conscious of this and make every effort to improve text as displays and exhibitions are updated. Make sure you are involved in this, as you can advise on a number of issues. Language and educational content are important, but so too is the overall design. Panels of text do not have to look like enlarged pages of a book pasted to the wall.

The relation of text to artefacts also has to be considered. Text must supplement the artefact or collection rather than using them as illustrations for a piece of writing aimed at a postgraduate level of understanding. There is growing evidence that traditional labels of more than 150–200 words are seldom read. Longer and more complex text is better saved for guidebooks and other supplementary publications.

Remember that you are writing as a stimulus. You want visitors and students to study the artefact or collection, not the text. They should come away with a better understanding

of what they have seen because any text they have read has helped them to look more closely and explore for themselves. Everything should be related to the artefacts and collections as directly as possible.

Remember, also, that you are writing for an audience that is on its feet and exploring, not one that is sitting in a comfortable chair with all the normal reference texts to hand. Therefore, any text must be brief and not require students to refer to anything else except the artefacts and collections they have come to see and work with.

Try to avoid using a formal, impersonal, academic style. This does not mean 'dumbing down', just that language should be as simple and as straightforward as possible. Use familiar words and concepts without being too simple or patronizing. At the same time, whatever you write has to last (unless you want to update every year). To that end, you must try to be timeless. There is nothing worse than a reference to some popular figure, icon, or idea that has gone out of fashion and been largely forgotten. Not only does it show that your text is outdated, but it may also mean that you become involved in explaining your references when you should be working with the artefacts and collections.

Vocabulary is extremely important. Do not use technical terms where you can avoid them. If you do use them, define them as simply as possible. If a text is overloaded with technical terms, even if they are all defined, it becomes turgid. On the other hand, one of the long-term objectives of museum education should be to make such terms more familiar. Understanding them increases understanding of the workings of museums themselves; they act as a shorthand, bringing great swathes of knowledge to bear in an instant. However, the mission to educate about museological terms and the processes behind them should be kept separate from text about specific artefacts. The workings of the museum would make an interesting exhibition around which educational programmes could be based.

Avoid long sentences and complex constructions that include subordinate clauses. This, however, has to be balanced with language sufficiently interesting to achieve its purpose. This is not a particularly easy balance to keep. Test the text on a number of audiences and take their comments into account before settling on a final version.

Do not include too many abstract concepts but, at the same time, do not shy away from communicating ideas and asking open questions. You are trying to educate and this cannot be done without guiding people into unfamiliar territory and encouraging them to explore it once they are there. As a rule of thumb, restrict one idea to a sentence and one subject to a paragraph.

Limit the use of evaluative language and closed statements. They have their place, but can be misleading. Where there is uncertainty over facts or controversy over ideas, make a feature of it in order to provoke thought and discussion.

Study newspaper articles for a useful format, especially in the case of museum text. They begin with a headline, which has the dual task of catching attention and letting the reader know immediately what is contained in the following text. The first paragraph gives an outline of the whole story. This is then followed by paragraphs that tell the story in detail. Progressively smaller print size points this up and allows people to choose how much detail they want.

The newspaper format is not the only way of presenting information, but it has worked successfully for newspapers for a long time. Remember that you should not overload a piece of text with too much information. Go for the key points, state them clearly, and then reinforce them. These will be remembered. Further information can be gleaned from other sources when it is more convenient for students to do so. While they are in the museum,

they should be using the artefacts and collections. References can be given at the end of a session or passed to the teacher who can then make sure that they are available for their students. If you refer constantly to books and other media, make sure they are available for sale in the museum shop.

There are several different basic formats of written material that you should consider. In all cases, everything you produce should be dated. This is especially relevant to material containing reference to temporary exhibitions or information about the content, times and prices of any services. However, as a general policy it makes sense to keep people informed about when materials were produced.

Establish a house style for all educational materials that makes their source and the connection between them apparent without restricting you to particular paper sizes or formats. An easily identifiable logo that is as effective small as it is large is a useful asset. The museum may already have one. Assess and rewrite any existing materials to bring them in line with educational developments.

LEAFLETS AND PUBLICITY MATERIAL

Leaflets, posters, booklets, and the like all come under the heading of publicity material and general information about education services. A leaflet, A4 folded in thirds, is a well-tried and successful format. They stack easily, can provide a series of spaces for different forms of information, and fit readily into a DL size envelope. Design of leaflets is important. The front cover should be attractive and identify where it comes from and what it contains. This still leaves nearly two sides of A4 to provide other information. Do not try to cram too much into the space. It is far better to give basic information and refer to further leaflets and booklets.

If you have a limited budget to spend on professional print design, it should be spent on this material. Teachers are often inundated with publicity and marketing material and unless it is eye-catching, it will suffer the fate of most – the waste bin. It is far better to use your money to catch their interest. Once that is done, the quality of your follow-up will keep the interest alive.

NEWSLETTERS

Newsletters are also a useful way of providing up-to-date information on the educational services and activities of the museum. They also offer the opportunity to reach a wider audience than information leaflets, using a more relaxed and personal style. If the museum has its own newsletter, an education page or supplement may be the answer, giving you the opportunity to explain the work of a museum educator and talk about the specific services you offer. However, be careful. If you institute a newsletter, it must be regular. This ties you to a deadline. This in itself is not a bad thing, but it is an extra commitment, especially if you are responsible not just for the writing but for the full production process.

BIBLIOGRAPHIES

One of the problems faced by teachers is finding quality material for reference and research. In your work, you will doubtless come across a large number of publications relating to the museum and its contents. Compiling critical bibliographies of these publications is a service

for which many teachers would be grateful. This may mean a degree of initial research, but that would be a useful project for you as well and would be an excellent way to establish links with your local library services.

GALLERY NOTES

Everyone is familiar with museum guidebooks, and knows that the majority of them are written for adult visitors of quite a high level of education. They are often produced with very high print runs to keep production costs as low as possible and some of them have not dated well.

Part of the problem is that many museums have small budgets and try to make such guides do too many things. From an educational point of view, wanting people to engage with the artefacts rather than the written word, written guides should contain no more than is necessary to ensure that visitors know where everything is.

Sufficient information about artefacts to stimulate interest in them can be supplied in museum text and labelling. If visitors want detailed information, then booklets and books can be made available in a shop that visitors come to at the end of their visit. This is just as true for teachers, who should always be encouraged to visit the museum before they bring students. Their preliminary visit should allow them the chance to explore the museum and come to know the physical space and its contents. Any text-based experience they might be looking for should be there at the end.

Gallery notes containing detailed information on the contents of galleries and exhibitions should concentrate on those artefacts. Aim at producing a series that covers the entire museum. These, along with other basic forms of information, should also be provided in a number of languages. Not only are visitors likely to be from many different parts of the world, but educational user groups may also be from abroad – not to mention local students who are studying foreign languages. This material will also be of use to teachers who teach languages and they may even be induced to help produce translations. It would be easy enough to find out which languages are most common and start with those.

TEACHERS' PACKS (RESOURCE PACKS)

Teachers' resource packs are related to the permanent exhibitions, education collections (for example, handling collections), and loan materials. However, they have a broader approach than gallery notes so that teachers can use them for general teaching as well as for preparatory and follow-up work on museum visits.

These packs can be produced in various formats, but A4 loose-leaf is the most useful and flexible. This material can be produced and sold a sheet at a time if necessary, so that you do not have the extra costs associated with binding the material. Sheets can be kept together in ring binders and added to without the need to reproduce material that is still valid. They fit readily on to photocopiers and computer scanners.

The loose-leaf format is very attractive to teachers. If a museum produces work packs, or any sort of resource material that is too fixed or contains large amounts of irrelevant material, then teachers will be less interested in buying and using it. This is partly because it does not and cannot meet their particular needs. However, it is also because it becomes like any other resource book. Teachers, like the rest of us, have to be careful about how they spend their money. If they come across a resource that is flexible, full of information and

illustrations, which can be organized as they want and to which they can add other material, they are more likely to buy it. This is especially so if they can follow up with visits to the place where the material was produced, talk with the person who produced it, and make use of the resource on which it is based. The best way to ensure that you produce what teachers want is to involve them in its production. The mechanics of this has been discussed and the advantages are obvious, especially if teachers at all levels of education are involved and the finished product is, wherever possible, free of copyright.

Always include illustrations where relevant. The younger the student, the more illustrations (although older students appreciate them as well). Make sure they are of good quality. If photographs are used, make sure that the reproductions of them are clear. If the illustrations are hand-drawn, try to use a professional artist. Excellent text can be made to look poor if the accompanying illustrations (which attract the eye first) are of poor quality. Teachers also like plenty of illustrations that they can copy and use in their teaching. All illustrations should be accompanied by a scale, so that the true size of the artefact is readily apparent.

The actual content of the resource packs will depend on the content of a museum's collections and the subjects that are being taught by teachers. These need not be tightly restricted to subject areas but can take a thematic approach and include a number of different subjects. For example, museums with extensive historical collections covering a lengthy time-span might produce a series of packs on life in the local area during a given historical period, looking at domestic life, politics, clothing, food, technology, leisure, work, and so on.

Topics related to museums can be looked at as well. One of the most obvious of these is archaeology. An understanding of the principles of archaeology is helpful in understanding artefacts when they are being studied (why some survive and others do not, how they are found, recorded, cleaned, interpreted, and so on). This also relates to an understanding of the archaeology of the area local to the museum. If the museum contains geological or natural history materials, these too can be looked at in similar fashion. The range is limited only by the imagination of the museum educator and the teachers who become involved.

STUDENTS' PACKS (PROJECT PACKS)

Project packs for students have much in common with resource packs for teachers. Like resource packs, they can be compiled with the aid of teachers, who can indicate the sort of material they believe should be included. This should be, primarily, material drawn from the museum resource and clearly replicated.

One of the best features about project packs is that they present an opportunity for students to make use of primary source material in a controlled way. You can easily include replicated copies of documentary material, references to artefacts in the museum, and references to books to be found in local libraries. Illustrations and text derived from a number of other sources can also be included with appropriate permissions. At no time should you attempt to produce a textbook. The aim is to provide access to primary material without the need to go through lengthy search procedures. It also protects a resource that is in demand from degradation through overuse.

Students are provided with the opportunity to work with source material, assess it, and extract information from it that is relevant to their work. As with all other such material, it should be of high quality. There is a case for such packs being kept within the museum so that students get used to working in a particular environment. However, excessive demand

may mean that such packs need to be reproduced in quantity so that they become available for schools to use.

For older students who have experience of working with primary material that is fragile, you can still set up resource packs which have to be used in the museum and which contain the genuine article. This could be seen as a next step in training students to make use of the full resource and undertake their own search and research programmes.

ACTIVITY PACKS

Museum-produced activity packs, containing information and instructions for a whole host of activities to be pursued by students, can be produced for formal education groups. However, they have many drawbacks in that situation. Foremost amongst these is that their target audience is narrow and a whole series of such packs would need to be produced to suit all age and ability groups. It is far better to work in concert with teachers of formal and non-formal groups, providing them with the resources they need to produce their own material. This will then be targeted at the correct age and ability group, and even more narrowly tailored to the particular group that the teacher is working with.

Any activity pack and programme that you devise should be aimed at informal group-ings, especially family groups. Activities can also be built into exhibitions. Such packs should aim to put fun to the fore (although all activity within the museum should be enjoy-able) and should contain work that family groups can do together. This is difficult to achieve, especially as it will be necessary to produce new material of this nature on a regular basis.

At a very simple level, an activity pack may consist of colouring books filled with line drawings of artefacts on display. There can be word searches that require those doing them to have looked at artefacts closely, and crosswords that require the same. Further activities can be included that allow visitors to interact with exhibitions. These will need to have clear and simple instructions so that time is spent doing rather than trying to understand how to do.

WORKSHEETS

Although worksheets come within the general category of activity packs, they are consid-ered separately here, as they are controversial. Some people think they are wonderful. Others believe that they destroy the purpose of visiting museums and should never be used. They are certainly problematical simply because they are extremely difficult to devise well. To be successful they often require more time spent on them than they are worth. Unless you have the time and the skill, they should be avoided.

There are logistical problems associated with the use of worksheets. Younger students may be unused to working with clipboards and find the process unduly clumsy and stress-ful. Giving the same sheet to a large group means a travelling bottleneck that inconven-iences other visitors as well as making it difficult for the students to see anything properly.

There are also educational problems associated with worksheets. They have a tendency to induce competition amongst students to see who can finish first, resulting in short cuts being taken to find relevant text in the museum. Museum-produced worksheets are rarely completely relevant to the work students are doing. They get in the way of the unique ways of working in the museum, focusing instead on the written word in a largely unnecessary

exercise. Students of all ages can remember astonishing amounts of information as well as complex ideas after long periods without the need to write anything down.

Worksheets can be useful in the correct context. For example, they can be used as an initial follow-up back at school in order to fix certain facts and ideas in a given order in preparation for long-term follow-up work. In that respect, they are the responsibility of the teacher, although there is no reason why you should not be involved in their design (especially by supplying pictures and factual terms).

Worksheets can also be used for very specific tasks that lead to other things or bridge one part of a student's work with another. They should never be used as the sole or major part of any museum work you produce or offer, simply because the focus will be on the worksheet and not on the museum and what it contains. If over-used they reduce the museum to a three-dimensional reference book and that violates one of the basic principles of museum work: it should be something that can only be done in a museum.

If worksheets are unavoidable, then great care needs to be taken with them. They should be designed so that large groups of children do not congregate in one place at one time. They should refer to those things relevant to the group using them and which are readily accessible. It is no good, for example, setting work on an artefact in a case that only adults (by dint of their height) can see clearly.

Make the sheet place-specific – especially useful in large museums, otherwise children will spend the rest of their visit wandering around trying to find what they are looking for. Be specific about what sort of answer is needed (notes, text, drawing, several answers). Provide a clear space for answers – boxes for drawings, lines for written answers (with numbers if there are several pieces of information to be found). Make the language and vocabulary suitable to the group.

MATERIAL SUPPORTING OR SUPPLEMENTARY TO MUSEUM COURSES

If you run courses for older students, especially those training to teach or already in the profession, it is well worth providing the content of each session in note form for those who attend. This means that students do not have to worry about taking notes and can thus concentrate on what is going on. It gives you the opportunity to expand on certain points that time limits may preclude from the session itself. It also allows you to provide supplementary information in the form of bibliographies and the like.

Such material is not difficult to produce, as it is merely a formalized extension of any preparation you will have made for the session or course. Whilst this is not essential, it is an extra that students attending such courses will much appreciate. This is one of the many small touches that helps to build your reputation.

SPECIALIST MATERIAL ON SUBJECTS RELATING TO MUSEUM COLLECTIONS

Other members of museum staff may be persuaded to produce monographs or more generalized but learned pieces relating to the museum's collections and its concerns. These should be aimed at the public but with the aim of increasing their knowledge and understanding of museums. Booklets that explain the work of members of the museum staff (including the front-of-house staff) would also be an attractive feature. It would surprise many people to learn what goes on in museums.

MATERIAL RELATING TO LOCAL HISTORY AND LOCAL ARCHAEOLOGY

Museums cannot contain material relating to every aspect of local history, archaeology, geology, natural history and so on. However, such things are of interest to museum staff as they are the context from which much material is extracted (unless the museum is highly specialized). It would make sense, therefore, to produce information on such contexts that will be of interest to visitors, teachers, and students who have an interest in local history and the locale in general. This could include material on notable local people, places, buildings, and events. If the museum is in an urban setting, then town trails can be arranged which use the context of a walk through the streets in order to point out interesting features and tie them in with the history of the place. If good relations exist between museums within the locality, there is ample opportunity for them to pool their resources in this respect and take visitors from museum to museum.

PRINTING

If you are going to be producing printed material in any quantity, it is well worth taking the time to learn something of desktop publishing and of the printing process. Being able to lay out a page of material, choose appropriate fonts and sizes, and discuss such issues with whoever is doing the printing will lead to a high quality of production.

You will also need to decide which printing process is most appropriate. A short run can be managed by the printer attached to your computer. Longer runs can be achieved using photocopying equipment. In both cases, you need machines designed to withstand constant use. Bear in mind that although you can achieve good quality results with such technology, you are restricted in what you can produce – leaflets, loose-leaf packs, and so on.

If you want professional, properly bound, permanent products of high quality such as books, you will have to use an established printing company. With modern print-on-demand technology, there is no need for cupboards filled with unsold stock and financial limits on the number of publications a museum can produce. Setting up texts and designing covers is relatively easy and inexpensive (although you may need to make a one-off payment for necessary software). These can be transferred electronically, stored for a modest fee, priced realistically, and printed in small quantities as and when they are needed. Print costs per unit tend to be marginally higher, but this is offset by the ability to keep a large list of items (including highly specialized material) in print.

COMPUTER SOFTWARE AND CD ROMS

Computers feature ever more widely in our lives. They provide a number of opportunities for the production of material from software that enables useful research databases to be set up through to the production of CD ROMs. Even with advances in the sophistication of desktop computers, this is still a specialized area and in order to produce material of any value you will probably need to consult specialists.

CD ROMs offer an excellent opportunity for sharing large collections of visual material that might otherwise be difficult for large groups of students to access. Photographic collections and documentary material can be processed on to disks along with paintings and drawings. This is especially valuable if your museum has large reserve collections of material that rarely see the light of day and need special protection. Initial outlay is likely to be expensive but the finished product has excellent sales potential.

Producing some or all of the materials discussed above will provide any museum educator with a secondary resource of immense importance. In the case of small museums or museums where the museum educator has other duties, or where the person charged with providing such a service has no teaching experience, it is the main way of providing an education service. With a little imagination, it can be an education service of which to be proud.

10 *Direct Services*

Direct educational services are the most time-consuming that a museum educator can provide. However, they can also be the most satisfying as they offer the opportunity to interact with educational users and obtain immediate feedback. It is not just feedback on your approach that is important, but the fact that you have the opportunity to learn from others. You will be surprised, if you are prepared to listen and learn, how astute students can be – especially younger ones who have yet to pick up certain academic prejudices. Their questions are searching and their eyes are sharp. They will ask things for which you have no answer – and one of the lessons that any student must learn is that answers cannot always be found. Younger students will see things that everyone else has missed, literally and metaphorically.

There are a number of approaches you can take, from the formal to the informal and from the static to the active. They all require a great deal of planning and preparation. Providing these services should not be allowed to dominate your time to the extent that you have no room for anything else in your working life. It can easily happen and you must set aside time for other activities.

Static presentations

Static presentations are the least active forms of direct service and are quite often used in outreach work. They will be dealt with here as they apply in the museum context and will be considered again in Chapter 11 as they apply outwith the museum. In essence static presentations mean giving some form of talk, be it a formal lecture, a more informal talk or a seminar. These will work with all ages and abilities of student as long as they are appropriately worded and presented.

To present something as a lecture raises an expectation that it will be both formal and of a certain academic level. The setting, if possible within your museum, should match this expectation. If you do not have a lecture theatre or similar facilities, there is no reason why an appropriate gallery should not be used. However, you must be able to provide adequate seating that meets safety regulations. You must also be prepared to compete with the distractions of what is displayed there (although it may be that the lecture is about or related to the exhibition).

Such formal events need careful organization. They present one of the public faces of the museum and you should be aware of this at all times. A great deal of prestige can be attached to lecture series or annual lectures, with high-profile guest lecturers and prominent persons being invited to attend. However, the lecture should be relevant to the museum in some way. Speakers, be they in-house or guests, should be chosen for their ability to lecture well.

Advertising and invitations need to be prepared in good time. Sometimes catering is required for a general buffet or for selected guests. Unless you have a restaurant in-house, find a good caterer who will provide appetising food to suit many tastes and dietary needs. All other facilities need to be well signed, and decisions must be made about access to other parts of the museum. This will depend largely on the reason for the lecture. If it is part of a series of general lectures, then restricted access will probably be the best option. If the lecture is given to launch a new exhibition, that, at least, will have to be open for view. There is also the question of whether those attending are to be invited or whether the lecture is open to all. A mix is possible, but invited guests must be given some privilege not available to others such as supper or a guided tour.

Do not forget that the museum will need to be tidied up after such an event. This should be done immediately. Never leave it until the morning after, as that brings you too close to the deadline to open the museum to the public.

Informal talks, although more casual and more likely to be open to all, need just as much planning. Advertising is again important, as are all the other arrangements. It is their content and the presentation that differs. Less academic talks, with the aim of bringing in the whole of the community, should be lively and informative. They can also be tailored to suit specific audiences; even twenty-minute talks at lunchtime can attract people in large urban areas.

Seminars, too, can take on a number of forms, but remember that discussions can go on for a long time and this must be allowed for. Seminars are more likely to be part of courses offered by the museum rather than one-off affairs, although talks and lectures should provide opportunities for the audience to ask questions.

Storytelling is also an excellent way of conveying ideas and information while having a great deal of fun, passing on local myths, legends, and history. It is certainly likely to be a bit livelier than a formal lecture. This is an art form worth developing or, if you do not feel comfortable with the idea, professional storytellers can be employed. Storytelling has a long and venerable history throughout the world and is still popular today in many countries. Do not make the mistake of assuming it is for young people only. Adults also enjoy listening to tales, and if the storyteller is good, you should have no trouble in attracting audiences. Of course, your material must relate to the museum, and its collections and artefacts can be used to help illustrate the tale. In a sense, all teaching is a form of storytelling and it is invaluable in any direct work you do.

Ambulant lectures

Moving on from static presentations, the next area to consider is ambulant lectures. These fall into three main categories. To begin with, there are those that can be used to familiarize visitors and students with the layout of the museum. All visitors – but especially children – require orientation. Even a brief explanation of what they will be doing during a visit can be very useful. Telling students what they might learn actually increases the likelihood that they will learn it. Orientation sessions are also useful for students who are likely to make repeat visits or who will be spending some time in the museum. They can spare a few moments to learn where galleries are and where other facilities such as toilets, eating areas, shops and the like are situated. These sessions need not take long and are worthwhile, even if you also produce leaflets with plans of the building's layout. All this can save you from

answering the same questions repeatedly later. Students benefit as well, as it allows them time to become familiar with the feel and style of the museum without the fear of getting lost or missing anything.

Next is the category that most springs to mind when ambulant lectures are considered – guided tours. Guided tours may sound a little old-fashioned these days but they still serve an extremely useful function. As with familiarization tours, they offer the opportunity to explore a particular gallery or collection in detail so that students have a basic framework for later work. Such tours, however, should not consist simply of the museum educator moving from artefact to artefact and from display to display, lecturing as they go. That method is what has brought guided tours into disrepute. Involve the students in what they are seeing, turn it into a story, relate it to other work, and get them to do all the interpreting. If students are made to work for their information in a structured and enjoyable way, they will learn more.

Try to avoid using guided tours, no matter how interactive, as the sole aspect of a visit. Other work needs to be done with them. Such an approach may be limited, in any case, by the size and design of the museum. If the museum is closed to all but students, there is no problem. In normal circumstances, however, other visitors will be in the museum and the interface between them and educational groups can be an uncomfortable one if visitors feel they are being excluded from certain parts of the museum by the presence of large numbers of students at work. Some do not mind the presence of students. It is not unknown for such visitors to ask if they can join in or at least stand at the back and listen. Others, however, are put off by educational groups, uncertain about sharing space with them or even hostile to their presence. Balancing the educational role of the museums against the sensibilities of others is difficult. It is partly a matter of presentation. If the museum has a reputation for its educational work and notices are posted that visitors may encounter groups at work, problems are less likely.

One thing you, and anyone else who conducts tours, should be aware of is visitors who stray into the area you are using. If they seem hesitant, do not be afraid to break off what you are doing and address them. Welcome them, explain briefly what you are doing, how long you will be there and invite them to stay. They may do so or, knowing that the place will be free in ten minutes' time, they may elect to return.

Finally, there are 'backstage tours' in which groups are given the opportunity to see those parts of the museum not normally open to the public. For obvious reasons these work better with smaller groups and even then need to be tightly controlled. You should also ensure that all relevant health and safety standards can be met before taking non-staff members into areas not normally open to the public. Furthermore, these tours must take into account the fact that you are disrupting the working lives of colleagues. Even if they are all enthusiastic, you need to keep disruption to an absolute minimum and should perhaps confine this sort of work to students who are studying relevant courses, such as museum studies or archaeology.

Activity-based sessions

Options that are more active will require rooms and spaces away from the galleries, as they would otherwise be highly disruptive for other visitors. You may also need specialist equipment that can only be placed *in situ*, such as benches, sinks, messy work areas and so on.

This does not preclude some activities taking place in the public part of the museum, but it should be based elsewhere.

To begin with, you can arrange and offer demonstrations of varying kinds. The richest area is in demonstrating the techniques that were used in the past to produce the various types of artefact to be found in the museum. Pottery, metalworking, stonemasonry, weaving and the like can be shown in action and provide a valuable insight into construction and form that may not be evident from a study of the finished product. What is more, demonstrations provide an excellent forum for craft workers using traditional methods, as they can show their skills to a wider audience.

From watching others work, one can move on to activities involving varying levels of participation. For example, there are handling sessions in which genuine artefacts and replicas (although the genuine thing should be used where at all possible) are made available for students to pick up, handle, touch, feel the weight of, and examine in detail. The psychological impact of touching the real thing, even if it is an old bit of broken pottery, is immense. This is especially relevant for younger children, for students with visual impairments and for those with other difficulties. Often, tactile experiences have more meaning for them and make a greater impact.

Handling sessions presuppose the existence of a handling collection. There will always be caution from curatorial staff about the use of artefacts for handling. Some of these arise from genuine concerns, but should never be accepted as an excuse to offer substandard material. Handling collections are essential to a first-class education service, and there are strong educational arguments that you can use to persuade curators of their value.

Despite the many debates and disagreements about the exact nature of the benefits of touching and handling, psychologists are in broad agreement that such activity is beneficial. Some, like Piaget, argue that it is only relevant at a particular (and early) stage of development. Others, like Bruner, argue that handling is beneficial at all levels of development, but for different reasons. One thing is certain: in most westernized cultures, language as a mode of learning has come to outweigh any other form of experience of the world and has led to an unbalanced development of the human being.

John Dewey (1963) has argued convincingly that education should be based on direct experience. One of the most direct forms of experience is touching. When the objects we touch are from cultures distant and sometimes alien to our own, there is a great psychological impact that cannot be achieved even by looking at the same object from close quarters.

One of the facts to be taught through handling is that some objects are too fragile or precious to be allowed this sort of treatment. This can lead to discussions and work on what makes something fragile and what makes something precious. This in turn will lead to areas of work on the nature of museums, what they are for, and all the work that goes on within them.

Do not put a handling collection together on an ad hoc basis. Try to work towards some specific aims. Themed collections that relate to programmes of work or pieces that are connected with artefacts on display are just two examples. Nor is it always necessary to use old objects. Contemporary material can be purchased or commissioned, especially if it is the process that needs demonstrating as much as the finished piece.

When teaching people how to read objects, it is essential that they are able to handle them. Detail only becomes apparent on close examination. You can probably find one or two unusual-looking artefacts in the museum's collection whose original use is obscure. A

careful examination of the artefact should eventually lead students to working out its function.

The logical progression from watching and handling is participation in activity-based workshops. As with all the approaches mentioned here, there are a number of basic forms that such workshops can take – the age and ability of students being major determining factors. Learning through doing and making leads to a far higher level of understanding than any other method, as long as it is part of an integrated approach that involves other methods. All such activity should derive from the museum's collections and should be concerned with exploring the creation and use of the artefacts, as well as coming to an understanding of the social and historical environments in which they existed and which helped to form them. Remember, these workshops can be costly to mount and require a high degree of preparation and clearing up. Weigh up the inconveniences against the benefits and decide how often you want to offer such activities. If they rely on materials that are largely reusable and small-scale, they can be offered on a regular basis.

Some of these activity workshops can grow out of other activity-based approaches. Where demonstrations lend themselves, students can participate and create objects for themselves using the techniques demonstrated. For example, paper-making, although messy, is immense fun. It leads not only to an understanding of paper, but also of the source materials that can be used in its production, and thus its value. Moreover, students have something to take home at the end of the day. Such concrete end products are particularly suited to younger students, but are often appreciated by older students as well.

Differing crafts can also be gathered together at one time in order to demonstrate living in a particular historical period. This may involve wood- and metalworking, weaving, cooking, clothes-making, shoe-making, making cosmetics and medicines, playing games and so on. A whole host of skills brought together in this way and suitably demonstrated can help to create a sense of how people lived at a given time in history.

Organizing such workshops is time-consuming and none too easy, as it means coordinating the activities of a number of people. Indeed, it needs to be done a long way in advance, as many craftspeople travel widely to promote and sell their wares. This commercial aspect needs to be taken into account, and time and space should be created for people to promote their craft and sell the things they make. This is a very good opportunity to market the museum education service. An increasing number of re-enactment societies can also offer a similar service as a ready-made package.

Much simpler single activities such as drawing can take place throughout the museum without too much disruption. It is also possible to build activities into exhibitions so that they become a natural feature of the museum experience. As always, it is a matter of researching your market and providing what is needed within the limits of your resource.

Another form of active involvement that makes use of students' informed imagination is re-enactment and role play. These are slightly different activities but invariably work together. Role play involves taking on a role and living through a variety of experiences common to that role. A student might, for example, dress in a representative costume of an eighteenth-century villager and perform a number of everyday activities associated with village life of that period. Re-enactment may involve those same students acting out a specific event in village history with students taking on specific roles, as in a play.

The setting for such work is very important. A purpose-built museum is a less effective setting than an old house with a history of its own or a ruin or reconstructed site to which

the museum is attached. The essential thing is to make the most of the environment and to devise the best methods of doing so.

There is a role here, too, for museum staff to dress in period clothing and become living repositories of information and skills. Some museums already do this on a permanent basis and to great effect. Other museums do not lend themselves to this approach, although there is no reason why education staff should not adopt specific roles to lead particular types of education session.

Games and simulations are also an important active form of work, although they are often neglected by museums. Indeed, games are still looked on with suspicion in many quarters despite the great degree of sophistication they have reached. These range from simple observation games that can be played by individuals throughout the museum to more sophisticated detective games for individuals and for groups. Much more sophisticated simulation games can also be devised and played, making use of artefacts and collections.

The form of such games depends on the content of the museum's collections, but situations can be created for students to resolve using knowledge gleaned from a study of artefacts and information within the museum. Such games can develop through a number of stages. Social and historical issues can be explored and resolved through the playing of games of 'what if' based on historical information and understanding. There are many excellent books on the subject. Like many other such activities, games take a great deal of thinking out and time to create, especially as they are very open-ended, but the rewards are far-reaching. They are certainly an extremely creative way to make use of the museum resource. Students who have played such games could be encouraged to consider devising their own, a further activity for them to undertake within the museum.

Teacher training

Of all the direct services you can offer, the most far-reaching and the most important are training courses for student teachers and practising teachers. The aims of such courses are twofold and quite simple. The first is to ensure that teachers are aware of the best ways in which to make use of the educational resource that museums represent. The second is to make your work as a museum educator easier. These aims are two sides of the same coin, as they are both achieved by equipping teachers with the skills and experience they need to use museums well and with confidence.

Whilst the organization of such courses of work for initial teacher training (ITT) students will differ from that for practising teachers on in-service training (InSeT), their content will cover much the same ground. Students following ITT courses can, when their other commitments allow, attend the museum during the day and spend prolonged amounts of time working within the museum environment. Intensive courses taking place over a five-day period work just as well as half-day sessions spread over a full term. For practising teachers, the demands of their work mean that training sessions would have to be offered at other times. Official training days can be made use of, but the demands on these to update teachers on administrative and curricular matters mean that available days are too infrequent to mount any but one-off sessions. Whilst these should be used, longer courses (which are of greater benefit) need other approaches. Short twilight sessions, weekend courses and vacation courses should all be considered.

However, if you are going to attract teachers into these, remember that you are asking them to give up valuable time. Many will do so willingly. Teachers are extremely committed people. Their work is a vocation and they will do much to improve their skills and understanding. To make your courses more attractive, make sure you provide some recognition of attendance at the end of it. A certificate of course completion is one answer, but it should be something they have had to work for and which guarantees that they have reached a minimum level of competence and knowledge.

Certification is pointless unless it confers a real benefit. It might be worth setting up an accreditation scheme, in which you offer a training course to teachers on how to use your museum. If they pass, they are awarded privileged access to the museum and its educational services (including follow-up courses). This is especially useful if you are oversubscribed, as priority can be given to certificate holders. If such a scheme were run in concert with a group of museums, with practical and orientating work in each, the certificate would give the teachers access to several museums and those museums would have a guarantee that certificate holders are competent to be let loose on the resource.

The content of such courses should include, as a minimum, certain essential areas of study. To begin with, candidates would need to understand the educational role of museums and the reasons why teachers should use them. Teachers would also need to appreciate that museums are unique places of education, different from the schools and colleges they work in. Special methods and approaches are necessary for successful work.

It would also be useful for teachers to understand what is done by museums and museum staff. A behind-the-scenes look at the various areas of activity would not only accomplish this, but also introduce some of the basic concepts that are vital to an understanding of working with material culture.

This should be supplemented with some of the basic skills involved. In particular, teachers should learn how to handle artefacts – especially fragile and delicate ones. You also need to cover the use of cotton gloves, acid-free storage mediums, humidity and temperature control, ultraviolet light levels, and so on.

Having gained this background in the nature of the resource they are going to be using, teachers would then be encouraged to think how they should plan and prepare for bringing groups of students to a museum. Teachers should appreciate the need to integrate museum work with what they do and to prepare both themselves and their students for the work. They will all be working in an environment and with a medium with which they are largely unfamiliar. Preparation is, therefore, crucial.

A number of sessions should be devoted to working with artefacts. Single objects, groups of objects, buildings, sites, pictorial material, and documentary material all need different approaches to yield information. Each of these can also provide different types of information depending on the sort of questions asked of them. In addition, teachers should be introduced to the various forms of service that will be available and appropriate within different museum environments.

Finally, think how to follow up visits both in terms of the students' work and in terms of the teacher's assessment of the visit. Feedback to the museum is important, and assessment is easier if teachers know what sort of information museum educators are likely to want. There are other things that can be done in conjunction with teachers relating to specific coursework. These are discussed in Chapter 13.

By giving such courses, you are not trying to do yourself out of a job. There are many other things a museum educator must do. However, those tasks are made easier if you have

more time and are confident that teachers are working in the museum with the necessary skills, experience, and confidence. Not the least of these many other tasks is running courses for education staff from other museums and other professionals who have an interest in the museum. Some of these people will be using outreach material and wish to use it competently. This may be especially important if some of the outreach projects you run depend on other people to maintain them, such as in prison or hospital education units, or in the case of school museums.

Work with ITT students brings its own particular problems, not least of which is the fact that ITT courses rarely (if ever) include the use of museums, libraries, art galleries, and other such complementary resources. This means that any work you do with students must be done under the auspices of lecturers who recognize the value of museums and galleries. Perhaps the most important thing you can do (besides working on an ad hoc basis with students) is to join with like-minded museum educators and ITT lecturers to lobby for the use of museums as an educational resource to be formally included in ITT curricula.

Fieldwork and site work

If you work in a museum that is attached in some way to a site of archaeological or historical importance, or if your museum is home to a field archaeology unit, or if it houses artefacts and collections connected with local history, you may consider that you have the right to develop education programmes and services that make use of this extended resource.

If this is the case, you could be offering guided tours and activity workshops in places other than the museum. These involve extra complications, not least of which are the legally binding health and safety issues that may apply. These vary according to place and circumstance and need to be gone into very carefully – especially if any external site you work on has hazards that students are not used to coping with.

You should also bear in mind other aspects of such work. Weather is an all-important factor that can make or mar outside work. You could point out that in the past the weather had a great impact on people's lives and that to experience its effects is part of the learning process. However, you will need to guard against prolonged exposure to adverse conditions, especially with younger students.

Special skills are also required and can be taught; for example, surveying can provide groups with invaluable and copious amounts of data to take away and work on elsewhere. Recording of such data (a skill used indoors as well, but with special problems in the open) also needs to be taught and practised.

Notwithstanding all the problems and special needs involved in outdoor work, the rewards are enormous – especially where such work can be linked with materials held in the museum's collections. Cold and damp as it can sometimes be, it is an adventure to explore such places under guidance. Students are offered an equivalent experience to the one gained from handling artefacts. Here they tread the very ground where their ancestors walked, worked, and lived out their lives. They can see how material culture extends to buildings and landscapes. They can learn to interpret these and connect them with the artefacts kept elsewhere. They can also come to appreciate something of the working conditions of those who painstakingly win these artefacts from the places they were lost, and consider some of the ethical arguments that surround such work.

Precisely what sort of activities you plan and carry through in such situations depends on the specific resource and location (be it urban, suburban, rural or wilderness), as well as its place within our culture. Some activities acceptable on some sites are not acceptable on others. The final form of activities depends on you and the ingenuity you bring to bear.

Museum staff training

Apart from all the services you offer to groups outwith the museum, you should seek to set up internal training programmes as well. Even museums with a small staff can benefit greatly from formal training, especially where people are expected to take on a number of roles or be involved in decision-making.

Such training sessions can range from familiarization with internal structures and procedures to learning about what everyone does within the museum, where everything is kept, and what sort of things are on display and which kept in store. New members of staff should certainly have induction sessions, as this will increase their confidence and bring them up to peak working efficiency much more quickly than if they were left to learn things in a haphazard way. Personnel departments may already offer such training but not many museums have personnel departments.

This sort of training regime should be accompanied by a handbook of structures and procedures that sets out in clear language everything that is expected of staff and how they should do things, down to filling in expenses claim forms and annual visitor figure returns. It should also include maps and plans that locate everything in the museum, a note of deadlines for the presentation of various forms and reports, and a calendar of fixed events. This is vital for new staff who may have a great deal of new information and procedures to assimilate, especially if the museum is tied to the bureaucracy of local or national government. Such a document should be cross-referenced and well indexed, with both official terminology and the in-house slang that is used to refer to things. Above all, it must be kept up to date.

In addition to basic working procedure and general familiarization, all museum staff should be kept abreast of developments in education so that they understand what is going on when students visit and appear to be doing quite bizarre things. Greater understanding means that staff can play their part in what is happening – a sound management strategy that leads to greater commitment.

It could be argued that larger museums that have education departments should be using them for more formal staff development. This will have to be done in conjunction with specialists within the museum so that, between you, you can draw up detailed programmes of work for the training of staff that outline, step by step, what should be learnt and in what order. This makes it easier for the museum educator to set the programme in place and find the requisite teaching staff.

There are also nationally recognized qualification courses that will benefit museum staff. These can be overseen by appropriately qualified museum educators. Many of these are arranged by professional organizations and are well worth investigating, as you may be able to establish your museum as a training centre.

These, then, are the main types of service that you can offer. Each type has a myriad of forms and, as you develop one, others will suggest themselves. If you are starting from scratch, it would be wise to talk with other museum educators and see what their approach

has been. You will not be able to copy them exactly as what they have done will probably not suit your situation or the demands that are likely to be made on you, but you will always be able to find inspiration from the work of others and, when the time comes, others will be able to find inspiration from you.

11 *Outreach*

Not all the work you do as a museum educator can, or should be, confined to the museum. It is preferable, for all the reasons discussed earlier, that educational user groups come to the museum – the visit itself is an important part of the experience of working with material culture. However, a number of factors militate against this. Some are legitimate, but others that are put forward are fallacious.

In general, there seems to be a growing reluctance to take students out of their schools to experience the wider world and its educational potential. One of the main reasons put forward is finance. Emphasis on 'basic skills' means that less money is available for what some would consider the 'luxuries'. It is a false economy and rather ignores the fact that many of the basic skills can easily and, sometimes, more readily be taught in a non-school environment such as a museum.

Another reason given is lack of time. Constant changes to the content of various curricula are a major cause. Teachers have to spend time assimilating these changes. This leaves them little enough time to consider how they might relate to or be enhanced by visits to museums and galleries, even less actually to plan and implement such visits.

Working practices are also changing in schools more rapidly than once they did. Moves toward personalized learning programmes, for example, are often cited. Although, in themselves, such programmes do not preclude museum visits (indeed, they offer greater opportunities for students to make use of a wider educational resource than can be provided by their school), they are time-consuming for teachers to supervise and make group work much more difficult to coordinate.

Personalized learning programmes rely heavily on computers and the Internet, both in schools and at home. Whilst museums can be providers of information via this medium, the increased use of computers is antithetical to the exploration of material culture. Reliance on computers also degrades the ability of students who use them constantly to devise their own solutions to or make their own readings of the world about them.

These 'problems' are further compounded by social changes. A perception of increased dangers in the world (nationally and locally), a rise in litigation following a number of accidents involving students, the need to carry out risk assessments and comply with a growing burden of health and safety regulations, all contribute to the belief that visits are more trouble than they are worth.

None of the aforementioned are legitimate reasons for not visiting museums. They are merely perceived as such and sometimes used as excuses. They are, however, a reality that erodes confidence in the worth of visits and informs an increasing reluctance to leave the classroom. As such, you need to be aware of these factors and of ways in which to counter them. Where that fails, you need to be able to work round them to provide a museum experience outside the museum.

It is also important to remember that there are many legitimate reasons why visits are not and cannot be made. Problems with cost, travel arrangements, curricular and other needs are not always an excuse. Those most disadvantaged by society rarely have access to what so many of us take for granted. If you do not address their needs, they will find themselves without access to yet one more part of their community, one that has the potential to widen their horizons in so many ways.

Besides that, groups that can and do visit also have legitimate need of outreach services, which can extend the effectiveness of their visit in a number of ways, principally through preparation and follow-up work. Groups are also limited by finance and logistical considerations to the number of visits they can make to a museum in a given year. If they can only visit once, they can still make frequent use of the resource through your outreach services.

In order to accommodate those who cannot (or will not) visit the museum, it is essential that you have educational services and programmes of work that can be offered outside the museum. In essence, this means taking artefacts and expertise out into the community. Not only does this fulfil certain educational and social needs, but it also acts as an effective form of marketing. Circumstances change. Teachers well served by your outreach programmes will think of you first when visiting a museum with their students becomes a realistic option.

Important as they are, however, outreach services can be time-consuming for a museum to administer. The condition of materials has to be monitored on a regular basis, administrative records have to be kept up to date, and, where museum staff are involved, time outside the museum has to be regulated. Materials also have to be prepared, repaired, and renewed. New materials have to be put together to meet changing demands. All this can easily tie up a member of staff full-time. You need to think long and hard before venturing into this area, balancing the needs of educational user groups and the wider community against your available resources.

If you decide to go ahead with the planning and development of outreach, several options are open to you, falling into the two broad categories of indirect and direct services. Indirect services are those you set up and administer but which involve minimal levels of contact between you and those using them. It is worth concentrating on these to begin with as they are less time-consuming. Direct outreach services involve you (and possibly other members of the museum's staff) in working outside the museum in direct contact (to a greater or lesser degree) with educational users.

Indirect outreach work

TRAVELLING EXHIBITIONS

Temporary exhibitions come in many sizes and degrees of complexity. If your museum produces an in-house programme of temporary exhibitions, based on artefacts in its reserve collection, it should be possible to design them so that all or part (depending on the size and educational relevance of the exhibition) can be reused when the exhibition is finished. This will require careful planning from the outset, but once the principle is established, the museum can produce a resource that can be loaned to other museums, to community groups, and to schools.

The content and construction need to be carefully designed in order to incorporate two aspects. The first is that if the exhibition is relatively large, it can be scaled down physically

to a useful size without the need to add new elements (or keep this to an absolute minimum). The second is that the content can be similarly reduced if necessary. Ideally, the exhibition should also be flexible enough to cater for the needs of different user groups.

There are also practical considerations. The travelling element of the exhibition has to be taken apart, packed into a small space, easily stored, transported, and re-erected. If possible, it should be designed so that one person can transport it and set it up in half a day or less.

Basic, modular units including secure display cases, along with detachable text and clear instructions for layout are essential. The sections should be designed so that they can withstand movement and continual dismantling and reconstruction. They should also be able to be stored in the smallest possible space. Once in place, all artefacts on display must be secure and the whole structure must be safe enough to comply with health and safety standards. At the same time, it is important to avoid each exhibition looking like a row of notice boards with a few artefacts attached.

Travelling exhibitions can, of course, be designed and constructed in their own right. You do not have to make use of the material from temporary exhibitions. However, it is clear that producing them specifically and only as travelling exhibitions is an expensive option. In whatever way you approach them, if they are sturdy, vibrant, and of sufficient relevant interest, they will greatly increase the presence of the museum within the community. They can be offered not only to schools, which will undoubtedly benefit, but also to groups who may not normally visit. Old people's homes, community centres of varying kinds, and other public places can all be enhanced along with the museum's reputation and profile.

MOBILE MUSEUMS

Mobile museums are akin to travelling exhibitions. They are small, mobile, and can be altered regularly. Their advantage over conventional travelling exhibitions is that, once set up in whatever vehicle you use, they do not need to be unpacked and packed at every venue. This makes them ideal for short-term displays. They are, of course, something of a luxury, but may be worth considering, especially if you operate in a large but sparsely populated area. However, that is not the only criterion for their use. They can operate just as well in crowded urban areas.

The remit of a mobile museum can be extremely broad. The content need not be dictated by narrower educational needs. It can be parked in popular tourist spots to give people a taste of what they will find in the museum itself. It can be taken to or hired out for community events, fêtes, and fairs. It can also be taken to places where people, through whatever circumstance, have little opportunity to visit museums – peripheral housing estates that are badly served by public transport, factories or industrial estates where they operate night shifts, remote villages, prisons, and so on. One of the main destinations, however, must be schools.

The beauty of a mobile museum is that it can give an idea of the atmosphere of a museum, something a box of materials cannot do. Varying in size from a small caravan to an articulated lorry, mobile museums provide a blank space that can be filled with artefacts and wall displays specific to particular needs. Once on site, they can be kept for the sole use of students who can visit in small groups without the worry of travelling back and forth to the museum itself (which may be some distance away or difficult to get to) and without worrying about inconveniencing the general public.

There are a number of problems. Buying and maintaining a large, reliable, and safe vehicle is very expensive. The vehicle must be extremely secure if it is to be left anywhere overnight; it needs secure parking space at the museum; and the contents must be able to survive bumpy road journeys, as well as changes in humidity, temperature, and light. There are also administrative and running costs, especially if the vehicle is used at weekends and in remote locations. Mobile museums are heavy on staffing if used effectively in school settings, as there needs to be at least one staff member permanently with the exhibition. Such a project should not be undertaken lightly.

SCHOOL MUSEUMS

A school museum is just that – a museum run in conjunction with or owned by the school. If you are working with schools, it may be a simple case of maintaining a small, secure display of artefacts in each school. This can be themed or eclectic depending on the school, and changed on a regular basis – perhaps once every academic term. If you work with a number of schools, displays can be rotated. Teachers can have access to the artefacts (as they would with any other loan material) for use in their teaching whilst the school as a whole demonstrates that there is a wider educational resource within the community. The museum benefits in that there is a constant reminder of its existence – not just through the presence of the artefacts, but also through the regular visits made by the museum education staff.

If you are going to work with schools to help them develop their own museums, you will need to stress to them that it is a long-term commitment. Running a museum is a time-consuming and exacting business. It should not be started without first thoroughly exploring the whole project; nor should such an enterprise, if started, be seen as a substitute for visiting museums. No school will ever be able to compete with the resources at your disposal. In spite of that, if the school is committed to the project and has researched it fully, there is no reason why it should not start a collection of its own.

Your role will be to guide with, or act as an intermediary for, advice and information. This can cover the whole range of questions such as insurance, collecting policy, storage, conservation, environmental control, handling, cataloguing, display, security, disposal, and so on. If you are involved from the start, you can ensure that good advice is given – although you can never ensure that it will be heeded.

No matter how small the intended museum, it must be run exactly as if it were a full-scale operation. Before a school accepts a single item, you must ensure it has a collecting policy. This should explain the purpose of the collection, what the scope of the collection would be, the legal position regarding transfer of ownership and rights, how the collection is to be managed and, if the worst should come to the worst, how they intend to dispose of the collection. As this will form the basis of any agreement that transfers ownership (temporarily or permanently), it needs to be legally watertight.

Permanent collections need to be catalogued and stored in a way that protects the objects and makes them accessible to all teachers and students. Thought needs to be given to student participation in the maintenance of the collection. There are many opportunities here to enlighten students about the care of objects, the purpose of museums, and careers within them and associated fields such as archaeology. Student participation is vital. They are trusted every day in other situations with materials that are as delicate and valuable as anything likely to find its way into a school museum. The opportunity to work with

material objects that are valued for reasons other than present utility or financial value is of the greatest importance.

Interesting as school museums may be, you must only act in an advisory capacity. You simply will not have the time to do any more than that.

UNDERGRADUATE STUDIES AND DISTANCE LEARNING MATERIAL

A number of different courses at undergraduate (and sometimes postgraduate) level have strong natural connections with museums. The importance of ITT has already been discussed. Specific subjects such as history and archaeology have varying degrees of connection. The most obvious, however, are courses in museum studies, which are becoming increasingly established in institutions of higher education around the world. More than 250 such courses are taught in the United States, a hundred or so in Canada, 30 or more in Australia, and more than 50 in the United Kingdom.

These courses vary in complexity and intent, but it is worth exploring the possibility of working in conjunction with course providers to make your museum an integral part of their work. This may include contributions to course material, lectures, training sessions, and work placements. Any materials that you do produce or offer should be in tune with current accepted methods of presentation, which invariably means making them available via the museum's website. This is especially the case if material is to be used for distance learning. There are many books available on this subject and there are probably experts in any institute of higher education with which you work.

This is an ambitious area with which to become involved. Some institutions are reluctant to involve outsiders, no matter how good their academic credentials and relevant experience. However, as you build up a resource of material for older and more academically advanced students, it would be a sensible way of capitalizing on your effort.

Direct outreach work

TALKS, LECTURES, AND WORKSHOPS

It is almost inevitable that, as your museum education work develops, you will be asked to speak about what you do. To begin with, this is likely to be to other museum professionals and people closely allied to the museum world such as teachers, students, and parents. However, if you are doing your job effectively, the net will be cast wider and you will find the opportunity to talk to a great variety of audiences about museums, their educational role in society, and the specific work that you do. Lecturing thus fulfils two roles: general publicity for the museum and education about the specific work that goes on behind the scenes.

For a general talk, you will need different approaches and different lengths to suit different audiences. However, you will probably be able to devise variations on a single theme. There is no reason, though, why you should stick to a single talk. Indeed, if you are called upon to lecture frequently, it would be wise to have a number of different talks to offer. This not only means you can go back to a particular audience more than once; it prevents you from becoming stale.

Even if your theme is the same – museum education – it is possible to talk about different aspects of the work and, as your experience grows, to regale your audiences with anec-

dotes (both serious and humorous) from your working life. When you have contact with people, even if only for part of your working day, there are always plenty of those.

If you intend to illustrate your talk with slides, they must be of top quality. Nothing is worse than dirty, out-of-focus, badly lit shots of obscure items. It is far better to do without them than to use bad ones. You can always take a few items from your teaching collection instead – enlivening your talk and demonstrating the importance of contact with the real thing.

Always leave time at the end of your talk for a question-and-answer session. You may have covered your subject so comprehensively that everyone is satisfied, but this is rare. Indeed, it is far better to announce that you will be taking questions and leave certain topics open-ended enough to prompt questions and discussion. This can be aided by the presence of artefacts, drawing your audience into the process rather than talking at them.

To avoid confusion and the chance of incompatibility, provide your own projector(s), stand(s), screen, extension leads, multi-purpose plugs, control leads, lectern with discreet reading light, notes (forget everything else but never these!), an unbreakable flask of water (you will get dry and cannot rely on your hosts to provide this), spare bulbs, spare fuses, screwdrivers, insulating tape, lens cloths and, if you offer a number of different talks, the right sets of slides. Make a comprehensive checklist and go through it every time you prepare for a talk. On top of all that you must make sure that the venue has adequate blackout. This may seem excessive, but lack of any one of these items can turn an entertaining session into an unmitigated disaster.

Be choosy about who you give talks to. Like all the other services you offer, it must be for a purpose. The museum must benefit as well as the prospective audience. Set yourself a strict lower limit of audience size. This will depend on the area you work in – rural areas will generally provide smaller audiences than urban areas. If a small group desperately wants you to give a talk, suggest that they join forces with several other small groups. It is no use travelling for several hours and going through the rigmarole of setting up, only to find that you are talking to half a dozen people.

Always find out precise details of the venue and make a preliminary visit if you can. This enables you to see where everything is, find out where you can park, and ask your host about the precise format of the evening. Make sure your host has a brief curriculum vitae so that they at least get your name and job title correct. Never fill in for someone else at the last moment. Such events are likely to be flat as you are not the expected speaker – you are the substitute, second best. Not ideal circumstances for giving a talk!

Always take promotional literature for the museum and for the education department. You can even take relevant merchandise to sell. If the talk is to a major group or large audience, you can send out press releases in conjunction with the organizers.

Whether or not you charge for giving talks depends on museum policy. You can ask, at the very least, for expenses to cover travel and time. If you have to travel a long distance, this should include the price of a meal. If you are in demand, then you should consider charging a fee, at least of those who can afford it.

DIRECT WORK IN SCHOOLS AND OTHER INSTITUTES OF FORMAL EDUCATION

Rural areas where schools are few and far between and urban areas where schools are too poor to support much in the way of extra-mural activity are the best places to set up pro-

grammes of work in which you have direct contact with students. In essence, this means taking material from the museum to a particular school and working directly with students on their home ground. Unless you have a background in classroom teaching, this will be new territory. You will have to be aware of the ground rules and of the differences from working in a museum. This is also an option for in-service training sessions with teachers. It may not be ideal, but it is much better than nothing.

In terms of preparation, travelling and actual contact time, such work is expensive. Where it is done, it should be organized so that best use of time is made at a given site – perhaps with several sessions with different groups of students, as well as time spent with staff in, for example, an after-school training session. Whilst it is preferable, as always, for students to visit the museum, it certainly does no harm for you to become familiar with the students' normal educational environment.

COMMUNITY GROUPS

There are other areas in the community with which links could and should be forged. Therapeutic work with groups of disabled people goes on all the time and there are a number of ways in which work with artefacts can provide a useful stimulus. Whilst many disabled people can actually visit the museum, there will always be those who need the museum to come to them.

Older people, too, can benefit from the stimulus that work with artefacts can offer, especially if the museum holds collections of material from the last 150 years. Reminiscence sessions help to stimulate conversation, which increases levels of intellectual activity. Such sessions can also provide a wealth of social and historical material for the museum. If people are willing, their memories and thoughts can be recorded and used to form a sound archive for which present-day and future historians will be grateful. If you are going to do this, make sure you work with good quality recording and audio storage equipment.

Some hospitals have education units for long-stay patients, young and old. Young people who have their formal education interrupted by injury and sickness often have trouble re-assimilating themselves into educational habits. Their environment and their condition are not always conducive to learning, but anything that can be used to aid their education usually also helps to aid their recovery. This is equally true of older patients who have suffered life-changing illnesses (such as strokes) and major injuries. Whilst much of their time and effort is given over to recovery and re-learning how to use their brains and bodies, these activities not only sometimes need a context (which you can provide), but there are also times when a distraction from them is equally beneficial.

Prisons and secure units for young offenders also have education units with which you can work to help towards the rehabilitation of those for whom museums are so alien that they might as well be on another planet. The chance to explore new worlds and participate in new activities can be very important in rebuilding new patterns of behaviour and expectation.

There are many other ways in which the museum can reach out into the general community. Exhibitions at community centres and work with various ethnic groups, as well as involvement with various community forums, all help to increase the integration of museum and community. There are doubtless many other ways in which this can be achieved, but they will depend on the specific location of the museum and the community in which it resides.

In all these cases, you will have to seek out and make contact with the relevant member of staff or representative. Before you do so, make sure you are prepared to take on what can be difficult and demanding work. If you take that step, you will be moving into areas that are probably new to you, and you should allow yourself to be guided by the experts.

CONSULTANCY

Finally, as your skills, experience, and expertise increase, you may find yourself called upon by other museums and museum professionals to aid them in the establishment and development of their own museum education services. When that happens, it will be a wonderful feeling, as you realize that others value the work you have done to the extent of considering you an expert. If there is a sufficiently large market, it might even be worth promoting your skills in this way for smaller museums that cannot afford to take on staff of their own, but who would value guidance in certain areas. This depends largely on the management of your own museum and the way it is constituted, but it is certainly a prestigious venture that would reflect well on the museum as a whole.

CHAPTER 12 *Loan Services*

A loan service is a specific form of outreach programme and should be integrated with any other educational programmes that you offer – both within and without the museum. They tend to be popular with teachers and support a range of other activities. They also, in certain circumstances, represent the major (if not only) form of education service that many museums can provide. For that reason, they are dealt with here in more detail.

Loan services have much in common with handling collections in that material from the museum is made available for students to touch and examine, allowing them the experience of contact with genuine historical and archaeological material. The difference is that this material can be borrowed by teachers and taken into school for their students to work with over a longer period. This can be done in conjunction with specific visits or as an opportunity for students to work with material culture and get to know some of the techniques for reading such artefacts.

Loan services can be expensive to set up and complicated to run, with administration taking up a great deal of staff time. If you intend to set one up, make sure there is an adequate market for it and that you research thoroughly the actual requirements of the user groups. It is far better to spend time in extensive research to assess what type of loan materials would be most appreciated than to waste time marketing something that no one wants. Your research will give you an idea of the scope of the desired resource, as well as the size of the market for such a service. It will also give you an idea of priorities, so that the artefacts likely to be used the most can be put in place first, allowing time to select and prepare other artefacts once the system is working.

Another great problem in setting up a loan service is that of curatorial suspicion or hostility. As with handling collections there is a great reluctance to allow artefacts to be handled by the 'untutored', let alone allow them out of the museum unsupervised by museum staff. There may even be legal and insurance complications that need to be resolved. A delicate balance has to be reached and maintained here. On the one hand, it would be unrealistic for education staff to expect high-quality material to be released for use, but it would be churlish of curatorial staff to lend only that material which they would otherwise have discarded. That said, there are times when very poor-quality material is of use in education. Generally, however, quality should be the criterion, not quantity.

A loan service is not a separate entity from other services you offer – although it may be the only service you *can* offer. A package of loan material should be seen as an integral part of a group of services offered in conjunction with a specific programme of work, whether that relates to permanent or temporary exhibitions. Not only does this make it easier for you to put a loan package together; its integrated nature will make it more appealing to teachers because of its direct relevance to their visit to the museum.

Aim to keep the administrative set-up as simple as is compatible with the need to check the material each time it is returned. You do not want to spend your time on complicated paperwork and users do not want to spend time waiting for you to complete it.

The aim in providing loans is not just the artefacts *per se*, but education in the attitude toward them. Students must be allowed to work with artefacts in order to learn an appropriate respect for them, along with the correct techniques for handling them. Moreover, not all loan material need be for handling. It is perfectly possible to loan items in sealed cases. Other options include developing a range of replica artefacts. This might be expensive in the case of complex pieces, but simple pieces that lend themselves to 'mass' production are always worth considering. Visual material (such as prints, slides, and video) is much easier to reproduce, although care must always be taken to ensure that colours are matched accurately. The production of CD ROMs has already been mentioned.

Despite the varieties of material available, there are two basic kinds of loan service. The first might be described as 'pick-and-mix', in which teachers are allowed access to the entire collection of loan material to choose what they want. Whilst this provides a high degree of flexibility for teachers, it can be an administrative nightmare requiring huge amounts of paperwork to ensure that everything is properly monitored and accounted for.

The second kind of loan service offers pre-selected collections on certain themes and topics. This means a great deal of research on your part to find out exactly what teachers want and then providing packages that satisfy their needs. The advantage, however, is that you keep a much tighter control over materials that are loaned and the administration is easier. This does not preclude special loans, but it does leave your loan collection intact for controlled development.

Nor do loans have to be collections of artefacts. It is possible to put together collections of material that can be used by teachers for preliminary work or follow-up. These can work to a theme but contain entirely modern materials like slides (with commentaries), videos, replicas, workbooks full of relevant activities and suggested lines of research, and so on. Most often, however, a teacher will want a small collection of related artefacts. They may be of a common type (for example, writing implements) or connected with a theme (for example, weaving).

Value of service and artefacts as educational resource

Given that loan services can be time-consuming, it is important to understand their value to educational users as well as to the museum. Whilst the emphasis throughout has been on trying to get educational groups to visit the museum, there will always be groups who cannot do so. Without outreach programmes, they are effectively cut off from a part of their own heritage and, in some cases, an understanding of the heritage of others. As the central reason for museums is the preservation and display of material culture, it is essential that outreach programmes include the opportunity to experience and work with artefacts. In so doing, the museum is ensuring equality of provision, not just for schools, but also for the entire community.

Material displayed and worked with in schools is seen by parents and other adult visitors to the school. Indeed, it is not unknown for this material to attract parents, especially if the material relates to periods that, whilst it may be history to younger students, is within living memory of parents or grandparents. Likewise, material borrowed by community

groups can also stimulate interest, discussion, and feedback to the museum in terms of information and the donation of artefacts.

Where formal educational groups are concerned, access to artefacts is an important element in a teacher's delivery of the curriculum. Students can only learn so much from text and pictures. A much greater understanding derives from handling and exploring objects related to what is being studied. This applies to all areas of the curriculum and is by no means confined to history. An exploration of this is to be found in Chapter 13.

Artefacts also act as a stimulus for cross-curricular work. No object can be seen solely in terms of a single subject. A lantern, for example, may come from a particular period in history and relate to a specific social condition, but its manufacture broadens that aspect of its existence whilst at the same time being the focus for a study of materials, economics, and so on. This helps students to relate one subject with another by being applied to or derived from a particular focus.

In general terms, working with objects opens up the opportunity to explore the whole of material culture. This allows consideration of the different ways in which we value objects and how that is tied to a broader understanding of the world and of the society in which we live. It also provides a way into exploring how different cultures have approached the same problem and how different cultures value things differently.

This, of course, cannot be achieved without an understanding of the past, as it is through time that these things develop. Comparison of values and techniques of production, along with an attempt to understand the thinking behind solutions to design problems all help to shed light on what can be a difficult area of understanding, especially for younger students. Concepts connected with time are not easy to learn, especially today when we live in a society in which many of our material possessions are considered old after a year and are replaced.

Handling and working with artefacts has a lasting impact on students. Most education is text-based, and anything that enriches that is of great importance. This is especially so for those students who have problems with literary skills and classroom-based study. Such students derive a great deal from working in a different way. They are able to make use of skills that are not accessed in using text and can make progress in understanding concepts that would not be revealed to them via text. The more opportunity students like this have to work with material culture, the better is their educational and social progress.

The fact that the artefacts in question are genuine, historical artefacts merely enhances the impact further. What is more, there is a magical element to this from which even older students are not immune. To have immediate contact with the lives of everyday people from the past is both exciting and stimulating, even when (or perhaps especially if) the objects are mundane.

There is a further point here. We have already considered how a question of value is raised by exploring material culture and handling artefacts. That students are aware of this and trusted to work with such objects is good for self-esteem. Where students have a particular problem with self-image (often because they have problems coping with the normal, text-based approach to learning), this can be of great value to them and to their peers.

Practical matters

In choosing material to include in a loan collection, there are clearly a number of issues to be taken into consideration, quite aside from those already raised. If you are starting from scratch, it is important to begin with a small selection of items. Starting small will not only allow you to develop the collection but also to cope with a new system of administration, ironing out any problems before they develop into fatal flaws.

Quite aside from popular material, and eventually developing as large a collection as you can, there is a question of what is appropriate. All artefacts can provide stimulus. However, other factors have to be taken into account. Objects that are too large or heavy may be what teachers want, but there are questions about transport, along with safety and security, which have to be given careful consideration.

There is also the question of whether all artefacts should be the genuine article or whether replicas are acceptable. Questions of fragility answer themselves. Certain items are simply not robust enough to be handled and would not be included in a handling collection of any kind. However, they may be extremely important in respect of education and replicas are the obvious (if sometimes expensive) answer. Replicas do also remove some of the pressure from teachers who may worry about genuine artefacts being damaged whilst in their care. They also provide valuable lessons in themselves, with students being asked to see if they can tell the difference and discuss just why some objects are genuine and others are not.

A loan collection must be kept separate from items not seemed suitable for loan or handling. Not only does this prevent the possibility of fragile or rare items being loaned by mistake, it makes it easier to monitor the status of loans. This will undoubtedly create pressure on space and will probably require a major reorganization of storage space within the museum – which is another good reason for starting small.

Exactly how the artefacts are organized depends largely on the type of items in the collection and the way in which loans are made and administered. If you loan themed boxes or collections, they can be kept together in those particular collections. If you operate a supermarket approach and allow teachers to choose whatever they want, other systems will have to apply. Whatever the case, everything needs to be clearly labelled and treated with the same care as other artefacts. You have, in essence, a library of objects and they need to be grouped in categories that make it easy to put collections together.

Loan material should be well presented. Although expensive, boxes containing loan materials should be sturdy (aluminium carrying-cases are ideal) and prominently and indelibly marked with the museum's name, address, and telephone number. The contents should be well packed in shock-absorbent material so that nothing moves in transit. Bear in mind that some materials, even though deemed safe for such service, will need other forms of protection against, for example, too much light or extremes of temperature. Be guided in this by curatorial staff. All items should be readily identifiable and accompanied with notes on their care as well as teaching materials.

The level of information for teachers depends on the system you use. Whilst it would be possible, in theory, to have separate sets of notes for each item, the only practical way of delivering these is to make them available online as downloadable files. It is then up to the teacher whether they wish to read them online or download and print hard copies. Booklets accompanying themed boxes or collections are easier to produce. However, these will come in for wear and tear and should be replaced on a regular basis.

Produce a catalogue of what you have on offer. This should be clearly laid out, comprehensive, and indexed. It should also contain full details of how to book loan materials, general notes on the care of objects, and the responsibilities involved. Make sure that, like all other publications, it is dated and updated regularly. This should be available online as a downloadable document as well as a hard copy version for those without access to the Internet. Ideally, each item should be represented by a clear photograph as well as a written description, along with a unique identity code to make ordering easy.

Your booking system should allow teachers to book well in advance. You also need to keep a detailed record of who has borrowed material and what they have used it for, as this will aid your development of the resource. It must also allow you to check for losses, damage, general wear and tear, and any other problems so that they can be dealt with in the appropriate manner immediately they become apparent. Aim to keep the administrative set-up as simple as possible (and as legal requirements allow – after all, you may be loaning material that was itself loaned to the museum). Subject the service to constant assessment so that it always meets the expectations of those who use it.

The administrative system can be based on the Brown Issue system that libraries used before the advent of computerization and bar codes. Each object has its own issue card that, when the item is loaned, is placed in the teacher's ticket. This is then filed in stacks under the date set for return of the item. The system is simple and rapid. No matter how much administration you do (entering the information onto a computer, for example), it means that teachers can borrow and return items quickly. It also means that you can tell at a glance who is due to return material. Using this system has the advantage of limiting the number of items that teachers can borrow at any one time. What is more, when first issued with tickets they can sign a declaration that they will look after the items in their care instead of having to do it each time they borrow an item.

If you are extremely lucky and work in a museum with a large staff, it may be possible to appoint someone whose full-time task is the development and administration of a loan service. Indeed, in museums where the loan service constitutes the whole of the education programme, this will be essential. Collections of certain items (such as replicas, slide sets, videos, CD ROMs and the like) can be established at and loaned through teachers' centres and community centres.

As with any material borrowed from a library, you will have to set a time limit to the loan. This will vary, depending on demand and the size of your collection. Four weeks is good enough if the service is used heavily, but if there is less pressure then half a term or a full term may be possible. Impose fines for overdue returns and make sure that all borrowers know that they exist and what they are.

How the loans are conveyed to the school and back to the museum is a question that will have to be decided at the outset. In widely spread and largely rural areas where the loan service is the main educational programme, it may be possible to make use of the education authority's courier service (if it has one). If such a service does not exist, or its use is impractical, you will have to decide whether the museum makes deliveries and collections or whether that will be left up to teachers.

There are cases to be made for both systems. If teachers have to come to the museum, you have the opportunity to check the material in their presence to ensure that it is all there and in the same number of pieces as it was when it left the museum. It also brings the teacher into contact with the staff responsible for the service as the loan collection itself. Providing your own delivery system, on the other hand, will take pressure off teachers who

already have much to do. In the end, it will come down to how much the museum can afford.

A decision will also have to be made about whether or not to charge for the service. Wear and tear on materials means that they will have to be replaced on a regular basis. Someone has to establish and administer, as well as maintain the artefacts and other materials. Research and development work has to be carried out. If a charge is made, however, it is important that it be kept as low as possible to ensure that no one eligible to use the service is excluded.

Development of the service

Once the system is established and working well, there are two major ways in which it can be developed. The first of these is in the training of teachers to use the system to fullest effect. Although loan material is undoubtedly popular with teachers, many do not know how to use it to its full potential. Most teachers are, after all, text-oriented. Many more do not bother with a loan service at all because they do not understand the value of three-dimensional objects, or their relevance to the subjects they teach. Teachers and student teachers must be shown (a) that examples of material culture can offer a great deal to the education of their students, (b) how to get the best out of such objects for themselves, and (c) what your loans collection contains and how they can make best use of it.

A more ambitious form of development is to broaden the loans system to include people. This means compiling a databank of experts on some of the themes by which loan boxes or collections are compiled, as well as relevant artists and artisans who can illuminate other aspects of material culture. These should be people who can be approached to provide talks and activity sessions. All the usual legal safeguards have to be put into place and it has to be remembered that these are people and not objects. They cannot be taken off a shelf as and when a teacher wants. However, building up a resource of local experts such as this is a worthwhile way in which to connect schools, museums, and their community.

13 *The School Curriculum*

Having considered some of the ways in which you can present programmes of work, it is worth taking a quick look at the major areas of subject-matter dealt with by teachers – especially those working with five- to sixteen-year-olds. Most teachers who bring students to museums are teachers of history. Whilst this is quite natural, it is a great shame that teachers of other subjects do not consider museums as a realistic option. One reason, of course, is that they are unaware of any relevance that museums might have to what they teach. It is incumbent upon the museum educator, therefore, to draw any relevance to their attention and to work in concert with them to develop appropriate programmes of work.

It is not possible to go into detail here about individual subjects. Their characteristics change from place to place and time to time. However, certain basic principles remain unchanged. Each of the main subjects to be found in school curricula is treated briefly below, with just a few examples of their connection with museums to give a flavour of the work that could be done. With each subject, the aim is to consider those skills and areas of knowledge that are basic to the subject and that can be taught or practised using museums. No attempt has been made to cover any other subject matter, as the scope is too broad.

Language

Language work falls into two broad categories – native language and foreign languages (both classical and modern). Within these categories, there are a number of specific areas of interest in which students can benefit from working in a museum environment. Museums use language in a number of contexts and forms, from labels to guidebooks, display panels to visitor information signs. These can be studied and analysed in their environment. Work can be done with the help of the museum that may not only provide a contextualized study of language, but also benefit the museum by showing ways in which it could improve its own use of language.

Communication skills can also be practised. A number of oral and written exercises can be undertaken within a museum environment. Descriptive and analytical language can be practised, along with report writing, using signs and symbols, giving clear instructions, and so on.

Special programmes can be devised to help students who have language and learning difficulties. Language is always best learnt and practised in a context, and a museum can provide a fresh context that may help to stimulate interest, especially through working with artefacts and moving away from text-based approaches. Many students who have poor writing skills and who do not do well in a school situation can use their verbal skills to great effect in this different environment.

The same applies to the learning of foreign languages where expeditions to museums can aid the practice of oral skills as well as broadening vocabulary. With a little extra effort,

workbooks and worksheets in appropriate languages can be devised, as well as more comprehensive guides for older students who are more fluent in the language.

Beyond this, museums may contain historical material that relates to earlier forms of language, allowing students a chance to see how the use of language has changed, and to explore some of the social and historical reasons for such change. This can include the study of place-names, maps, documents, letters, diaries, and other documentary material.

The history of writing can also be studied within the museum context, especially if the museum has relevant examples and artefacts in its collections and can provide materials for students to work with. Workshop sessions can be set up to look at the making and use of quills, wax tablets, paper, ink, printing blocks, and other materials and techniques related to writing.

Literature

Two aspects of literature can be covered using museums. The first has to do with the author of the work. Some museums are devoted to writers (primarily places of residence that house artefacts relating to that person). These, however, are specialist museums; it is unlikely that a more general museum can provide the same sort of resource. What they may have is collections relating to the time in which a given author lived. These can offer an interesting insight into the life and times of a writer, as well as any social or historical factors that influenced their writing.

The second aspect has to do with the work of literature itself and its temporal setting. This too can be explored in museums. Costumes, artefacts, documents, even vehicles and buildings, can all help to bring a period to life and add to the understanding of the way characters behave in the situations in which they find themselves.

Mathematics

Although some aspects of mathematics are probably more relevant to archaeology – and by association to museums – there is a considerable overlap. In archaeology, the use of surveying (involving the collecting and recording of data), accurate measurement, quantitative analysis, set theory, plotting, and the like are all skills that can be taught and practised in relation to archaeological work associated with museums.

However, museums also contain a wealth of materials that are open to mathematical investigation. To begin with, any artefact that is catalogued is usually measured. Means of measuring the most diversely shaped of artefacts and recording those measurements is a good starting-point. This could be followed up by looking at ways in which the measurements can then be used for further investigation. The use of mathematics in the original construction of artefacts is also a rich field for development, for example in exploring early forms of measure and standards of accuracy, along with the instruments used for this. There is also the somewhat neglected area of the social and spiritual aspect of mathematics and number for more advanced students, which can be explored within a museum context.

Science (physics, chemistry and biology)

Museums are filled with examples of material culture. The study of materials and their use in all forms of construction is a prime area for scientific investigation. The origins of materials, the processes used to win them and prepare them for use, as well as the processes and tools used during manufacture can all be studied in a museum context. It is also possible to look at the effects of stress and wear and tear, as well as the processes of decay that affect materials.

In addition, a great deal of practical science goes on in museums with conservation and preservation techniques being applied to organic and inorganic materials. Scientific methods of dating are also of relevance. Artefacts and remains are studied scientifically in order to obtain information on a whole range of subjects including genetics, disease, and climate change. Many museums also hold natural history collections and materials relevant to environmental studies.

Geography

Although it is geology that most springs to mind when earth studies and museums are linked (many museums have a geological collection of some sort), there are many other aspects of geography that can be studied using the resources of a museum. Social geography evolves through time and this may be reflected in the collections held by a museum, especially where the natural resources of a given area have been exploited as a main source of employment and wealth creation. Studies relating to the development of settlement can also be reflected in museum collections. Geomorphology enables us to differentiate between landscapes shaped by nature and those shaped by the work of human beings, whose tools and remains, along with other evidence of human activity, may be studied. Museums may also hold collections of maps that provide an extra dimension to the study of the development of a given area. The making of maps can also be studied.

History

There is an obvious and well-understood relation between a study of history and the need to have access to primary source material. This is what museums contain. Students have the opportunity to assess this material, taking into consideration its nature, condition, and state of preservation, which may all relate something of its importance in the past. In this way, it is not just history that is studied, but also the relative importance of events, people, and record keeping through time.

The opportunity also arises to compare the importance of documentary source material with artefacts, as well as the many ways in which both can be interpreted. The reading of objects and collections of objects is a special skill, but one that can provide as much information as can be gleaned from documents. It is in museums that these skills are concentrated and where they can best be taught to students.

Sociology, politics and citizenship

Whilst museums deal primarily with the past, it is possible to use them to aid in teaching about current affairs and future conduct. After all, the present and the future are shaped by the past; events and attitudes in the world today have their genesis in yesteryear. Documents, pictorial material, and artefacts can all shed light on social and political movements and ideas.

Citizenship is a far more nebulous concept and museums may not seem obvious candidates for work in this area. However, every visit to a museum requires certain behaviours of students. This provides ample scope for discussion about people's responsibilities in social situations and how different environments and expectations can affect how we behave. Visits are also the ideal opportunity to put ideas and attitudes into practice. It is also possible to assess their worth and their effect on interaction and participation in general and educational activity in particular.

Craft, design and technology

Every artefact that has been made or used by human beings has an aspect of construction or design, even if it is the simple recognition of the potential of a natural object as a tool. Where collections of artefacts exist, it is possible to study the evolution of a design and consider the various pressures that led to any changes. It is also possible to look at materials from a design and technology perspective. You can study how their use has changed over the years, and how different peoples (in different times and cultures) have approached the same design problems and come up with alternative answers.

In addition, there are museums themselves. Museum design (of both buildings and exhibitions) is an extremely rich field that is well worth exploring, from internal layout and visitor flows to exhibiting artefacts, their safe storage, and design of efficient catalogues and archive systems. Again, the benefits can accrue to both students and museum.

Aspects of information technology can also be taught in a museum context. The use of complex databases for cataloguing and scientific analysis is where computers first came to the fore in museum use. Now, with the advent of various forms of scanning and sophisticated graphics, it is possible to use computers for a much wider variety of tasks.

Archaeologists were also quick to spot the potential of computers, and the introduction of powerful portable computers has proved invaluable. This is becoming more evident with the increasing sophistication of software that allows very quick interpretation of results from electromagnetic and other non-intrusive field surveys.

Art

Apart from presenting the history of art and offering the opportunity to study works of art, museums and galleries allow students of art (as of other subjects) to study the social conditions under which works of art were conceived and produced. In addition to that, students can also learn about the various forms of visual recording used by archaeologists and museologists – each of which has a specific use. Sketches, site recording, the formalities of producing illustrations for archaeological reports, photography, the visual design of exhibitions

and so on can all be looked at in context within museums. There are also other areas of art and crafts where artefacts can be studied (jewellery is a good example), both for technique and design, in order to provide inspiration for present-day pieces or for producing replicas – an extremely useful approach to understanding the processes involved.

Music

Music plays an important part in our lives. For many it is merely entertainment, but it has often played a social and historical role. This is especially so since various forms of mass media have enabled the reproduction and distribution of music and songs to a wide audience. Music is also an integral aspect of cultural identity. Museums may hold sound archives that can be explored. Museums may also have collections of musical instruments and artefacts relating to specific musicians and composers. They may also be able to illuminate the social context of specific pieces or styles of music.

Drama and theatre arts

Students of theatre or even members of amateur dramatic societies often become involved in presenting plays with historical contexts. Local communities put on pageants celebrating local history. Drama is often used to explore relationships and conflicts that a historical context. Museums can provide a wealth of information on local history, social history, costume and prop design, set design, correct ways of carrying and using objects and so on. This is in addition to the literary aspect connected with playwrights and their work, already mentioned in the section on literature.

Physical education

Physical education is often thought of as being little more than games or gymnastics. However, much has changed in this area of education, and physical education now takes a much more holistic approach to the body and physical well-being. Health issues are reflected in social history generally, and may even be the focus of exhibitions where museums have appropriate collections. Many major sporting venues and organizations now have museums for those with specific interests in particular sports.

Spiritual, religious and moral education

It may seem odd that spiritual religious, and moral matters can be studied in places devoted to material culture, but we are beings with material existence and our spiritual lives are often expressed in material ways. Outside of living places of worship, museums are where religious artefacts are most likely to be found. There is a great deal of ethical debate about museums holding such material and it would be healthy to involve students. What is more, we often forget that museums are not simply collections of material objects. They are places of the muses where artefacts can, if well presented, provide students with inspiration.

Understanding material culture presupposes an understanding of the non-material culture that led to its creation. As much as we can analyse artefacts, we cannot hope to understand them completely until we have some appreciation of the hopes, aspirations, thoughts, beliefs and behaviours of the people who created them and of the cultures in which they lived. If we do not address that, we are not educating truly or fully those who come to museums.

14 *Logistics*

It is a sad fact of modern life that many companies and organizations in the service sector are so poorly managed that a problem-free encounter with them is now the exception rather than the rule. This reflects badly on them and counteracts much that they do in the way of marketing. They may feel they can afford to waste money, time, and reputation in this way, but you, as a museum educator, cannot. It is of vital importance, therefore, that you do all in your power to ensure that all your administrative and educational dealings with user groups are problem-free.

We all have our own style of working. We all organize things on our desks and in our working spaces in individual ways. However, we should not allow our style to get in the way of efficiency. Much of what follows is common sense, but it is easy in the day-to-day hurly-burly to become muddled and to make things unnecessarily complicated. If you can sort out straightforward administrative procedures at the very start, and stick to them, you will not only save yourself a good deal of work in the long run, but you will also ensure that even in times of crisis you have a system that will not fail.

Whatever you decide to do, sit down and think about it first. Then research it. Having done that, amend your first thoughts accordingly before beginning to construct systems and programmes of work. Your working day, your working week, and your working year must have time built into them to allow you to do these things. The natural urge is to get out and act. However, if you crowd out preparation, evaluation, and administrative procedures with teaching activity you lose the chance to become an educator. You end up being a museum teacher and a bad one at that, always in a muddle and always running to catch up.

Proper organization and preparation can benefit you in many ways. Each section that follows discusses the basics. They are mostly small procedures, but they do help to make life easier. Examine every aspect of your work in light of what you read to see if you can organize it in a more integrated, simpler, and efficient fashion.

General practice

Administration is an inevitable part of museum education work. You may feel it is a chore to be suffered as a consequence of all the enjoyable things you do, but you must take it seriously. You should realize that all your administrative tasks are integral to the services you offer. For example, the paperwork involved in taking a booking is an essential part of the service that is being booked. The information you gather and pass on to others allows for the smooth operation of that service. It also allows you to evaluate the popularity and effectiveness of the service, essential if you wish to keep making improvements.

All administrative work should be dealt with as soon as possible. If it cannot be dealt with immediately – and your systems should be designed to be as simple as possible to allow

this – then the first opportunity afterwards should be taken. Most work can be done there and then, filed away, and forgotten. Do not on any account let work pile up until you are forced to do it. Things will get lost, you will miss deadlines, and it will take extra time to get everything organized. Indeed, the task may become so overwhelming that you reach the point where you are left with a permanent backlog.

Mail

Ensure that your mail is opened as soon as it arrives. Use a date stamp to record when you received it and then sort it into categories depending on urgency and ease of reply. Not everything will need a response – circulars, replies to letters you have sent, and so on – but they will all need some action, even if it is only to read them and take note of their content.

Aim to respond to all letters that need a response within 48 hours, even if it is only to say that you have received the letter and will reply fully in due course. Pre-printed postcards can be used for this. Little is more contemptuous than not answering letters.

Keep all correspondence on file in chronological order in relevant categories. File hard copies of replies with their respective letters. It is just as easy to take a file out of a cabinet, as it is to find what you want on a computer and match it with the material you have had to take out of the cabinet anyway. Computers are all very well, but if there is a power cut or the system crashes when you are dealing with something, you are stuck. And remember, the point of a filing system (whether in cabinets or on a computer) is to keep things in such a way that you, or anyone else, can find what you want without difficulty.

E-mail should be checked just once a day. Treat it the same as any other form of formal correspondence. Lay it out neatly, check spellings, and always append a machine signature. Learn how to organize your e-mails into folders and keep your address book up to date. There are many other features available with e-mail software and it would pay to take the time to familiarize yourself with them. You should also become conversant with software devices such as spam filters and firewalls that protect your computer from viruses, spyware, and unwanted mail.

Record keeping

Keep a statistical record of all your educational activity. This will, as it builds up, provide you with an invaluable source of information about the uptake and popularity (or otherwise) of services, seasonal changes and long-term trends. It will also give you information about individual user groups, as well as different sectors of the education market, showing you which ones use you most, and which use you least. From such information, it is possible to devise future strategies and identify areas of the market that need targeting. You will also need to keep such information in order to produce accurate reports for management and financial backers.

You do not need to keep complex information, and most of it can be derived from booking forms (of which more later). Keep all your raw data, even if you process them regularly. The least amount of information you require is: who is using the education services, which specific services they are using, how many in their groups, when they come, and how long they stay. If people have to pay for any or all of your services, keep a note of receipts,

even if they do not come directly to the education department. If kept on a properly configured database, this information will automatically update when you enter material.

If you keep personal information on record – especially on computer – make sure you comply with the law. It is illegal in some countries to hold personal information on computer unless you are (a) registered to do so, (b) have the permission of those on whom you keep information, and (c) allow them to see what you hold should they so demand. Check whether the museum complies and precisely what sort of information you are allowed to keep.

Library

If you are building up a museum education library of books and journals, keep it well catalogued, with a separate system for noting the location of any material that is loaned out. How far you go in cataloguing is entirely up to you, but a basic record of title, author, publisher, ISBN, and date of publication is the bare minimum. This can be kept as a simple card index. If you are starting from scratch, you might want to include detailed information on the content of each book or journal, building up a comprehensive index. Free bibliographic software is available online. If you keep your catalogue on computer, make sure it is readily available to others.

Keep your books and journals in order, even if you only have a few. As your collection grows, you may wish to put them into categories. Journals can be stored in cardboard magazine boxes and should be kept in chronological order. Label boxes clearly and try to keep them tidy. Nothing hinders research more than having to sort everything out first.

Reports

Gratifying as it is to be asked to report on your activities, do not use this as an opportunity to show off any latent literary talent. Reports are ephemeral, especially if they report good things. It is therefore wise to keep them brief to the point of being skeletal unless you are asked specifically for detailed information. If anyone wants to know more, they can ask you to prepare a supplementary report that goes into the subject in greater depth.

Always keep to the same format and order and head each section. If the report is to include statistical information, keep it as simple as possible. State clearly who has produced it, who it has been produced for, and date it. Always keep the original for yourself.

Forward planning

Whether you are working alone or as part of a team, you will need strategies for coping with your workload. Build time into your working schedule for forward planning. If you are starting from scratch, ensure that you have an amount of time for setting up before you open your educational doors to all and sundry. That way, you will have a solid structure in place to support you through what are likely to be hectic days.

Try to plan your days, weeks, months, and even years – in outline at least. Know when special events are likely to be needed to coincide with new exhibitions. Work out whether there are seasonal offerings you can make that are relevant to your museum. Know the dates of school and college terms. Know the dates of public holidays.

Something as simple as a wall planner can be an invaluable guide to the shape of your year. A diary will also help you plan your workload, especially if you block out time for yourself in advance. Try not to eat into it. If you are in and out of your office a great deal during the day, photocopy that day's page of your diary and keep it with you. It is an effective way of making sure you know where you are meant to be without having to remove your diary from its place on your desk. After all, other people may need to consult it in your absence.

In planning your day, give yourself time at the start to look at your mail and sort it for dealing with later, as well as preparing for the day's work. Make sure you take a break during the middle of the day. You will do nobody, least of all yourself, any favours by overworking. At the end of the day, you will need time to clear up, wind down, assess what has happened, and cope with any administrative tasks you will invariably have. This may seem to leave little time for anything else, but in reality, it takes up less than a quarter of your working day.

Meetings

If you are the only person responsible for education, you have the advantage of knowing everything that is going on and being in touch with everyone. If you are part of a team, then it is important to set up a structure whereby all team members are kept informed. This can be done through formal meetings, the structure of which makes it easy to keep track of who has been told what. If you work in a small museum, it can be done less formally. Whatever approach you take, set aside a regular time in your working week for a formal staff meeting. You can close the doors on everyone else and sort things out without interruption.

For other meetings, you must consider whom you are meeting and why, and present yourself accordingly. It is common courtesy to be on time and to look presentable. Never go into a meeting unprepared; it creates a bad impression. If you have not received an agenda two days before the meeting, get in touch with whoever is responsible and ask for one. If it is still not clear to you either what the meeting is about or what your role is, telephone whoever is responsible and clarify things. It is far better to do this than to turn up without relevant information.

Always ensure that you receive the minutes of any meeting or portion of meeting you attend, and do not be afraid to challenge them and get them corrected at the next meeting if they are inaccurate. If they have to be corrected, make sure you obtain a copy of the corrected version. They represent the official record of that meeting, and will be referred to if there is any confusion or dispute.

Choosing equipment and material

You will use a great deal of equipment and material in your work, and care must be taken when choosing such resources for use with educational groups. Consumables such as paper, card, pencils, paints, glues and so on all need to be chosen in forms that are compatible with use by young students. They need to be non-toxic and safe.

Paper is a precious resource. Use appropriate types for given tasks and always make the best use of it. If paper is used on one side only, save it, and cut it down to make scribble pads

for your own desk. Make enquiries about local recycling schemes. All consumables can be obtained in bulk through various agencies (manufacturers and suppliers alike), and they are well worth approaching for sponsorship in kind.

Heavier equipment such as tables, chairs, and the like also need to be chosen with great care. Not only must they be safe, but they also need to be durable and appropriate. Chairs for very young students are neither comfortable nor healthy for adult use. Tables must be of the right height and appropriate for the use to which they are put. If they are collapsible for easy storage, make sure they are childproof.

If you are providing facilities for students to eat packed lunches, remember that tables and chairs will have to be cleaned afterwards, floors swept and mopped, and debris disposed of. As this furniture may be needed for other uses, make sure that health and safety legislation will allow tables used for art and craft work to be used for eating as well.

Working equipment such as computers, projectors, printers and so on are very expensive and any purchase has to be considered very carefully. If new equipment is to be purchased for the purposes of education, within all the normal constraints, you must have the final word on what is chosen. Think hard about the use to which you will put anything, research your options thoroughly, and always get the equipment that most closely matches your requirements. Compatibility is also important, especially where computers are concerned. So too is maintenance. If you rely heavily on some pieces of equipment, make sure you can get them repaired quickly or replaced if they break down.

Electronic equipment is increasingly sophisticated and expensive. If you work in a large museum there may well be a central office where photocopiers, laminators, scanners and the like are located for common use. If you do not have the luxury of all the latest technology, look for ways of using someone else's. Local resource centres may offer you good rates, especially if you save work up and have it done in bulk. Once again, sponsorship is a possibility, especially for one-off ventures.

Enquiries

Keep a record (name, work title and contact details) of all enquiries about education services. If, after your initial response, the enquirer has not come back to you, follow up with a telephone call or e-mail. If you have space on your initial leaflet, ask enquirers to write and say why they have not made use of you.

If the enquiry is by letter, fax or e-mail, it can be dealt with easily enough by sending a leaflet. If there are specific enquiries not covered by a general leaflet, answer these briefly and invite the enquirer to make an appointment to see you in person.

Keep a message book by your telephone at all times. Make a note of all calls. Date, time, whether incoming or outgoing, who was talked with and, briefly, what about. If you are out of the office, anyone else answering the call can fill it in for you. When you have dealt with a call, mark it off. This record not only allows you to keep track of how much you use the telephone, but also gives you an idea of how effective it is as a medium. Furthermore, the message book acts as a record that can be referred to if a dispute or confusion arises.

Booking procedures

Any booking procedure you devise must be as simple and as quick as possible for those making a booking, yet should obtain sufficient information for all your needs. At the very least you will need the name of the teacher or group leader, the institution where they work, the size of the group they are bringing (including additional teachers and helpers), the age of the students, what service they want, what date they want it, and what time they want it. This will need to be matched with available space in the museum for visits or available resources for other services.

You may wish to set a limit on the number of educational visitors in the building at any one time. This will depend on the size of your museum and the services that groups want to use. It also depends on whether they all want to make use of other facilities such as cloakrooms, workrooms, eating spaces, and so on. This can become extremely complex and you will need to devise a simple way of knowing who will be where at any given moment of the day. A chart with the areas available along one side and the times in use along the other can easily be blocked in as bookings are made and gives you a quick visual reference of who and what is available.

These working conditions should be explained to people who make bookings, especially if you cannot fit them in on their preferred date. This situation can become complicated if you allow postal or e-mail booking as there is always a delay in information moving back and forth. You may need to insist on personal or telephone booking only.

You will also have to bear in mind, when devising your booking system, who else in the building needs to know about visitors. This might include shop staff, security, front-of-house staff, other education staff, café staff, and so on. Rather than hand these people details on an ad hoc basis, it might be easier for all concerned if you give them a weekly diary with salient points (such as date and time, numbers, age, what the groups will be doing and where they will be going). This presupposes that bookings must be made at least two weeks in advance, but that is not a bad policy.

If you allow provisional bookings to be made, these must be confirmed or cancelled at least two weeks before the intended date of the visit. If you ask for an advance on any charges, make this non-returnable if groups pull out less than two weeks before they are due (unless, of course, there are mitigating circumstances).

All bookings should go into your diary – in pencil for provisional bookings and ink for confirmed bookings. You may need to design your own diary if you run a number of different services – a standard A4 page with normal diary space at the top and sections at the bottom for visits, loans, outreach, and any other services. This is easily reproduced and can be kept in a sturdy ring binder. At the end of each month remove those sheets and file them. Replace them with a blank set at the end. That way you constantly have twelve months in your diary.

By far the simplest way of ensuring that you get all the information you need is to devise a booking form. If possible, make this an all-purpose form that can be used to book any or all services offered by the museum educator – including loans and outreach work. A single form has obvious advantages, not least of which are ease of administration and cheaper printing costs.

Design your booking form in two parts. The first part should contain the information you require from a teacher or group leader to make a booking (name, date, time, numbers, what service they want and so on). The second part of the form can contain space for

relevant extra information. You may also wish to compare numbers booked with numbers on the day, keep a note of how punctual a group is, their mode of transport, and any other information you feel is relevant or needed for evaluation and research.

When booking groups in, ask if there will be individuals who have specific and special needs that will need to be taken into account. This can range from various disabilities or medical needs through to such concerns as students from ethnic or religious communities that do not allow certain activities or contact with certain artefacts. You need to be aware of these things and sensitive to them.

A booking is a form of contract. You are agreeing that you will provide the service requested. Teachers agree to arrive on a certain date at a certain time with an agreed maximum number of students. It should be made clear to teachers that they also have other responsibilities, most important of which is the students they bring with them. You may agree between you who is to teach, but they are at all times responsible for the behaviour and welfare of students. It may even be a requirement of your management that a booking is confirmed by you in writing and that such a confirmation contains the conditions under which the booking is made. This may include further stipulations such as student-teacher ratios, disclaimer of responsibility for damage or injury incurred from an expressly forbidden activity, disclaimer of responsibility for loss or theft of property, and so on.

No matter how tempted you are to improve your numbers, never overbook, even if it means turning people away. You should be offering a quality experience, not going for quantity. Once word circulates that you are so good that you are fully booked, teachers will get into the worthy habit of thinking well ahead.

Remember, also, that as the resident expert you have a perfect right to refuse entry to any group you feel is coming for the wrong reason or which would prove disruptive to other educational user groups and general visitors. Any teacher who wants to visit just to fill in an afternoon and go shopping while you watch their students, or who could not get in last term but wants to come now (despite the fact that they are studying something else in the classroom) should be firmly dissuaded.

The whole booking procedure can be put onto computer, but the system you employ needs to be specifically designed for your needs. There are a number of advantages, not least of which is the speed with which a computer can collate information and print out copies and confirmations. If you decide that a computerized system is worth investing in, you must make sure that everyone is properly trained in its use and that anyone who is likely to take a booking has direct access to the system. If not, your whole education service will collapse.

A sample booking form, a list of suggested conditions, and a sample booking chart are to be found in Appendix 4.

Computer housekeeping

Although they are not yet universal, computers are used almost everywhere for administration. Their use for specific tasks has been mentioned elsewhere, as is the need to be competent in the use of the various forms of software they contain. Here, however, the concern is for general housekeeping.

Do not store files haphazardly. Work out a logical system of folders and sub-folders so that it is easy to save and retrieve material. Choose file names with care so that you can tell

at a glance what is contained therein. Incoming correspondence should be titled with the surname and initial of the person to whom it is addressed as well as the date it was sent. Dates should be the year in full followed by the month expressed as a two-digit number followed by the day, also as a two-digit number (for example, a letter sent to me on the 29 July 2004 would be named: Talboys, G – 2004-07-29). Files like these will automatically be saved in chronological order.

It is very easy to download material for research, place e-mails into folders, and generally allow a computer to fill up with clutter. This makes things more difficult to find, uses up space, and slows down the computer's operations. Housekeep at least once a month. Delete unwanted e-mails and files, use the disk clean-up programme, and defragment the hard drive.

Computers come with software and (if you are lucky) manuals. You will probably buy additional software (and manuals). Keep all this in one place and close to the computer. Software is usually supplied on CDs. Buy a CD storage wallet so they can all be kept together. Should your computer suffer a systems failure you will have everything to hand to restore it to working order.

The one thing not protected is all the information that you have put onto the computer in the form of files, databases, address books, and so on. For this reason, it is essential that you get into the habit of backing up all this material on a regular basis. How you make back-ups depends on the sophistication of your computer and the amount of material involved. Re-writable CDs are the commonest solution, but increasingly capacious and easy-to-use external hard drives make it easy to save not only your files but also your software with all your personal settings.

Preliminary visits and observation

Teachers should be invited – indeed, they should be strongly encouraged – to make a preliminary visit before actually bringing their students. This can be before or after they have made a booking. If the museum normally charges an entrance fee, this could be waived for teachers on preliminary visits. In particular, teachers will need to familiarize themselves with the museum in a general sense and get a feeling for the atmosphere of the place. They will also need to think of the logistics of the day, sorting out their group's route around the museum, assessing likely problem spots, locating toilets, education spaces, places to leave bags, coach parking, and so on. In addition, they will be able to decide on which areas they want their group to concentrate, study the displays and artefacts, and work out what supplementary material they might need. Having done this, they will no doubt have questions and you should try to make yourself available to answer them.

If teachers cannot visit in person, a booklet will help. What teachers particularly want is information on the following points:

- Is there parking for their transport? If not, is there a convenient drop-off and pick-up point? How far is the parking or drop-off point from the museum? Will they have to cross any roads, walk through busy streets, and so on? Is the museum close to public transport routes?
- What are the opening times of the museum? Will the museum open specially for educational user groups?

- What are the admission charges, if any? Are there concessions for students, groups, educational parties and so on? Does a deposit have to be paid? Does payment have to be made in advance, on the day, or is the museum willing to invoice the school?
- Does the museum meet all legal requirements in respect of accepting minors on to its premises and working with them?
- Who should be contacted to make a booking? How much notice is required? Are provisional bookings allowed?
- How does the museum organize groups or expect teachers to organize groups on arrival and during the day? Is there a limit to the number of students that can be brought? What numbers and adult to student ratio can the museum cope with? Are there established rules of conduct? Will there be other groups present at the same time?
- Can the museum separate groups from the public and other educational user groups at any stage of the visit? Are there places where bags and coats can be left in safety? Is there an education room? Does it have to be booked separately?
- Where are the toilets, how many are there, and are washing facilities adequate?
- Is there sufficient all-round provision for differently abled students?
- If they are staying all day, is there somewhere adequate to sit and eat?
- Is photography permitted?

It is worth bearing in mind that the quality of a teacher's preparation for a visit depends as much on the quality of the information provided by the museum as on anything else.

Handling groups through the system

As well as the educational content of any service you offer, you are responsible for the structure of any visit within the museum itself. That means that every aspect of the visit must be catered for. If you are working with the group all the time they are there, it is a simple matter for you to guide them through from start to finish. However, you will not always be in that position and it must be made clear to teachers that they have specific responsibilities in respect of being in certain places at certain times and ensuring that their students comply with any in-house rules and codes of conduct.

If you have the space, set aside an area where arriving groups can congregate away from normal visitor flows into the building. This is especially useful for groups that arrive in bad weather. They will have a chance to gather themselves, listen to any instructions, and organize themselves before they start work. If you are working with them, this is a convenient way of taking control, welcoming them, and briefly letting them know what will be happening.

Be prepared for groups who arrive early. In most cases, these are easier to accommodate than those who arrive late, as they can simply start work a bit earlier and spend a little more time in the museum. Groups that arrive late must stick to their agreed timetable even if it means curtailing or cutting out some of their activities.

You may also have a room or rooms where students can leave their coats and bags and base themselves for work in the museum itself. If that is the case, and a group is making use of this facility, they should be taken straight there rather than congregating in the museum. Such areas must be secure if students are to leave their belongings.

Before any group is set to work, they should be reminded of their responsibilities (for example, not going anywhere without the consent of a teacher); told of emergency procedures for the day (for example, what to do if separated or lost); and reminded of what time and where they are to reassemble. Even if you are not working with them, this is a good opportunity to welcome them and let them know what is expected of them.

Give clear guidance to teachers about where they can work and at what times. This is especially important on busy days or if your museum is small. In very large museums, it is not quite so important but none the less advisable. In very small museums, you may have to restrict access to one group at a time, which gives them a slightly freer hand while there.

If students are making use of a refectory within the museum, ask them to confine themselves to that room and the toilets. Do not allow any food or drink out of that room under any circumstances. Make the rest of the museum out of bounds for the lunch break. Make sure that you allow sufficient time for students to eat and digest their food and relax a little. Refectories must be provided with plenty of litter bins and access to cleaning equipment to cope with spillages. You cannot dictate what students eat or drink, but encourage them to place their litter in the bins. Discourage them from placing half-empty cans or bottles of drink in the same place, as they will leak. If there is a sink, get them to tip unwanted drink away. If there is not, provide an area where cans and bottles can be left upright to be disposed of later.

If students wish to visit the museum shop, insist on small, supervised groups and do not allow them to take bags in with them. Large groups with bags swinging from their shoulders can cause considerable damage to stock. In addition, shoplifting by a small minority of students is a sad fact of life and it is wise to reduce the opportunities for this to occur.

If students are working in the museum for a full day, try to timetable their activities so that the afternoon session is shorter than the morning one. If you are working with them all day, try to make the afternoon different in tone to the morning. For example, if the morning consists of very structured tasks, the afternoon could be given over to a more fluid structure in which students can follow up items of particular interest discovered earlier in the day.

At the end of the day, check all rooms and areas used by students to see if anything has been left behind. Lost property comes in all shapes and sizes, from pencils to coats and bags, cameras, and lunch boxes. Identify the owner of the property or their group as soon as you can, label it, and arrange with the appropriate teacher for prompt collection.

First aid and emergency procedures

First aid is an extremely worthwhile set of skills to possess. It may well be obligatory for the museum in which you work to have first aiders on staff. If so, find out who they are. If no one in the museum has first aid skills, persuade your management to fund you to take a course. These are rarely expensive. You may never need to use such skills, but it is far better to have them and not use them than it is to need them and not have them.

Know where all the first aid kits are kept and satisfy yourself that they are adequate. You should also have medical emergency telephone numbers to hand, and an established procedure for coping with major injuries or illness. Never, under any circumstance, administer

any form of medication, not even aspirin. Minor emergencies also occur. If the women's toilets do not contain appropriate dispensing machines, keep a ready supply of tampons and pads.

You should also know the museum's emergency evacuation procedures inside out. If there is ever a fire or any other event that means evacuating groups in your care you must be able to do it calmly and with authority.

Museum User Group

Most educational visits to museums are made on a one-off basis, even those made by regular visitors. This is hardly an efficient way of working for you or for them. The setting up of a club for regular users has already been mentioned. The precise details depend on your circumstances and the results of any research you undertake, but you should offer members certain benefits.

Payment for membership could be made at the beginning of the financial year. This would entitle members to a certain number of visits and services in the year free of charge with, perhaps, reduced rates for any excess. Other perquisites could also be offered including, perhaps, a newsletter with first notice of new services, previews of new exhibitions, discounts on museum publications and merchandise and so on. Different classes of membership could be established. Passes could be arranged for or season tickets sold to older students, allowing them entry to carry out longer-term studies.

Any such system would need to offer distinct advantages in order for teachers and students to part with large sums of money, and it would need a coherent structure to deliver those advantages without fuss. Booking could be made easier in that a member would have a reference number, quotation of which would give the museum information about name and so on. Regular visitors would also be encouraged to book all their visits for the year at the beginning of the year. If all these services are offered at a discount rate, schools and teachers will be tempted and the museum will benefit from injections of capital sums that can earn sufficient interest in appropriate accounts to cover any deficit in earnings from the services offered.

Evaluation and research

There are different perceptions about evaluation, but all too often, it is seen as an exercise imposed by Big Brother. This is because it has been abused in the past, shrouded in secrecy, and used for negative ends. To counter that, it is essential that evaluation is built into the system and understood to be a process of education whereby all museum staff are given the opportunity to look clearly at the work they are doing, assess how well it is going, and see how they can improve upon it in the future.

No one likes to be judged, especially by those outside their field of professional competence. However, proper evaluation is not about passing judgement on individuals. There are many aspects of museum work that can be evaluated, of which the performance of personnel is just one. Moreover, if individuals are having problems, then regular assessment will prevent these becoming damaging and will point out ways in which the problems can be rectified.

Evaluation is, in any case, only half the story. If it is to be truly effective, it must work hand in hand with research. Both must be integral to the museum. In terms of education, the purpose is threefold. In the first place, it is to evaluate the services and the educational effectiveness of the museum in general. Second, it is to be used to conduct learning research. Finally, it is to be used to study the educational work of other museums and other museum educators. That is why it is essential that education staff are not tied solely to gallery teaching.

It is no use evaluating anything if aims and objectives are not defined at the outset of any project. What, for example, would be the point of determining how many facts are learned by visitors to an exhibition whose main purpose is to evoke an emotional response? This is another reason why museum educators must be part of the whole museum process and have an input in planning and design.

Evaluation does not just come at the end of an event, but should be used for continuous monitoring of the whole process. To a large degree, we do this sort of thing unconsciously, but any project should be looked at during the stages of its conception and throughout its life to ensure that all is going well. Part of the evaluation process comes into play when you have to start juggling with the different criteria you have for a given project. Cost, size, accessibility, security, and a host of other considerations have to be balanced while still trying to retain the purity of the original concept.

Some people like to work to set formulas and have questionnaires they refer to at each delineated stage. An approach of this nature provides a useful framework, but there is a danger that if you adhere to it too rigidly you end up designing projects to conform to the evaluation system, destroying any spark of originality they may have had. Be aware of the questions you need to ask, but never allow them to become a straitjacket.

Evaluation can be accomplished in a number of ways. By verbal means (formal meetings, informal discussions and feedback from teachers, students and visitors), it is possible to gain a general and sometimes quite detailed picture of whatever is under discussion. Written responses to questionnaires on specific workshop sessions, exhibitions, loan service materials, and programmes of work can elicit detail that is much more specific and can be controlled by you in order to keep the evaluation to a particular point. More generally, letters from teachers and students after in-house and outreach sessions can provide useful general information. Observation of how students and teachers respond to sessions can also yield good information. Finally, statistics provide a very telling analysis of certain aspects of what is offered to educational user groups.

Do not confine evaluation to new projects. Extant exhibitions, services, and programmes of work should also be looked at on a regular basis to see how they are standing up to the test of time and new developments. It is not possible to alter everything on a regular basis because of this, but knowing how changes affect static displays and projects can provide insight into ways of approaching them that give them new life at very little cost in terms of money or energy.

Quantitative evaluation is relatively easy and the raw data you keep can be used in a number of ways to help build up useful amounts of information. However, this provides little more than a framework – an outline picture. You may know how many and when, and be able to predict trends, but you still get no sense of usefulness or impact. To fill in that outline you need to undertake much more difficult qualitative evaluations. From these you can get an idea of how successful and popular programmes of work are and aim for the even more elusive goal of finding out why. With that sort of information and understanding, you

can produce the ideas that will move your work forward to levels that are ever more successful.

You will not be the only person interested in evaluating your work. Outside bodies, particularly those that provide funding, may wish to do their own evaluations. This external appraisal is usually quantitative in nature but it can be a useful means of evaluating your own evaluation.

Evaluation and any results and research that are connected with it are not just for your benefit. There is a much wider role in providing analysis and evidence of the effectiveness of museum education. As long as the evaluative work you do is soundly based, there is a large audience of museum educators and educationists in general who have a healthy appetite for anything that will help them gain an increased understanding of education. There are rich veins of research to be mined in museum education and, despite the good work that has already been done, there is much that would benefit from detailed study.

15 *Resourcing and Funding*

All that has gone before in this book counts for nothing without two essential ingredients: people and money. These basic resources make all the rest possible, yet they are the most difficult to acquire. Even large national museums have to work to relatively tight budgets. For small museums, the very idea of taking on an extra member of staff is often out of the question. They have neither the money nor the space. Yet that has not prevented many of them from making tremendous efforts to provide some form of education service.

Personnel

PROFESSIONALS

Finding the resources you need to make educational provision is not impossible, and there are a number of avenues that can be explored. In the first instance, someone has to be found who can do the job. The obvious and preferred solution is to employ, full-time, someone who meets the criteria set out in Chapter 3.

Other sources of personnel are available to a museum. All staff contribute in one way or another to the educational work of the museum. Few of those who have specific responsibility for education are specialist educators. Museums should, to begin with, actively and constructively develop the educational capabilities of staff, volunteers, and all who work in or for them.

Somewhere in the area, there may be another museum that already has a museum educator. It may be worth approaching that museum to see if their museum educator can be hired for a short time each week in order to assess your museum's educational potential and draw up an action plan. This has the virtue of involving a fixed sum of money, getting the help of an established museum professional, and ending up with a framework on which to build up an education service. The other museum benefits as well, if they are able to spare their museum educator. They get the money and they lose their museum educator for just a small amount of time each week for a fixed period while helping another museum to establish a new service. The marketing potential alone is very attractive.

Other solutions are possible. If the circumstances are right, a number of small museums could band together and contribute a proportion of the costs of employing a museum educator whose brief would be to provide services for all the museums. Any potential problems could be averted by strict adherence to agreements with respect to time, funding, and distribution of income. However, if the post is organized correctly there are a number of distinct advantages.

Although it would take longer for the museum educator to get services up and running in all the museums involved, and although the choice of services would be limited, once they were established the museums could find themselves involved in joint ventures and

benefiting from marketing and advertising that draws them all in. Teachers using one museum could be made aware of all the others in the group and persuaded to make use of them as well.

Once a museum education service is up and running, even if it is limited, its success may well persuade funding bodies to find the extra money needed to do the job properly. It would also be an attractive prospect for possible sponsors to see that the museums in question have been able to achieve a great deal with limited resources.

Curators and other museum staff have also taken on the task of providing education services or assisting with them. No one who works in a museum ever has spare time on their hands and it is a mark of these people's commitment, as well as their understanding of the importance of education in museums, that prompts them to do this – and often with great success.

VOLUNTEERS

Many museums make use of volunteers to run their education services. There are those who have reservations about this approach, but most of the problems they envisage are easily overcome, mainly by careful selection. Volunteers must be committed to the work and be prepared to do it on a regular basis. It is no good having people who do not turn up when they are expected because they felt like doing something else or nothing at all. In return, any museum that does take on volunteers must provide them with first-class training and treat them like other staff members.

It is in this two-way deal that the main problem of using volunteers lies. A considerable amount of time and effort is required to train them and the training must be done by a competent person who is an expert in museum education. Once trained, they need someone to organize them and set them up with programmes of work. Although some volunteers may have the necessary skills and experience, a museum educator usually needs to be on hand for a scheme involving volunteers to work properly. This can be done by museum educators from elsewhere and the coordination handled by curatorial staff.

Whilst some museums tap this resource quite freely (and the United States can provide many fine examples), many do not. This is partly prejudice. Many museums still see themselves as the preserve of an intellectual elite, in terms of employment if nothing else. However, local museums, which may well display artefacts associated with local industries and ways of life, have a great resource to tap, especially with older adults. Their use is not always appropriate, but is at least worth exploring.

TEACHERS

Yet another avenue is to work in conjunction with local teachers. Some ways in which teachers can assist have already been discussed, but that was in the context of working with a museum educator. Those methods still apply, even if organized by curatorial staff. However, teachers can take a more active role through secondment and sabbatical work.

Although teachers may not have much museum experience, they have the advantage of knowing their own sector of the education system and of knowing exactly what teachers in that sector want of museums. How much can be achieved in the time they have in the museum depends on a number of factors, but at the very least they can assess the situation and draw up work plans for the museum. Other professionals working in the community can also help, bringing their knowledge of the sector in which they work. If secondment is

chosen, the differences in pay and conditions (including holiday entitlement) must be looked at and problems anticipated and catered for at policy level.

CONSULTANTS

A museum might also consider hiring a museum education consultant or freelance. This is a growth area and much good work has been done by freelancers. The key to working with such people, or anyone else who comes in on a temporary basis, is to agree very precisely the limits and expectations of their work. Hire a person to do a specific job and you will get that job to a greater or lesser degree. Hire a person with only a vague notion of why, and you will be left with little but that original vague idea.

A major drawback is that consultants and freelancers can be expensive. They have to make a living like everyone else and the nature of the work makes them an expensive option. However, you are paying for an expert and you can tailor your needs to suit what you can afford.

All these are possibilities to be borne in mind if the preferred option of a permanent museum educator is not realistic. They all have drawbacks and, in the end, some of them can prove more expensive than taking on a member of staff. Whoever takes on the task and whatever sort of service is offered, professional organizations, area museum councils and other such bodies will offer advice and training. However, if the exercise is successful, the arguments for a permanent museum educator are strengthened.

Budget management

Having found a solution to the problem of personnel, it then falls to the museum or the museum educator to manage and raise finances. The funding of museums is a complex issue as they rarely receive monies from a single source and even if they do, it is rarely, if ever, sufficient. Every penny must be spent wisely and every activity undertaken tightly controlled. For all that, museums must secure (and museum educators must fight for) funding sufficient to allow education services to develop rather than remain static.

The most effective way to keep control of finances is to set limits to expenditure. Such limits are likely to be imposed on anyone working in a museum, as funding rarely if ever matches requirements. Even – perhaps especially – where funding is tightly controlled you need to know exactly where every penny goes. If you work in a small museum there may be no separate education budget. In this situation, however, the museum educator is likely to have close contact with those who do have financial control, and will have some say in the way money is allocated. Whether or not they have direct control of educational budgets, museum educators need to be aware of finances to (a) see how they might make their own operation more financially efficient and (b) argue the case for more money or control.

The normal way of exercising financial regulation is through budgetary control. In practice, this means forecasting future expenditure, usually on an annual basis. This does not exclude costing longer-term projects, but such costs will then need to be broken down into annual costs so that they can be included within a single finance system.

Expediency will dictate that an education budgetary year coincides with the financial year used by the rest of the museum. Whether this coincides with the regulatory tax year or not, it will invariably differ from the educational year. Although more difficult, it would be

wise in such a situation to forecast two years ahead, the first year in detail and the second year simply to cover inflationary rises. That way, the finances for overlapping financial and educational years have been given basic cover.

Unless the museum is very large – in which case it may well have specialist finance staff – budgets will be restricted to working out how best to spend an annual sum. You may be allowed to negotiate for your percentage of the museum's total budget. For this, detailed projections of spending are essential, especially if the case has to be made for extra expenditure (for example, to set up a new programme of work or establish a new service).

In setting up a budget, you will find that records of visitor numbers and other such statistics will prove invaluable. Not only do they allow forecasts of overall numbers to be made, but also accurate assessments of seasonal fluctuations.

In the first instance, a budget should be divided into Income and Outgoings. Each of these can then be subdivided as necessary. The two basic categories should balance. That is, for a given budget period, the total sum of Outgoings should be the same as the total sum of Income.

Income should include details of all distinct sources along with the amounts to be received from each and any conditions that may be attached. For example:

- the educational share of the museum's overall income, as well as expected income from charges for services (if these are made);
- financial sponsorship (only include sums that have been ratified);
- sponsorship in kind (which should be shown as its financial worth as well as the actual benefit);
- grants;
- fees (from consultancy, lecturing and so on);
- materials sold (if such proceeds are allocated to an education budget rather than being absorbed by the museum in general);
- donations;
- miscellaneous items.

All this very much depends on what services are offered, along with policy, if any, on charging. For each item of income an annual figure should be given, together with any figures and dates for items of income that will accrue at specific times of the year. Finally, a total can be given along with a monthly (four-week) sum. A four-week month is preferable to a calendar month as it is a fixed period.

Against all this are set items of expenditure, which may include:

- salaries and expenses (if education is financially autonomous);
- capital items;
- running costs and maintenance of equipment;
- charges made by other departments if the museum has an internal market;
- stationery and materials;
- printing;
- marketing;
- training;
- subscriptions to professional organizations;
- miscellaneous items.

For each item of expenditure an annual figure should be given, along with a monthly (again four-week) figure.

From this, it is possible to make up alternative budgets, much as one would when seeking sponsorship (see below). These alternatives should be based on a series of lesser and greater percentages of expected income. This way, variable costs and those that can be varied by appropriately altering activity can be adjusted against fixed costs such as salaries in order to make a series of balanced budgets. Working out such eventualities gives you the opportunity to remain in control of a situation and take advantage of any fluctuations, rather than reacting to them with makeshift measures.

All this is only part of the story. Producing a budget is generally a prelude to negotiation (another good reason for producing several, with variations of income). Moreover, once your income is fixed, you then have to make sure you stick to the budget you constructed.

Keeping control of expenditure is essential and entails a regular review of income and expenditure. Every four weeks should suffice (coinciding with the original four-week periods used in calculation) unless there is a great deal of money moving in and out of the education department, in which case more regular reviews may be necessary. Most computers come ready supplied with appropriate software for budgeting and budget review, as well as projections based on a large number of factors, so the task should not be too onerous. If you are going to buy a computer, look at this kind of software very carefully. For small, simple budgets, pen, paper, and a calculator will suffice.

Some people tend to expect too much of their budgets, especially where the computer is involved. You cannot simply feed in the appropriate figures, print out the results, and assume you are keeping an adequate check on finances. There is much more to it than that. The figures produced (whether by machine or by pen and paper) are merely a convenient way to keep track of what is happening. They will not tell you why it is happening.

Keep a record, therefore, of expenditure and income as it occurs. This is a habit well worth cultivating, as it is all too easy to forget items and find yourself in a mess later on. If you note items as they occur, it is then a simple task to collate this information on a regular basis (the frequency depending on the amount of financial traffic). Pulled together every four weeks, this information allows you to compare actual figures with projected figures, and keep a rough mental check on them in that period. In the case of unexpected income or expenditure, do not just note down the amounts and what they were for. Keep a note of why they occurred.

Where the actual figure of expenditure exceeds the projected figure, it is then a matter of finding out why (perhaps a one-off emergency, for example, or an unforeseeable rise in the cost of materials) and keeping a close eye on that area of spending either to bring it under control or adjust the figures accordingly. This is especially useful if the total expenditure for the period is over budget. If the monthly total balances out (because of underspend elsewhere) it is not such a problem, but it still requires close monitoring, as other areas of the budget cannot be relied upon to continue underspending and indeed, may overspend themselves elsewhere in the year because of seasonal fluctuations. It is a multidirectional balancing trick that requires some skill.

Even this does not guarantee budgetary success. Much depends on the accuracy of your forecast and a close check kept on expenditure. What is more, there are other factors over which you have little or no control. Try to build a little slack into your budget if you can. It is always better to come in under budget than to overspend – as long as this is not used by funding bodies as an excuse to cut your budget for the following year. This is all too common

a problem, which often leads to overbudgeting and consequent spending sprees at the end of the period to ensure that all money is spent (whether those things bought are wanted or not). If this occurs, it will need to be discussed with management.

This is a very brief guide to setting up and running a budget. For simple set-ups, it should be sufficient, but it is always wise to look at these matters in more detail, especially as sponsorship and other sources of funding are playing an ever-greater part in museums. There are many good books on these and other relevant financial subjects to be found in your local library, many of them very well and clearly written. It might even be worth finding out if your local college offers classes in financial management, book-keeping, or general business practice.

Fund-raising

SPONSORSHIP

Beyond the normal and established sources of funding for a museum there are other ways in which cash or services can be obtained. One of the main ways is through sponsorship. Sponsorship is the payment of money or the donation of services by a business to another organization for the purpose of promoting the business's name, products, or services. It is a form of advertising in which the name of the business is linked with some other activity that it sees as desirable or having common ends. The money involved is usually part of the general promotional expenditure of a business.

Sponsorship is generally made in one-off deals but it can also include long-term arrangements. Unfortunately, like all other sources of finance or services, it is not limitless. Many more people seek sponsorship than have it granted. You will be competing with others and need to persuade those businesses you approach that you are a worthy recipient of their money. In general terms, this means that they must be persuaded that their money will be well spent, that their contribution will be obvious to all, and that their association with you will be beneficial to them.

You will have to balance this with the need to avoid what some might consider the over-commercialization of your activities or the even more heinous situation of allowing business to set the agenda. In most cases, there is no real problem, but it is worth bearing in mind.

Of course, you can avoid a great many problems in this area by being careful about who you seek sponsorship from and the kind of deals in which you are prepared to engage. This means precise targeting. Do not simply get a list of local businesses from your local chamber of commerce or the telephone book and write to them all. This wastes everybody's time, your precious resources, and will achieve few results.

Research your subject first. Local business directories that give details of companies and the business section of your local newspaper are good sources of information. Not only will you find out what the businesses produce or offer in the way of services (especially useful if you are looking for services in kind rather than cash), you will probably also gather details of staff, the company's community record, and its current financial standing. Although there is no reason why you should not approach companies that are in the doldrums, you are more likely to get a favourable response from companies that are doing well. Use this information to build up profiles of potential sponsors. Produce a digest about each company or business that will fit on a single side of paper and keep these together in a folder. Any other information you gather can be kept separately in files.

One of the next key pieces of information to gather is who to contact. Marketing personnel are the best bet, if the company has them. If it is a small business, go to the very top. Where you intend to approach the local or regional office of a large national or multinational company, get in touch with the head office first with a very brief request about who you should contact in your area.

Part of the rationale for gathering information is to choose companies that you feel happy about working with and which you feel would benefit from an association with the museum and the specific projects you have in mind. Some links are obvious. Some no-go areas are obvious. Most of the time you will have to look to a broader theme to interest a company. A carpet factory may well be prepared to sponsor educational material for your collection of carpets and tapestries, but is less likely to be interested in early archaeology (although the managing director may have a son or daughter studying archaeology at university and be only too glad to help – you never can tell).

Although you may, in the first instance, be looking for a specific one-off deal, it is worth remembering that sponsorship, if successful, can develop into a more lasting relationship, especially if you are looking for services in kind.

Obtaining sponsorship is a matter of wooing the potential sponsor. You cannot rush into it and simply ask for money for a given project. To begin with, make a short approach by letter. Make sure it is addressed to a specific person, the one who will deal with your eventual application. Make sure you have their name correct as well as any title, qualifications, and job title they may have.

The aim of this letter is to get an interview so that you can discuss the deal face to face. Keep the letter short. Show that you know what their business is, explain what you want sponsored, and demonstrate how that sponsorship will help them. At this stage, you do not need to offer detail. What you want and what the business wants out of the deal are two different things, so you need to sell the idea sufficiently well to get an interview.

Keep to one sheet of paper (although there is no harm in enclosing general leaflets about the museum and its record of accomplishments). Do not waste money on expensive and glossy prospectuses. There is nothing more likely to convince a prospective sponsor that you do not need money than giving the impression you have money to burn at this stage.

Nor must you let the proposal falter at this early stage by ending your letter with a phrase such as, 'I look forward to hearing from you'. You probably will not. End with something more positive, like, 'I will telephone in a week's time to arrange an appointment'. And make sure you do. After all, you are doing the selling. Get your foot in the door.

If the company is not interested in sponsoring you, you will not get an appointment. Write them off for now, but do not write them off for good. There may be a number of reasons why they are not interested at present. They may even tell you why. Lack of money is the most likely answer, but they may also have set procedures for applying for sponsorship. If that is the case, find out what those procedures are. Take note of what they say for future reference.

If you do get an interview it means they are interested, but not that they will sponsor you. However, you have made contact and can discuss your current needs and longer-term prospects for a relationship. This meeting is the opportunity to let the company know that you have done your homework and know something about them and their market. Be confident in your knowledge but do not presume to know them better than they know themselves. Know your own market so that you can demonstrate how your two organizations

overlap and can accrue mutual benefits from the sponsorship deal. This not only helps to sell the deal, but it also demonstrates that you are a professional, someone with whom it is worth doing business.

Having secured an appointment, prepare a package of information you can take with you to sell the sponsorship idea. Make this as general as possible so that you can use it with a number of different companies. Include a section that explains why you want the money or services. This can be used with different clients. However, you will also need a section targeted at specific companies to show that you know them and can explain precisely what you are offering them in terms of advertising space, product placement, photo opportunities, and the like.

Never offer anything you cannot deliver. Be as precise as you can but leave enough room for manoeuvre and negotiation – after all, a company may be interested but only have a small pot of money available. They may be willing to be co-sponsors, but check to find out if there are companies with which they are not willing to appear. Have other packages for which you want sponsorship. They may only be able to afford something smaller, but you might strike lucky and find that they are prepared to offer a lot more.

Be honest with the people you meet. Let them know precisely what areas you have control over. Do not be afraid to say if there are still hazy areas, but be prepared to explain why you are coming to them at such an early stage. They may even be able to offer business advice.

Outline all the costs of the project for which you are seeking sponsorship. You must get this right. You will not be able to go back later and ask for some more because you forgot something. Not only does this demonstrate poor planning, but also the money will not be there.

Outline all the benefits and be prepared to listen to requests. They may ask for things you had not considered, such as the chance to host a corporate session (to impress investors or potential customers) within the museum. Do not say yes to anything you have no authority over. Note their requests and if it looks as if you will need the authority of others, set up a further meeting with those who have the authority. Remember, too, that you are the museum specialist and you know what will and will not work in your environment. Do not be afraid to advise in such areas.

While it is reasonable to consider the ideas and requests of the potential sponsor, do not let them take over. Know how far you are prepared to go before you enter the negotiations and be prepared to say no to anything that is unacceptable. You may be desperate for money, but you cannot build a relationship with a business if they think they can get away with dictating the terms of every deal. This will be especially so when it comes to signs and logos. They will quite reasonably expect their name to be prominent as sponsors (or part-sponsors – in which case they may want it to be clear how large their percentage of the deal is), but their name cannot be allowed to overshadow whatever it is you do.

You should try to ascertain as soon as possible (without being too blunt) what amounts of money or support your potential sponsor is prepared to allocate to you. If this is substantially different from your main project, then switch to whichever package is best suited. Even something as basic as paying for (or printing at cut price) the posters or leaflets can ease pressure elsewhere and make life easier for you.

At no stage of your meeting should you apply pressure of any kind. Even if your whole project relies on them coming through with the money, this should never be used as a sales pitch. It simply makes you look desperate. Sell your package on its merits and the benefits to the potential sponsor – nothing more and nothing less.

Your meeting is just a beginning. From it you can gain a great deal of information about the sort of project the company is looking to sponsor in the future, and you may well have some idea in outline of future projects at the museum. Even if you do not get sponsorship this time round, you will have gained a great deal of useful information to help with future applications. If you do get sponsorship, you are at the beginning of a relationship that needs to be maintained and developed.

You should keep in close contact with your sponsors as your deal develops, but do not burden them with inessential details – a brief weekly report will be sufficient. You should also put into action the little extras that make it work for the sponsor: private viewings of the museum (with refreshments) for the directors of the company; a special package for staff so that they get in at cut price for a set period of time; along with plenty of press coverage of this and the main deal. Make sure your sponsor has enough copies of leaflets and the like, as they may wish to send these to their clients in order to impress them.

Follow up with a summary after the event, showing what their sponsorship has done for you and showing how much coverage they have gained from it. They may well have done this for themselves, but if it is a small firm, they may not have the staff. This helps to cement the relationship and makes them more likely to support you in the future.

Where a transaction takes place (that is, where money or goods are given in exchange for marketing opportunities), you will need to check the position with regard to paying tax. This will vary from country to country. It may also depend on the size of the museum's income and whether or not the museum is a registered charity. There are many good books available on this; advice can also be obtained from museum organizations or financial advisers. Check carefully.

GRANTS

Money can also be raised from grant-giving bodies. Some of these are charitable trusts that exist solely to distribute the money in their care. However, it is also worth approaching trusts that are associated with companies. These vary enormously in size and objective, and careful research and preparation is required before approaching them.

To begin with, be clear about what you want the money for and how much you need. This can always be broken down into smaller amounts and several bodies approached. However, it is far better to specify what each smaller amount will be spent on within the overall project than to approach five trusts, each for a fifth of the cost.

There are many lists and directories of grant-giving bodies. Go through these very carefully, examining each of the bodies listed. Your initial research should yield a list of trusts to approach with useful details of each, including:

- the contact (name and title, if available);
- address;
- application deadlines;
- application guidelines (some trusts insist that you use their application forms);
- past donations;
- size of resources and annual grants;
- any conditions attached to the granting of monies.

Be certain that you meet the general criteria of whoever goes on your list.

Unless a trust discourages such contact, you should then telephone, explain as briefly and as clearly as possible who you are, what you will be seeking grant aid for, and check that you meet the criteria set by the trust. Not only will you save yourself unnecessary work by eliminating borderline cases, but you will also have the opportunity to find out what else the particular trust might require in relation to the application you make (such as accounts and annual reports).

As already stated, some trusts insist that you use their application forms. This will dictate the information you give and its form. However, if you are left to make an application of your own it should be concise and clearly written.

State who you are, where you work, and your position within that organization. Follow this with a summary – a very brief outline of what your proposal involves and how much you are asking for. Always be specific, as this shows you have done your homework and know what you want. Never leave your request vague or open-ended. Make it clear whether you are asking for a one-off donation, a recurring donation, or an interest-free loan.

Next, outline the education work you do within the museum. This provides a context for specific details of the project that requires money. If you are approaching a trust for a part of that sum, explain precisely what part of the project their money will fund. Emphasize who will benefit from the project. Even if the money is needed to buy equipment, be very explicit about the advantages it will bring to others.

Place the sum of money you are asking for in the context of the project as a whole. Mention what financial management procedures you have in place (especially if you are setting up a scheme that will have running costs), who else has given money, and who else is being approached.

Finally, list the objectives you hope to achieve by the project, and say how you will measure whether or not they have been met. Describe how you intend to achieve those objectives.

Presentation is very important. This is less of a problem with easy access to word processors, but it is still worth taking care over, as the look of an application is influential. You will be competing against many other applicants (sometimes many hundreds of applicants). The clearer the application, the easier it is for trustees to assess its worth. It is also better to submit a short proposal (no more than three sides of A4), provided all the basic information is there. Trustees can always ask for more information if they need it.

Approaching a charitable trust for money should not be considered a short-term measure. They may only meet once or twice in a year and their workings are often obscure. Be patient and be persistent.

Should you receive a grant, it is both polite and wise to keep the trust informed of the progress of the project they have helped to fund. If it all goes well, they are more likely to look favourably on you in the future (if they give grants to previous recipients). Most trusts are happy to work in obscurity, but it is always good to make public acknowledgement of them and their donation.

Other sources

Other sources of funding are available, including packages from local and national government, various statutory bodies, lottery boards and so on. The application process for these can be extremely complex and you should think hard about whether the time involved is

available and worth the possible return – after all, for all the hard work you put into any sort of application for money, there is no guarantee of success.

As well as money and services in kind, it is worth exploring a third avenue that has less immediate impact but which makes applications for sponsorship and grants much easier. Every year, museum education services are given awards by a number of different bodies, both large and small. Most of these consist of little more than the right to put up a plaque saying that you have won the award, but the prestige that goes with them enhances the image of the museum and the education work that you do. There is always press coverage when the award is made and, in the long term, the reputation you have for excellence will bring more and more work your way, increasing revenue and support along with it.

It would pay, therefore, to find out what awards exist that are in any way relevant to the work you do. They do not have to be specifically for museum education but may be, for example, for pioneering work done with disabled children. Know what they are, what the criteria are for applying, and do not be afraid to blow your own trumpet. If you do not do so, no one else will.

16 *Afterword*

In getting the practical details of museum education work correct and the service running smoothly, it is all too easy to lose sight of other aspects and aspirations. Of course, you have to get the details correct, but it is important to have a wider view of the work you do and goals toward which the details form tributary paths.

The nature of this wider view is, in large part, up to you. However, it is unlikely that anyone goes into museum education without the belief that it is important. It is certainly never well-enough paid or easy to make it a soft option.

Some reasons for its importance have been offered in this book. They are mostly centred on the belief that we must offer students an education of ideas as well as of facts and that we should help them to develop the wherewithal to continue exploring the world of ideas.

This may seem strange in places that are dedicated to the material aspects of our lives. However, that is to see or acknowledge only part of the function of museums. Every artefact is the product of an idea; every museum is a place of the muses. We ignore these facts at our peril.

The world, we are forever being told, is a rapidly changing and precarious place. The last one hundred years has seen a massive acceleration in the pace of change of so many things – material and non-material. It is imperative, therefore, that young people are increasingly better educated to cope with the burgeoning complications of the world in which they will live their lives.

A Gradgrind approach to education will not do, any more than confining students to the classroom. They need engagement with ideas as well as facts; they need engagement with the world. Museums, galleries, and heritage sites have a key part to play. They are places where facts and ideas merge and where the consequences of that merger can be examined. This means they are not just about the past, but also about the present and the future.

How this wider approach is achieved at the same time as delivering programmes of work about very specific times, places, people, events and artefacts is one of the great challenges of the job. No individual museum educator can hope to do it all. Yet each can make their contribution. Illuminating something specific can cast light into other areas that might otherwise remain dark and even unnoticed.

There is something else. In all this hard work and serious intent, we should not lose sight of the fact that in order for museums to become and remain important to students (and their teachers) there must always be an element of wonder, even a touch of magic or enchantment. You cannot force this, calculate it, or add it as an extra ingredient. However, by being open and by aiming to touch people's lives so they can make better sense of them and the world in which they live, the magic will appear and kindle that sense of wonder – a flame it is difficult to extinguish.

Appendices

The sample documents that follow should not be taken as fully comprehensive. They are simply included to give some idea of how such things may be worded. They can be used as the basis for similar documents, but it is advisable to start from scratch in any given situation to ensure that such a document fits your needs precisely.

1 *Sample Primary Education Policy Document*

This museum recognizes that it is an educational resource of enormous wealth. It will do all within its power to promote its educational role and provide a service for visitors in general and educational user groups in particular. This is enshrined within the general policy of the museum. Charges may be made for some or all of the services offered in accordance with a formula outlined in the appended secondary statement. The museum educator or museum education team should:

- ensure that the education policy and its practice relate specifically to and are in accord with the policy and practice of the museum as a whole;
- carry out their work professionally and, where necessary, in association with other staff in the museum;
- keep themselves as well informed as possible about subjects that relate to the collections and core work of this museum and museums in general;
- keep themselves as well informed as possible about the facts, theories, debates, and developments in education in general, museum education in particular, and related subjects (both locally and nationally), and ensure that the education service is offered in accordance with them where that remains compatible with the policy and practice of the museum education service;
- devise, research, and produce educational materials, and put into practice educational programmes that highlight and explore the collections and core work of the museum for visitors in general and educational user groups in particular, as well as devise ways in which they can complement work undertaken by students elsewhere;
- teach and otherwise work with visitors, students and teachers in ways that make best use of the museum and the museum educator, meet the needs of educational user groups, provide the most direct and appropriate forms of educational experience of the available resource, and which do not duplicate (as far as is possible) work that can be done elsewhere;
- establish, maintain, and develop links with professionals, groups and organizations whose interests are in accord with the museum in order to keep informed and communicate information;
- explain and disseminate information about the museum's work;
- promote use of the museum (formally and informally) by as wide an audience as possible;
- in close association with management, curatorial, and other senior staff, be involved with all stages of any developments within or of the museum;

- devise methods of record keeping and assessment, set targets, and monitor their work closely to ensure that it evolves in a positive way, including a full review of education policy and practice every three years;
- ensure that all museum education staff are fully aware of their rights and responsibilities and that all staff (paid or voluntary) working with minors are competent and trustworthy, and have been vetted in accordance with legal requirements.

2 Sample Museum Educator Job Description

Post title: Museum Educator

Responsible to: ...

Responsible for: ...

General responsibilities: To manage, develop, and service the educational activities and programmes offered by the museum.

Main duties of post:

1 To ensure that educational activity is carried out in accordance with education policy and the objectives of the managing body.
2 To work in concert with other museum staff and stay as well informed as possible about the collections and core work of the museum, along with any other areas of concern such as the archaeology and history of the local area.
3 To stay as well informed as possible about the facts of and theories, debates, and developments in education in general, museum education in particular, and related subjects (locally and nationally) and to adjust and develop educational activities accordingly.
4 To direct and support the work of any staff engaged in assisting with educational work (for example, preparation of work areas, welcoming and organizing parties, teaching, dealing with enquiries, processing bookings, and so on) and ensure that they are aware of their rights and responsibilities.
5 To devise, research and produce educational materials and put into practice educational programmes that relate to the collections and core work of the museum and to related areas (for example, local history and archaeology) where relevant.
6 To teach and otherwise work with visitors, students and teachers in ways that provide the most direct and appropriate forms of educational experience of the available resource and which do not duplicate (as far as is possible) work that can be done elsewhere.
7 To seek ways to increase the material and financial resources available for educational use.
8 To devise ways of complementing work undertaken by students elsewhere (for example, by producing and making available loan material and printed material for use by teachers and students).
9 To devise, research, and offer courses for students undertaking initial teacher training, as well as in-service courses for practising teachers.

10 To devise, research, and offer non-formal and informal activities, courses, and pro-
grammes of education for visitors and students.
11 To provide information and offer advice to students who have specific queries and
projects that relate to the work of the museum educator and the museum as a whole.
12 To keep a statistical record of all educational activities.
13 To report on the progress of all educational activities and programmes, on a regular
basis, to the managing body of the museum.
14 To contact, maintain, and develop links with professionals, groups, and organizations
whose interests are in accord with the museum and its educational activities and pro-
grammes, in order to keep informed and communicate information.
15 To explain, disseminate information about, and otherwise actively promote the educa-
tional activities and programmes of the museum to as wide an audience as possible.
16 To assess and fulfil museum staff training needs that relate to the work of the education
department and, in liaison with management and curatorial staff, the training needs of
staff in other areas of the museum.
17 To oversee the use of any educational research material.
18 To assist with general duties (to be specified) and make decisions, in their absence, on
behalf of any staff member to whom they are deputed.

3 *Sample Secondary Education Policy Document*

In support of the primary policy statement, the following secondary statements should be recognized. It is not possible to go into details here; the list is indicative only.

1. Objectives

The major objectives of the education service are:

1.1 To reach groups and individuals in all sections of the community (permanent and temporary) and all levels of the formal and non-formal education sector, irrespective of age, ability, or capability.

1.2 To raise public awareness of the existence and purpose of the museum and its education service.

1.3 To ensure that all activities the museum is involved in are appropriate, enjoyable, and educational.

1.4 To market the education service to educational providers.

1.5 To provide regular information to educational providers, community groups, and interested individuals.

1.6 To ensure the availability of the education service to outlying educational providers through use of various forms of outreach.

1.7 To develop techniques to evaluate the effectiveness of all educational activities.

2. Staff

2.1 List all posts that have a specific museum education role, along with a job description for each and the staffing structure of any department that has more than one member of staff.

2.2 List all other posts that have an occasional education role, with details of their normal duties, degrees of availability, and the specific roles they have agreed to undertake.

3. Space

3.1 List all those areas and spaces already given over solely or partly to educational use. In the case of shared areas and spaces, indicate who else has access and give details of how

and when they use them. This can include: museum display space that can be used for teaching collections over and above those on display within exhibitions; floor space and room space within public parts of the museum; floor space and room space that could be specifically set aside for educational activities apart from the public parts of the museum; space on notice boards and within publications for information and advertising; storage space that could be given over to educational materials (including teaching materials and collections, loan materials, equipment, stationery, and so on); office space; workshop space.

3.2 List, in the same way, all those areas that have potential.

3.3 Set out a case for the ideal use of teaching and administrative space.

4. Equipment available for use

4.1 Capital equipment (including such items as video recorders, televisions, audio recorders, slide projectors, audio-visual equipment, projection screens, display screens, and cameras), office equipment (such as photocopiers, typewriters, laminators, printers, computers and software), tables, chairs, desks, and so on.

4.2 Consumables (including such items as paper, ink, stationery, film, craft materials, and so on).

Indicate whether these are for the sole use of education staff or whether they are shared with other departments. If they are shared, indicate who has nominal control and what systems exist to book, borrow, and return such equipment.

5. Educational provision

Educational provision should be listed in three major groupings.

5.1 All currently existing services and programmes of work should be listed with brief notes about their uptake and effectiveness.

5.2 New services and programmes of work that could be introduced in the near future.

5.3 Programmes of work and services that could be introduced in the longer term or take time to establish.

Include a note of services that were once offered, but no longer exist as well as those that could be phased out or amalgamated with other existing or proposed services.

6. Constituency

List all potential educational users of the museum within an hour's travelling distance of the museum (longer if more rural).

6.1 All institutions of formal education.

6.2 All institutions of non-formal education.

6.3 Community groups and individuals (including adult groups, senior citizen groups, youth groups or clubs, special needs groups, tourists, and local people, along with the reasons they are likely to require access to the museum other than as general visitors).

6.4 Colleagues in museums and in education.

7. Teaching resources

In addition to any equipment available for teaching, the museum will contain a vast array of resources. Details of what is available under the following headings should be made, with an assessment of their suitability.

7.1 Books and other printed material kept in a research library.

7.2 Primary documentary material including text, pictures, photographs, and the like.

7.3 Secondary documentary material including video and audio recordings, photographs and slides produced by the museum, as well as computer software and catalogues.

7.4 Artefacts from the collection on display in permanent exhibitions.

7.5 Artefacts from the collection on display in temporary exhibitions.

7.6 Artefacts kept in the reserve collection that can be drawn upon for educational work.

7.7 Artefacts kept in permanent handling collections.

7.8 Loan materials.

7.9 Replicas of artefacts.

7.10 Mobile exhibitions.

Items 7.4 to 7.8 will be itemized in the museum's catalogue of artefacts. Such a catalogue should differentiate between artefacts, using the categories listed above.

8. Marketing

8.1 Current strategies (with an assessment of the costs and the effectiveness of each one).

8.2 Strategies that might be employed at a future date in addition or as an alternative to those currently in place.

8.3 A brief assessment of past strategies no longer in use.

9. Evaluation

9.1 Evaluation techniques currently in use (long-term and one-off projects, formal and informal, quantitative and qualitative), what they are used to evaluate, and the use that is made of any results (reports and ongoing assessment of services and programmes).

9.2 Evaluation techniques that could be introduced and for what purpose.

10. Funding

10.1 Source(s) of museum education staff salaries and relevant information on pay scales.

10.2 Source(s) of funding for capital costs for educational services and programmes of work.

10.3 Source(s) of day-to-day running costs of educational services and programmes of work.

10.4 Source(s) of current grants and sponsorships, details of what they fund and of any conditions attached to the funding.

10.5 Possible future sources of funding, with details of what the funding would support.

10.6 Details of any charges made for services or material costs, who is to pay these charges, and any formulas by which they are calculated.

In each case, the security of funding should be indicated so that it is clear which aspects are long-term (with any time limits noted), which need to be negotiated for on an annual basis, and which are one-off grants or sponsorship. Responsibilities for budget control and negotiation should also be given for each case.

11. Training

11.1 All current regular courses, seminars, lectures, workshop sessions, training sessions, and programmes offered by museum education staff.

11.2 One-off seminars, lectures, and workshop sessions given in the past by museum education staff.

11.3 Proposed and possible courses, seminars, lectures, workshop sessions, training sessions, and programmes to be offered by museum education staff in the future.

All the courses and sessions mentioned above should include details of who they are intended for, whether they are produced in liaison with other bodies (and whether they lead to recognized forms of qualification) and, in the case of courses already given, whether or not they were successful.

11.4 All courses, seminars, lectures, and workshop sessions attended by museum education staff, why they were attended, and an assessment of their effectiveness.

11.5 All courses, seminars, lectures, and workshop sessions that might benefit museum education staff in future (based in part on an assessment of areas of expertise that need strengthening).

12. Liaison

12.1 Internal staff structures, complaints and disciplinary procedures, and details of regular meetings at which attendance is obligatory.

12.2 A list of all individuals and distinct groups and organizations with which the museum educator has contact outside the museum for the purposes of information exchange, professional development, and formal and informal marketing. This should contain

brief details of the nature of the link, the regularity with which meetings take place, and the sort of information that moves between the museum educator and each party.

4 Sample Booking Form, Confirmation, Conditions and Booking Chart

GROUP VISIT BOOKING FORM

School/Group: ..

Leader's Name: ..

Address: ..

...

...

...

...

Telephone: ..

E-mail: ..

Date:/.........../...........

Visit number: of:

Number of Students:

Number of adults:

Age of students:

Arrive:

Depart:

Visitor Requirements
Service .. Cost

1. Which galleries required?
 1 ... @
 2 ... @
 3 ... @

2. Guide required? No/Yes Allocated to: @

3. Programmes required? No/Yes
 1 ... @
 2 ... @
 Allocated to: .. @

4. Education room? No/Yes From: to: @

5. Refectory? No/Yes From: to: @

6. Charges explained? No/Yes Total:

Deposit of: received on:/........./.........

Balance of: received on:/........./.........

7. Preliminary visit? No/Yes Date:/........./......... Time: With:

8. Special needs? No/Yes Specify: ...

...

...

9. Additional information: ...

...

...

...

Booking taken by: on:/........./.........

Diary checked by: on:/........./.........

Confirmation sent by: on:/........./.........

This copy for:
Education team:
Curator:
Front of House:

Booking confirmation (with conditions)

Write to confirm all bookings. Set up a template on a computer so that you can fill in all relevant details, delete unwanted information, and send a professional-looking and personalized letter. If your computerized booking system is sufficiently sophisticated, it may well do this for you, producing a confirmation letter from the information you enter on the booking form.

In addition to confirming the booking, the letter should contain a list of any conditions you impose, for example as follows.

1 If you or any of the other teachers involved with the visit wish to make a preliminary visit to the museum, you are welcome to do so. Such preliminary visits are free of charge on production of this letter. If you wish to speak with a member of the museum's education staff, you must make an appointment.

2 On the day of your visit, we ask that you be as prompt as possible (and as traffic will allow). We work to a tight schedule and need to start on time, especially when there are several groups in the museum.

3 If you wish your students to be in specific groupings during the day, please contact us beforehand to make the arrangements. Our ability to comply is entirely dependent on staffing levels.

4 On arrival – unless we have agreed on other arrangements – please report to the main reception desk.

5 If you are staying for a whole day and have brought packed lunches, we would be grateful if you would bring them in with you so they can be left in the refectory. This saves much time and fuss later on.

6 Please ensure that students are appropriately dressed, especially if they are undertaking practical work. There is safe storage space for coats and bags.

7 During lunch, if students are making use of the museum refectory, we ask that they confine themselves to this room and to the toilets. Food and drink must not be taken out of the refectory under any circumstances. Receptacles are provided for waste. Please do *not* place half-empty cans and bottles of drink in the bins, but place them upright on the tray provided. Students may also visit the museum shop provided they are in small, staff-supervised groups. No more than eight students should be in the shop at any one time. We ask that they do not take bags into the shop with them. All other parts of the museum should be considered strictly out of bounds.

8 Please note that photography is not allowed anywhere in the museum.

9 Please note that smoking is not allowed anywhere in the museum.

10 While we endeavour to ensure security, the museum cannot accept responsibility for loss of or damage to the personal items of students and teachers.

11 Although we undertake to provide access and (when requested) teaching, responsibility for students at all times rests with their accompanying staff.

12 Payment of a deposit confirms your acceptance of these conditions.

These conditions will vary depending on your situation, but they should be kept as simple as is compatible with legal requirements.

In order to make the process easier, and less prone to double booking, a simple chart can be blocked out as bookings are confirmed.

BOOKING CHART **Date:/........../..........**

Places & Personnel	Times								
	10.00	11.00	12.00	13.00	14.00	15.00	16.00	17.00	18.00
Gallery 1									
Gallery 2									
Gallery 3									
Gallery 4									
Gallery 5									
Programme 1									
Programme 2									
Programme 3									
Programme 4									
Programme 5									
Education room									
Refectory									

Education staff

AA									
JA									
TR									
JR									
BC									
EB									

Notes: ...
...
...
...
...
...
...

5 *Education Systems Compared*

The chart that follows is not a definitive guide. It is included simply to give an idea of the different names that are used in the English-speaking world to apply to different levels of various education systems. The situation is, in reality, much more complex, with combinations of systems being employed within a country or even within a district or region.

Education systems compared

Country	Age: 3 4 5 6 7 8 9 10 11 12 13 14 15 16 17 18 19 20 21 22 23 24
Australia	Grade: K 1 2 3 4 5 6 7 8 9 10 11 12 13 — Pre-school; Pre-Year; Primary School; Primary School; Junior Secondary; Junior Secondary; Senior Secondary; Technical and Further Education; Higher Education (College & University)
Canada	Grade: 1 2 3 4 5 6 7 8 9 10 11 12 13 — Pre-primary; Pre-primary; Primary School; Primary School; Junior Secondary; Senior Secondary; Senior Secondary; Post Secondary (College & University); Higher Education (College & University)
England & Wales	Key Stage / Year: R 1 2 3 4 5 6 7 8 9 10 11 — Pre-school (Day nurseries) (Nursery School) (Playgroups); Infant School; Infant School; Primary School; Primary School; Junior School; Junior School; Middle School; Middle School; Secondary School; Secondary School; Secondary School; Secondary School; Sixth Form; Further Education; Higher Education (College & University)
New Zealand	Grade: 1 2 3 4 5 6 7 8 9 10 11 12 13 — Early childhood education; Primary School; Primary School; Primary School; Intermediate School; Intermediate; Intermediate; Secondary School; Secondary School; Secondary School; Secondary School; Further Education; Higher education (College & University)
Scotland	Year: P1 P2 P3 P4 P5 P6 P7 S1 S2 S3 S4 S5 S6 — Pre-school (as England & Wales); Primary School; Secondary School (High Schools Academies & Colleges); College; Further Education; Higher Education (College & University)
USA	Grade: 1 2 3 4 5 6 7 8 9 10 11 12 — Nursery School; Kindergarten; Elementary School; Elementary School; Elementary School; Middle School; Junior High School; Senior High School; Combined High School; Four Year High School; Jnr Community College; Four Year College; Four Year College; Graduate School; Professional School

Bibliography

As with the previous edition, much of the foregoing text was derived from personal experience – my own and that of colleagues. This bibliography contains only those works used in corroborative research. It is, therefore, neither definitive nor indicative of the scope of the finished work. For more comprehensive bibliographies of museum education material, see those compiled by Mary Bosdêt, Gail Durbin and Annette Stannett and published by the Group for Education in Museums (GEM).

Ambrose, T. (1984), *Education in Museums, Museums in Education*, Edinburgh: Scottish Museums Council

Anderson, D. (1997), *A Common Wealth – Museums and Learning in the United Kingdom*, London: Department of National Heritage

Boodle, C. (1992), *A New Decade – Museums and Education in the 1990s*, London: National Heritage

Booth, J. H., Krockover, G. H. and Wood, P. R. (1982), *Creative Museum Methods and Educational Techniques*, Springfield, IL: Charles C. Thomas

Bosdêt, M. and Durbin, G. (1989), *GEM Museum Education Bibliography 1978-1988*, Group for Education in Museums

Budge, A. (ed.) (1993), *Journal of Education in Museums – 14*, Group for Education in Museums

Carter, G. (ed.) (1980), *Journal of Education in Museums – 1*, Group for Education in Museums

Carter, G. (ed.) (1981), *Journal of Education in Museums – 2*, Group for Education in Museums

Carter, G. (ed.) (1982), *Journal of Education in Museums – 3*, Group for Education in Museums

Carter, P. G. (1984), *AIM Guideline No 6 – Education in Independent Museums*, Association of Independent Museums

Collingwood, R. G. (1946), *The Idea of History*, Oxford: Clarendon Press

Dewey, J. (1963), *Experience and Education*, London: Collier-Macmillan

Durbin, G. (ed.) (1985), *Journal of Education in Museums – 6*, Group for Education in Museums

Durbin, G. (ed.) (1990), *Journal of Education in Museums – 11*, Group for Education in Museums

Durbin, G., Morris, S. and Wilkinson, S. (1990), *A Teacher's Guide to Learning from Objects*, London: English Heritage

Fairclough, J. and Redsell, P. (1985), *Living History – Reconstructing the Past with Children*, London: English Heritage

Goodhew, E. (ed.) (1987), *Museums and the New Exams*, London: Area Museums Service for South Eastern England

Goodhew, E. (1988), *Museums and the Curriculum*, London: Area Museums Service for South Eastern England

Goodhew, E. (ed.) (1989), *Museums and Primary Science*, London: Area Museums Service for South Eastern England

Greeves, M. and Martin, B. (eds) (1992), *Chalk, Talk and Dinosaurs? Museums and Education in Scotland*, Edinburgh: Moray House

Hawthorne, E. (ed.) (1999), *Journal of Education in Museums – 20,* Group for Education in Museums

Hawthorne, E. (ed.) (2000), *Journal of Education in Museums – 21,* Group for Education in Museums

Hein, G. and Alexander, M. (1998), *Museums – Places of Learning,* Washington, DC: American Association of Museums Education Committee

Her Majesty's Inspectorate of Schools (1988), *A Survey of the Use of Museums and Galleries in General Certificate of Secondary Education Courses*, London: Department of Education and Science

Her Majesty's Inspectorate of Schools (1989), *A Survey of the Use Schools Make of Museums Across the Curriculum*, London: Department of Education and Science

Her Majesty's Inspectorate of Schools (1989), *A Survey of the Use Schools Make of Museums for Learning about Ethnic and Cultural Diversity*, London: Department of Education and Science

Her Majesty's Inspectorate of Schools (1990), *A Survey of Local Education Authorities' and Schools' Liaison with Museum Services*, London: Department of Education and Science

Her Majesty's Inspectorate of Schools (1990), *A Survey of the Use of Archives in History Teaching*, London: Department of Education and Science

Her Majesty's Inspectorate of Schools (1990), *A Survey of the Use of Museum Resources by Pupils Aged 5-9*, London: Department of Education and Science

Her Majesty's Inspectorate of Schools (1990), *A Survey of Work Based on Drama by Pupils Aged 8-16 at Museums and Historic Sites*, London: Department of Education and Science

Her Majesty's Inspectorate of Schools (1991), *A Survey of the Use Schools Make of Information Technology Linked to Museums*, London: Department of Education and Science

Her Majesty's Inspectorate of Schools (1991), *A Survey of the Use of Museums by 16-19 Year Olds*, London: Department of Education and Science

Hewison, R. (1987), *The Heritage Industry*, London: Methuen

Hooper-Greenhill, E. (ed.) (1989), *Initiatives In Museum Education*, Leicester: Leicester University Department of Museum Studies

Hooper-Greenhill, E. (1991), *Museums and Gallery Education*, Leicester: Leicester University Press

Hooper-Greenhill, E. (ed.) (1992), *Working in Museum and Gallery Education – 10, Career Experiences*, Leicester: Leicester University Department of Museum Studies

Hunter, L. (ed.) (1991), *Journal of Education in Museums – 12*, Group for Education in Museums

Hynson, C. (ed.) (2001), *Journal of Education in Museums – 22,* Group for Education in Museums

Hynson, C. (ed.) (2002), *Journal of Education in Museums – 23,* Group for Education in Museums

Lowenthal, D. (1985), *The Past is a Foreign Country*, Cambridge: Cambridge University Press

Mosley, D. (ed.) (1989), *Journal of Education in Museums – 10*, Group for Education in Museums

Reeve, J. (ed.) (1983), *Journal of Education In Museums – 4*, Group for Education in Museums

Reeve, J. (ed.) (1985), *Journal of Education in Museums – 5*, Group for Education in Museums

Resource (2001), *Disability Directory for Museums and Galleries*, London: Resource – The Council for Museums, Archives and Libraries

Rogers, R., Edwards, S. and Godfrey, F. (2002), *The Big Sink*, London: Clore Duffield Foundation

Rogers, R. (2004), *Space for Learning,* London: Space for Learning Partnership

Ruskin, J. (1970), *Unto This Last*, London: Collins

Ruskin, J. (1896), *Fors Clavigera*, London: George Allen

Schools Council Joint Working Party on Museums (1972), *Pterodactyls and Old Lace*, London; Evans/Methuen Educational

Siliprandi, K. (ed.) (1992), *Journal of Education in Museums – 13*, Group for Education in Museums

Sorrell, D. (ed.) (1988), *Journal of Education in Museums – 9*, Group for Education in Museums

Stannett, A. (1997), *GEM Museum Education Bibliography 1988-1996*, Group for Education in Museums

Stevenson, J. (ed.) (2003), *Journal of Education in Museums – 24,* Group for Education in Museums

Stevenson, J. (ed.) (2004), *Journal of Education in Museums – 25,* Group for Education in Museums

Talboys, G.K. (1996), *Using Museums as an Educational Resource*, Aldershot: Arena

Wilkinson, G. (ed.) (1987), *Journal of Education in Museums – 7*, Group for Education in Museums

Winterbotham, N. (ed.) (1987), *Journal of Education in Museums – 8*, Group for Education in Museums

Index